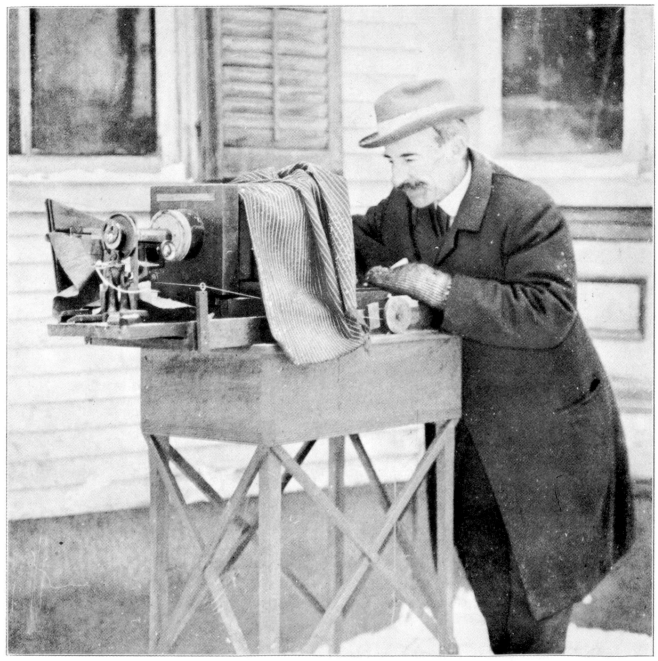

W. A. Bentley Photographing Snow Crystals

SNOW CRYSTALS

BY

W. A. BENTLEY

AND

W. J. HUMPHREYS

DOVER PUBLICATIONS, INC.
NEW YORK NEW YORK

Published in Canada by General Publishing Company, Ltd., 30 Lesmill Road, Don Mills, Toronto, Ontario.

Published in the United Kingdom by Constable and Company, Ltd.,

Standard Book Number: 486-20287-9
Library of Congress Catalog Card Number: 63-422

Manufactured in the United States of America
Dover Publications, Inc.
180 Varick Street
New York, N.Y. 10014

PREFACE

From Jericho, Vermont, through the patience and skill of Mr. W. A. Bentley, many exquisite pictures of the snow crystal have gone to the ends of the earth in books and magazines, and as lantern illustrations for classes in art and design. And from far and wide has come back the urgent request that all these pictures—all at least of particular beauty or especial interest—be somehow preserved from an otherwise sooner or later certain loss and made conveniently available alike to the scientist seeking truth, the artist searching for patterns of graceful form, and all to whom the beautiful in Nature has a strong appeal. But the labor of it obviously would be tedious and the cost very great, and so it seemed that the end desired must be far away, if indeed ever to be attained.

Yet it was not so, for one who heard this call responded graciously and kindly. His generous gift was by way of the American Meteorological Society, which in turn was charged with the responsibility of designating some one to select from these pictures, and arrange in proper order, all that have either distinctive beauty or promise of scientific value, and to prepare such brief text as might be necessary to go with them.

It also was decided to confine the pictures entirely to those taken by Mr. Bentley, except, of course, the one of himself at work, and further agreed to supplement the many pictures of snow crystals with a few illustrations of other, but more or less kindred, forms of water, especially frost and dew.

Acknowledgment is here made of the kind help and expert guidance of Doctors S. B. Hendricks, H. E. Merwin, C. S. Ross, and W. T. Schaller, in the preparation of the section on the crystallography of the snow crystal.

W. J. HUMPHREYS.

WASHINGTON, D. C.,
August, 1931.

CONTENTS

ILLUSTRATIONS

Reference is by number and page. The numbers are continuous, line by line, across the page as one would read. Thus *4*, page 45, means the first picture in the second row, or second picture in the first column, on page 45; *8*, page 67, means the second picture in the third row, or third picture in the second column, on page 67, and similarly for all others.

PART I
THE SNOW CRYSTAL

HISTORY

Snow, the beautiful snow, as the raptured poet sang, winter's spotless downy blanket for forest and field, has ever challenged pen to describe, and brush to paint, its marvelous mass effects. Nor is the aesthetic urge of its very tiniest flake or smallest crystal that gently floats from heaven to earth any less compelling. It is even more insistent—doubly more—for it not only quickens that response to the dainty and the exquisite that makes us human, but equally arouses our desire to understand, our curiosity to know, the how and the why of this purest gem of surpassing beauty and of a myriad myriad forms. But it is so tiny, so fragile, and so evanescent save in the coldest of weather, that few, very few indeed, have come to know the snow crystal at first hand. All the rest of us must get our knowledge of this endless gallery of Nature's delicate tracery and jewel design through the careful drawings and faithful photographs, microphotographs, by that devoted few whose enthusiasm never wanes and whose patience never tires.

The first observer of all who have tried to convey graphically to others some idea of what the snow crystal is like was Olaus Magnus, Archbishop of Upsala. His curious book on natural phenomena, published at Rome in 1555, contains a quaint woodcut devoted to this purpose. However, the engraver certainly must have lost the good bishop's sketches and instructions, and then given to his greenest novice the honor of making this first of all cuts of the snow crystal. At any rate, but for the assurance of the legend, the intent of the picture would be wholly unknown for only one of the twenty-three small illustrations bears any resemblance to the thing it is supposed to portray. Nearly three centuries later, in 1820, the tedious art of depicting the snow crystal by careful drawings reached the stage of highest integrity in the work of the Arctic explorer, Scoresby, with a wonderful approach to accuracy.

Then came the photographic microscope that leaves nothing visible unrecorded, and adds nothing, whether for "art" or symmetry, that is not really present in some form or other. But only an occasional enthusiast worked on the snow crystal with this revealing instrument; and of these in turn the most persistent of all and the most successful of all is W. A. Bentley of Jericho, Vermont, who pursued and still pursues this search with the insistent ardor of the lover and the tireless patience of the scientist. And so it has come about that his careful search of snow after snow, winter after winter, for nearly half a century among the northernmost of the New England mountains has revealed not just a few crystal varieties, but many hundreds of forms, all based on a common hexagonal pattern—many, though, with their alternate sides more or less suppressed, even to the stage of being equilateral triangular. Not only did he find this great multiplicity of kinds, but also he skilfully obtained beautiful microphotographs of them, and thereby made it possible for others to share at leisure, and by the comfortable fireside, the joys that hour after hour bound him to his microscope and his camera in an ice-cold shed.

Finally, from time to time, during the last dozen years or more, the x-ray specialist has tried, by his subtle means, to coax the ice crystals to reveal its innermost secrets—to show what its smallest crystal unit is, and how shaped, and to throw off at last all disguise as to what exact type of crystallization it really belongs. Still the answers are a little evasive, especially those that concern the form of crystallization. But the specialist does not yet admit defeat in this particular—in fact he seldom needs to admit hopeless defeat about anything—and pretty soon he probably will be making good-sized ice crystals under controlled conditions and searchingly examining

13

them with microscopes, polariscopes, piezoelectrometers, etching fluids, x-rays, and by every other means the circumstances may require and his ingenuity can devise. Then, if not before, will the snow crystal answer "yes" or "no" without qualification or equivocation, to the various questions about it we long have asked without response, and in all cases offer entirely satisfactory and unmistakable replies.

TAKING THE SNOW CRYSTALS'S PICTURE

Taking fine pictures of worth-while snow crystals requires good judgment, quick decision, speedy action, and great skill. They blow away and even melt away cringingly at the faintest breath, nor can they long endure the radiated heat from a nearby human body. Hence it is that skill and speed are of the very essence of success in photographing the snow crystal that but a moment is here then gone forever.

But how is it done? First you catch your snow crystal. This is conveniently done by holding a smooth black board, a foot or so square, a moment or two, or as long as necessary, in the falling snow. The catch is then taken under shelter, to keep it from being blown off the board or otherwise disturbed, where the light is good and the temperature that of outdoors. After a hasty inspection with a suitable magnifying glass a promising crystal, if one is found, is transferred carefully and with most delicate touch to a suitable glass plate—a microscope slide—with a small wooden splint, and there pressed down flat or brought into other proper position and made slightly to adhere to the glass by the gentle stroke of a small wing feather. After this it should be more minutely examined with a microscope to determine whether or not it is worthy of photographic preservation. If it seems to be worthless there is nothing to do, of course, but start all over again. When, however, a photograph of a crystal is to be obtained it obviously is necessary to take it with a photomicrograph camera, that is, a microscope fitted with a camera bellows and plate holder where the eyepiece normally is placed, or farther removed. The camera is turned toward the sky (clouds actually) either directly or through a window; then, or previously if more convenient, the crystal, adhering to the glass slide, is properly centered in front of a low-power, ½- to 3-inch microscope objective, and the focusing so adjusted as to give a picture of the desired size. The plate holder is then put in position, lens covered, slide of plate holder drawn, lens uncovered for time of exposure, lens covered again, and slide put back. One may proceed now, if one likes, similarly to make other exposures while the snow falls, and attend later to the developing, fixing, drying, labeling and storing of the negatives for future use. The light that comes through the crystal and by which its picture is made can be regulated by a suitable stop or round opening. In practice it appears to be best to make this stop rather small and to use a moderately "contrasty" photographic plate. The proper time of exposure, under these conditions, is around twenty seconds but varies so much with the brightness of the sky and with the equipment and plates used that each worker in this field must judge from his own experience what length of exposure to give.

Evidently the camera may be stood vertically, if so desired, and the light of the sky or cloud turned up through the crystal by a suitably placed mirror beneath it. In other respects, too, the details of the procedure may be varied. It is only necessary to work intelligently and patiently toward a definite end. It is this end-product that counts, not the minutiae of the process of obtaining it.

Since the snowflake or crystal is colorless and transparent it is obvious that the contrast between light and shade in its picture taken by transmitted light are owing to corresponding differences in the refraction, or bending, of the passing light, by the crystal. Most of these differences, in turn, are caused by minute, but nearly or quite symmetrically arranged, air cavities. Some, however, appear to be produced by tiny ice ridges, others perhaps by grooves, and still others apparently by crinkled water films incident to incipient melting. Even other causes presumably contribute in some cases to the final result, but if present at all they appear to be less effective than those just mentioned.

Since the ice crystal is transparent it is evident that a picture of it taken by transmitted light against a white background, such as a cloud, can not stand out in marked contrast with its surroundings. This defect can be largely remedied, as Mr. Bentley has done on duplicate negatives (not the originals) for the crystal pictures in this book, by patiently and with scrupulous care cutting the film away from all parts not actually covered by some portion of the crystal. When successfully done this greatly increases the beauty and artistic value of the pictures and at the same time leaves their scientific worth wholly unimpaired.

Occasionally some portion of an ice crystal, usually the central part, shows such wealth of detail as to justify especial enlargement, and the consequent exclusion of the other portions. A few, but very few, of the following illustrations were obtained that way.

SOME FACTS OF OBSERVATION

Perhaps the first and most important fact about the snow crystal that impresses itself on the careful student is the usual similarity of its general shape, while the second fact to be noted, also of great importance, is the endless variety in the details of its structure. These details have been the basis of several classifications of the crystal, but classifications that are useful only for descriptive purposes, since each merges imperceptibly into any other or may be connected with any other by imperceptible gradations.

CLASSIFICATION

For convenience in describing ice crystals, not for grouping them scientifically or according to their crystallographic pecularities, we may classify them as follows—may, not must, for it is only a personal choice and not a requirement by nature.

A. Hexagonal column, usually three to five times longer than thick.
1. Plane and with ends normal to side faces (see page 210).
2. With ends terminating in thin plates normal to the sides and of greater diameter than the column (see pages 210, 211).
3. With end plates and also one or more intermediate plates, normal to the column and dividing it into equal or nearly equal parts (not represented in these pictures, but well known).
4. With one end pyramidal, and one plane (see pages 210, 211).
5. With both ends pyramidal (not represented in these pictures).
B. Hexagonal right pyramid. Not represented here in any of its forms, but all known.
1. Right pyramid complete.
2. Right pyramid truncated.
3. Double or abutting pyramids complete.
4. Double or abutting pyramids truncated.
C. Hexagonal plate, ten times (or more) broader than thick.
1. Relatively large and plane (see pages 24-49).

2. Relatively large and with simple extensions at corners (see pages 50-72).
3. Relatively large and with elaborate extensions (see pages 82-118).
4. Relatively small, with long plane rays (see pages 150-151).
5. Relatively small with fern, or plume-like, extensions (see pages 165-195).
D. Triangular plates.
1. Plane (see pages 204-208).
2. With extensions (see pages 200-203).
E. Twelve-sided plates.
1. With extensions, six of one kind and alternately six of a different kind (see page 197).

As already stated, this is not a scientific or crystallographic classification, but just a convenient grouping according to general appearance, or to whether the major growth has been longitudinal, giving a column, or lateral, producing a plate, and to their modifications. The above scheme, therefore, is in no sense immutable, but subject to compression, expansion, or other change, as one's needs or wishes may suggest.

Perhaps three-fourths of all snow crystals belong to the tabular type, and, as is true of the crystals of other substances, few of any class are absolutely perfect.

CIRCUMSTANCES OF OCCURRENCE

These several classes of the ice crystal vary greatly in abundance. Furthermore, the relative amounts of each differ exceedingly with the conditions under which it is formed. Thus the simpler kinds, that is, the columns, or needles, as they usually are called, and the plane hexagonal plates, occur most frequently and in relatively far larger amounts at great altitudes where the temperature is very low, the amount of water vapor therefore quite small, and the growth of the crystals relatively slow. They usually are abundant in the highest of the clouds, the cirrus and the cirrostratus—thin wisps and veils through which the sun and moon can be seen distinctly. We know they occur there because these are the clouds in which halos, or the distant rings about the sun and moon, so frequently occur. And the halos give this information by virtue of the fact that they are produced by light that passes regularly, or uninterruptedly, through the crystals from one hexagonal face to the second beyond it; that is, in and out faces inclined to each other at an angle of 60 degrees, in the case of the 22-degree halo, the most common of all,

and, in the case of the 46-degree halo, the next most frequent, in and out faces at right angles to each other, or side and end faces—courses in each case impossible through the more complex crystals owing to their numerous air cavities and other irregularities. These simple crystals, therefore, reach the earth in largest numbers in the western to northwestern (in the Northern Hemisphere, southwestern in the Southern) portion of a general snowstorm where the temperature is lowest and the falling snow fine and scanty; and also in very high latitudes.

The more complex crystals, on the other hand, especially those with branching extensions, occur at higher temperatures and, consequently, when the absolute humidity is relatively great. Hence they are most abundant in the front portion of the storm where the snow is heaviest and the clouds are lowest. Clouds of intermediate heights seem to give small, branching tabular crystals with solid, hexagonal centers. In other words, when the clouds are at intermediate levels the crystals tend to have intermediate forms. Whether this diversity in crystal form and detail is owing to differences in temperature, in absolute humidity, or in rate of growth does not appear to be definitely known. Neither does it appear to be an easy thing to determine, since at least a tendency to supersaturation is essential in any case for crystal growth, a condition that requires more and more humidity with increase of temperature. However, from the behavior of substances that readily can be crystallized in the laboratory under controlled conditions we infer that the differences in question presumably are owing chiefly, at least, to rate of growth—the small and simple crystals resulting from slow growth, the relatively complex varieties from comparatively rapid growth, such as would occur in air distinctly supersaturated with reference to ice, a condition that can obtain at any temperature considerably below the freezing point while it still is unsaturated with reference to liquid water. Presumably, too, the greater the supersaturation the faster is the growth and the more complex the resulting form.

The rarest of all ice-crystal forms appears to be the pyramidal, and, especially, the double pyramidal, or two pyramidal ends base to base, with or without a section of a column between them. This latter form, the double pyramidal, is not represented among Bentley's photographs, but it has been observed in polar regions by Dobrowolski (see Bibliography) and others, and is required to account for several halos of unusual radii, as explained in *Physics of the Air*

by Humphreys. The circumstance or condition that determines the occurrence of this form in such relatively large percentage as to produce well defined halos is entirely unknown. It appears, however, to be very unusual, because the consequent halos, though fully recognized, are but rarely seen.

Reference was made above to the difference in the snow crystals that commonly occur in the front (or warm) and rear (or cold) sectors of a general snowstorm. It must not be supposed, however, that this difference is in any way a matter of location or of the surface temperature, humidity, or what not; it is owing wholly to the different conditions in the atmosphere where the crystals are formed, that is, and obviously, they depend on the conditions that obtain at the place where, and the time when, they come into being, and not on the conditions that may prevail somewhere else at some other time.

From the fact that cirrus clouds commonly come into existence in previously clear air and not through the transformation of some other kind of cloud and from the further fact that these clouds consist wholly of ice crystals, it is evident that in these cases, at least, there is a change directly from vapor to solid without the occurrence of an intermediate liquid phase. The exact nature of the nuclei on which this sublimation, or condensation from vapor to solid, begins is not known, but presumably they are water-gathering, or hygroscopic, to be precise and technical, like minute particles of sea salt, for instance, just as the nuclei about which liquid cloud droplets are formed. But on the other hand a considerable portion of the crystals, such as *3*, page 37, *5*, page 46, and many others, seem to show a minute spherical center, as though the nuclei in these cases were water droplets. Perhaps the liquid particles froze to spherical pellets and the vapor, now producing supersaturation with reference to the ice, sublimed (condensed directly from vapor to solid) on to these pellets in the form of snow crystals. In any such case where the solid particles are fairly numerous all the remaining liquid droplets quickly evaporate (their tendency to evaporate, or vapor tension, being greater than that of ice at the same temperature) and thereby add their substance to the growing crystals. In this connection we might note also the fact that under like conditions the smaller a snow crystal the more rapidly it evaporates, so that in the presence of each other the larger crystals grow in size at the expense of the smaller. Generally, however, and especially for short intervals of time, this slow devouring of

the smaller crystals by the larger is not a matter of much practical importance.

MARKINGS

Every one of the hundreds of snow-crystal pictures on the following pages shows markings of one kind or another. These are not places set apart from their surroundings by distinct colors, for the crystal is everywhere colorless, but places that so disperse the light passing through them as to appear less bright than the adjacent por-

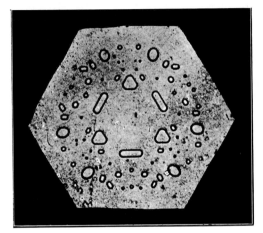

Fig. 1.—Snow crystal cavities, sides parallel to sides of containing crystal.

tions of the crystal. This can be effected by at least four different things, ridges, grooves, cavities, and water films, and it is practically certain that all occur in varying degrees and abundance. The presence of ridges in some crystals, especially along the junctions of crystal segments, or portions, at least, of radii toward, or in extension of, the hexagon angles have been shown by slow melting, or evaporation. When these are the last parts to disappear, as often is the case, it is quite certain that they were thicker than other portions of the crystal, and formed ridges on its surfaces, top and bottom. Such ridges are miniature convex lenses and so alter the course of the light through them as nearly always to appear relatively dark. Grooves evidently occur where the crystal segments, arms, or branches, have only partially welded together. Their action on transmitted light is that of a concave cylindrical lens, and therefore their record on the microphotograph is quite similar to that of the ridges. By far the greater number, however, of the lines and dots on the snow-crystal pictures are due to cavities, usually empty, but sometimes partially filled with water. Finally,

it seems likely that the wavy scallops are caused by the water films produced by slight melting.

SHAPES OF CAVITIES

Most of the cavities in the snow crystal are considerably to greatly elongated, but others are only slightly so, if at all. In many cases the walls of these latter, or more nearly round cavities, are conspicuously parallel to the borders of the crystal as a whole, as shown in Fig. 1. This patterning of cavities after the shape of the containing crystal is a common phenomenon. Indeed many cavity faces are crystal faces, and therefore tend to be, and often are, parallel to the analogous faces of the crystal as a whole.

PARASITIC CRYSTALS

It often happens that liquid cloud droplets are captured by snow crystals, as shown by *8*, page 54, *5*, page 69 and many others of the following pictures. Frequently, too, a small ice crystal develops in each of these droplets after its capture, and, what is far more interesting, the

Fig. 2.—Crystals in cloud droplets captured by snow crystal, sides parallel to sides of capture crystal, and sides of each parallel to sides of every other.

border of each droplet crystal parallels the border of the carrying crystal, at least as that border was in its earlier stages. Hence all the droplet crystals have the same orientation, that is, the sides of each are parallel to the corresponding sides of all the others. This striking phenomenon is illustrated by Fig. 2, above, which, however, owing to the great magnification, shows only a portion of the original or carrying snow crystal.

The cause of this remarkable effect derives jointly from two facts, first, that the crystallization in the droplet begins at the place of contact with the snow crystal, and, second, that the shape of the ultimate crystal unit is such that a multi-

17

tude of them can be fitted together into a structural whole only in certain definite ways. A droplet crystal, then, since it consists of exactly the same sort of material as that of the "capture" crystal, is in reality but a local extension of the latter, and therefore necessarily begins its growth with the same orientation of its units, which orientation in turn fixes that of the next accretion, or further growth, and so on to the end. Hence the capture crystal and the crystals in all its captured droplets have the same shape and the same orientation.

PICTURE CRYSTALS

What memory is there that does not fondly cherish the time when, as the last fire was burning low of a winter's night, granddad showed us beautiful faces and wondrous scenes in the glowing coals! And what joy it was to find faces, objects and every sort of thing ourselves in that fire—a delight never, never outgrown by any who have truly known its charm. And like delights over our clever finds in these hundreds of snow-crystal pictures await only a little hunting, delights of which we shall never tire and to which we shall return time and time again.

Here is a start with some of the best: *2*, page 42, pilot's wheel and army helmets; *10*, page 38, six hippopotamus heads; *8*, page 47, birds in flight; *10*, page 206, lunch being served, three milk bottles and a bowl apiece; *11*, page 205, as you like it—corner turned up, a Janus or two-faced ogre, each face with eye, big nose and long beard; corner turned down, a goat, or deer, with ears, eyes and stubby horns, eating from a feed box.

The rest of the many others each may find for himself—it is lots more fun—more pleasure in hunting than being told, more delight in finding than being shown. But don't fail to examine the delicate lace curtains, shown on pages 212 to 218, that Jack Frost spreads over your windows while you sleep. And be sure to look on page 226, for the beautiful pearls that adorn Arachne's fine-spun web; the "woolly bear" that got so wet; the fly with a bucket of water on his head; and the foolish grasshopper getting rheumatism in his joints!

CRYSTALLOGRAPHY OF THE SNOW CRYSTAL

It would seem that every detail concerning the crystallography of ice and snow should have been known long ago, but our knowledge of crystalline water is not yet perfect. It often has been studied, however, and the resulting literature already is quite extensive. Some of this is listed below for the benefit of the student—not all of it, by any means, but enough of the better to start him on the right road toward the finding of all the rest he may wish to examine. Then, too, he will have the help of the well-over two thousand following microphotographs—a much larger collection than was ever before gotten together.

But our state of ignorance about the crystallography of ordinary ice is not quite so profound as this confession might lead one to suppose, for we do know about it to within rather narrow limits—know that it does not belong to this, that or the other of many crystal types, and that it does belong to one or other of a very few types.

Only one in a multitude of snow crystals is so nearly symmetrical as to show no obvious irregularities. But this usual imperfection of form is common to nearly all substances, especially when their crystals are comparatively large or rapidly produced, and may be attributed to fortuitous disturbances of one kind or another in the course of their growth. Hence very small crystals, slowly produced under uniform conditions, generally are the best for crystallographic studies. Snow crystals so produced, that is, grown in very cold air, where they are small and widely separated, develop in their simplest forms. These are, mainly, more or less perfect hexagonal plates ten times, roughly, broader than thick. Hexagonal columns, three to five times longer than thick, with flat ends perpendicular to the faces, also are very common when formed, as specified, in air of very low absolute humidity. Another simple, but not very common, plate form is the equilateral triangle, occasionally perfect, or substantially so, *4*, page 206, but more commonly with truncated angles, plane, *6*, page 207, or with secondary growth, *7*, page 201, and many others. Finally, on rare occasions, the columns are capped at one or both ends with plates, simple or complex, page 210, or have a pyramidal termination at one end, page 210, or each end.

Perhaps the columnar crystal grows in length both ways simultaneously from a common center, but, be that as it may, the two ends do not always terminate alike geometrically, as is evident from the illustrations on page 210, and may never be so terminated in the crystallographic sense. However, this is one of the points about which "doctors disagree." Certain sketches by Dobrowolski and observations by Adams (see Bibliography for both references) indicate, but

perhaps do not prove, that single prismatic crystals grown from water vapor terminate differently at the two ends. Other sketches by Dobrowolski, however, show columns with pyramidal terminations at each end that seem to be exactly alike, a result that could follow from the growth of two individuals in opposite directions along a common axis in twin position. On the other hand, x-ray studies by Barnes (see Bibliography) of ice formed from liquid water indicate structures which would require the ends to be alike without twinning. But these studies, too, are inconclusive since, as only the oxygen could be taken account of, the x-ray pattern may be deceptive even if the crystals used were not twinned, as it certainly would be if they were twinned.

As a further contribution to this subject, it should be noted that several rarely observed but well known halos are all fully explained (see Humphreys' *Physics of the Air*, second edition, page 516) on the assumption that the snow crystals that produce them have like pyramidal terminations at either end, in which the pyramidal faces make an angle of 24°51', or thereabout, with the longitudinal axis.

Not only can the crystal grow lengthwise in the case of the column, or thicker in the case of a plate, which in reality is only a column much shorter than broad, but furthermore it can and does grow sidewise, and that, too, in such manner that the crystal remains, or tends to remain, quite symmetrical about three separate planes that intersect at angles of 60 degrees with each other along the axis of the column whether short (tablet) or long. In this case the aspect of the crystal, as viewed from the side, repeats itself at least with every 120 degrees rotation, as in *6*, page 200, *10*, page 205, *6*, page 207, and many others. Some of the crystals, viewed endwise, are equilateral triangles and many others carry on their faces triangular designs. Hence certain students of this subject believe that snow is crystallographically trigonal. Nor, as Wherry has shown (see Bibliography), is this idea necessarily inconsistent with the occurrence of triangular forms with truncated corners, regular hexagons, or other observed shapes, simple or intricate. If, however, the x-ray work, referred to above, was done on single crystals then ice formed from liquid water may have a higher symmetry than that exhibited by many typical snow crystals. In short, despite the great amount of work that has been done on the snow crystal, our knowledge of it still is far from perfect. Still it challenges the skill and the understanding of the wisest crystallographer, and its challenge must be accepted.

PECULIAR CRYSTALS

Numerous crystals shown in the following illustrations merit individual mention. Several of the most interesting of these are shown on page 197. Here numbers *1, 3, 10* and *12* appear to have been caused by the simultaneous growth of three crystals that early adhered to each other and thereafter occupied each its own one-third of the circle. Similarly, numbers *5* and *9* on this page, 197, appear to have resulted from the simultaneous and equal growth from two early adhering crystals. Numbers *8* and *11* of this page may be explained in much the same way. It will be noticed, too, that several of these cases, *5* and *9*, for instance, exhibit excellently the results of inhibition by interference. They may not prove the familiar dictum that two bodies cannot occupy the same place at the same time, but they do show that when two objects strive equally to occupy the same place at the same time neither can have it. The facts are that two arms or branches of the crystal that approach each other in their growth first become stunted from want of enough vapor to supply both adequately— each drawing from the same, or very nearly the same, space, and later, through actual contact, wholly stopped as to further development, at least in their original directions. The other crystals on page 197, namely *2, 4, 6* and *7*, show each twelve equally spaced branches, six of one length and set of markings and six of a different length and kind, occurring alternately with each other —a delight to the artist no doubt, but another puzzle for the crystallographer.

PARTIAL BIBLIOGRAPHY OF THE ICE CRYSTAL

SCORESBY, WILLIAM, *An Account of the Arctic Regions, with a History and Description of the Northern Whale-fishery*, Edinburgh, 1820. Contains ninety-six drawings of snow crystals, with descriptive text.

HELLMANN, G., *Schneekrystalle*, Berlin, 1893. Contains reproductions of a number of microphotographs and a summary of all that then was known about the snow crystal.

DOBROWOLSKI, A. B., *Voyage du S. Y. Belgica. Météorologie*, La neige et le givre, Antwerp, 1903. Contains many drawings and extensive descriptions and discussions.

DOBROWOLSKI, A. B., *Historja Naturalna Lodu*, Warsaw, 1923. Contains many illustrations

and extensive descriptions (in Polish) and a voluminous bibliography.

BENTLEY, WILSON A., various studies of the snow crystal, with numerous illustrations. *Monthly Weather Review*, vol. 29, pp. 212-214, 1901; vol. 30, pp. 607-616, 1902; vol. 35, pp. 348-352, 397-403, 439-444, 512-516, 584-585, and Annual Summary, 1907; vol. 46, pp. 359-360, 1918; vol. 52, pp. 530-532, 1924; vol. 55, pp. 358-359, 1927.

SHEDD, JOHN C., "The Evolution of the Snow Crystal," *Monthly Weather Review*, vol. 47, pp. 691-694, 1919. Contains many illustrations.

WHERRY, EDGAR T., "Snow Crystals from the Crystallographic Standpoint," *Monthly Weather Review*, vol. 48, pp. 29-31, 1920.

WRIGHT, C. S. and PRIESTLEY, R. E., *British Antarctic Expedition*, 1910-1913, *Glaciology*, London, 1922. Contains a general summary of what was known of the ice crystal to that date.

BARNES, W. H., "The Crystal Structure of Ice between 0°C. and −183°C.," *Proceedings of the Royal Society*, A., vol. 125, pp. 670-693, 1929. A detailed study of the ice crystal by means of Laue photographs.

ADAMS, J. M., "The Polar Properties of Single Crystals of Ice," *Proceedings of the Royal Society*, A., vol. 128, pp. 588-591, 1930. A study of ice crystals formed under controlled conditions.

PART II

THE SNOWFLAKE'S

CLOSEST OF KIN, AND

ITS COUSIN, THE

DEWDROP

ICE FLOWERS

Several forms of ice have been given the name "ice flowers." The first so called consists of places, inside a sheet of ice, shaped like certain snow crystals, *4*, and *6*, page 221, and that are made evident by slow internal melting under the influence of properly focused radiation. This name was bestowed by the physicist John Tyndall who first observed the phenomenon in 1862.

Such crystals also occur on the surface of quiet, slowly freezing water, *2, 3, 5, 7* and *8*, page 221. Presumably these crystals start down in the body of the water and are then buoyed up to the free surface, or to the under surface of the sheet of ice, if one has formed, where they become occluded as the ice grows thicker. When these crystals quit growing and other ice forms on and around them, they evidently are bounded by more or less distinct interfaces across which transmission of radiation is not quite perfect, and at which, therefore, absorption is greatest and melting most pronounced.

The beautiful tufts of hoar frost and rime, *9*, page 221, that occasionally form in great abundance on surface ice also have been called ice flowers, as indeed have at least two other phenomena not shown in these pictures—a regrettable and needless confusion.

WINDOWPANE FROST

When the air indoors contains an appreciable amount of moisture, and the outdoor temperature is considerably below freezing, the windowpanes often become covered on the inside with beautiful patterns of frost, pages 212 to 218, that rival the most delicate plumes and outdo the finest lace of hand or loom. We do not know the details of how this frost is laid on, but we do know that it gathers along abrasions as along Mr. Bentley's scratched initials, *4* and *9*, page 212. Evidently, therefore, the patterns for many an exquisite frost curtain are placed on windowpanes by the good housewife as she industriously polishes them to their finest luster—placed there unwittingly in the form of scratches which, though too fine to be at all conspicuous, Jack Frost follows unhesitatingly and unerringly. Exactly why the deposition of frost or ice should

start along a scratch, or abrasion, is not definitely known. The surface of the glass where it is unbroken presumably differs to some extent from the infinitesimal surfaces on the walls of the groove, but what part, if any, this plays in locating the frost is uncertain, especially as the scratch need not be fresh. Again, the temperature of the glass presumably is a little lower, while cooling is going on, along the edge between the extended flat surface and the adjacent wall of the groove, thus increasing the tendency to condensation here over that where the surface is unbroken. This, too, seems inadequate, since an exactly similar phenomenon, crystallizing along a scratch, occurs in the case of liquid solutions. Another fact, and one that may be important in this connection, is the existence along the scratch of innumerable, minute concave surfaces. From such surfaces evaporation is slowest, for a reason (the physicist calls it negative vapor tension) fully recognized, and onto which, therefore, condensation doubtless is first and fastest. But, be the explanation what it may, the fact remains that frost on the windowpane occurs most readily along fine abrasions, or scratches.

Scratches, however, obviously do not account for all the beautiful fern and plume-like forms of windowpane, and kindred surface, ice and frost, and often appear to account for none of them at all, for they occur in great abundance and in the most graceful curves even on a smooth pavement where it would be preposterous to expect guiding grooves to exist in such artistic sweeps and whirls. Of course, inequalities in the availability of moisture, whether liquid or gaseous, is an important factor in determining the direction of growth of surface frost; but where such inequalities are not pronounced, the pattern assumed appears to be determined partly by grooves and scratches, if any, in the surface, and partly by one or more other causes not definitely known. In addition to the curved forms there are at least two lattice types; one in which the crystals go off at an angle of 60 degrees to each other and form a herring-bone pattern, as in 2, page 214, and another, illustrated by 4, page 214, in which the angle of departure is 90 degrees, and the result a "Tannenbaum" (fir tree) figure.

In many cases frost on glass also occurs in granular and tufted forms, as shown on page 218. The determining cause of this form of frost probably is seldom, if ever, known with certainty.

DEW AND FROST

When the vapor in the atmosphere is cooled to a temperature more or less below that of saturation—commonly we say the air cooled below the dew point—some of it separates out as fog, cloud, dew or frost, as circumstances may determine. During still, clear nights surface objects, grass, leaves and what not, cool sharply by losing more heat through radiation to the sky than they get back from it. In turn they cool the immediately adjacent air, and, of course, the water vapor in it. As the temperature falls below the saturation point some of the vapor condenses on the cooling object, a blade of grass, say, in the form of dew, if the temperature is above the freezing point, or frost, when this temperature (the saturation temperature) is below the freezing point.

The frost and the dew collect first and most abundantly at points and along edges, because (so we believe) they cool fastest—reach the dew point first owing to the greater ratio there than elsewhere, of radiating surface to mass of material beneath, or quantity of heat available.

The first of these forms, dew, is shown on pages 224, 225, and 226, except 4, 6 and 8 of the first, which show clinging raindrops.

Frost occurs on outdoor objects in two forms, columnar, 1, 4, 5, 6 and 7, page 220, when deposited rapidly at temperatures not far below the freezing point; and tabular, 1, 2, 3 and 7, page 223, when deposited slowly in very low temperatures.

RIME

Rime, 2, 3, 4, and 8 of page 219, is a tufty deposit of ice caused by the sudden freezing at the time and place of impact of undercooled fog or cloud droplets. It builds out in the face of the wind, and sometimes accumulates in large amounts, even to the crushing of shrubbery and the breaking of trees.

GLAZE

Occasionally rain falls when the surface temperature is appreciably below the freezing point. At such times exposed objects become covered with a coating of slick and clearish ice, 1, 2, 3, 5, 6, and 9, page 222, which the U. S. Weather Bureau calls glaze. Many people, however, call it sleet, even though that term already had two other widely used meanings.

SLEET

When the temperature of the surface air is below the freezing point up to a considerable height, rain falling into it from above does not reach the ground in the liquid form, but as frozen pellets, *8* (magnified), and *9*, page 223. Many people call this hail, or winter hail, while many others, and such is the usage of the U. S. Weather Bureau, call it sleet. It is the kind of sleet that rattles, as would grains of rice, when it hits the windowpane.

GRAUPEL

Another kind of frozen precipitation, generally called *soft hail*, is the tiny ball of softish ice or granular snow, *5*, page 223, that looks as though it might have begun as a snow crystal and, by capture of undercooled cloud droplets, ended as a wad of rime.

PLATES

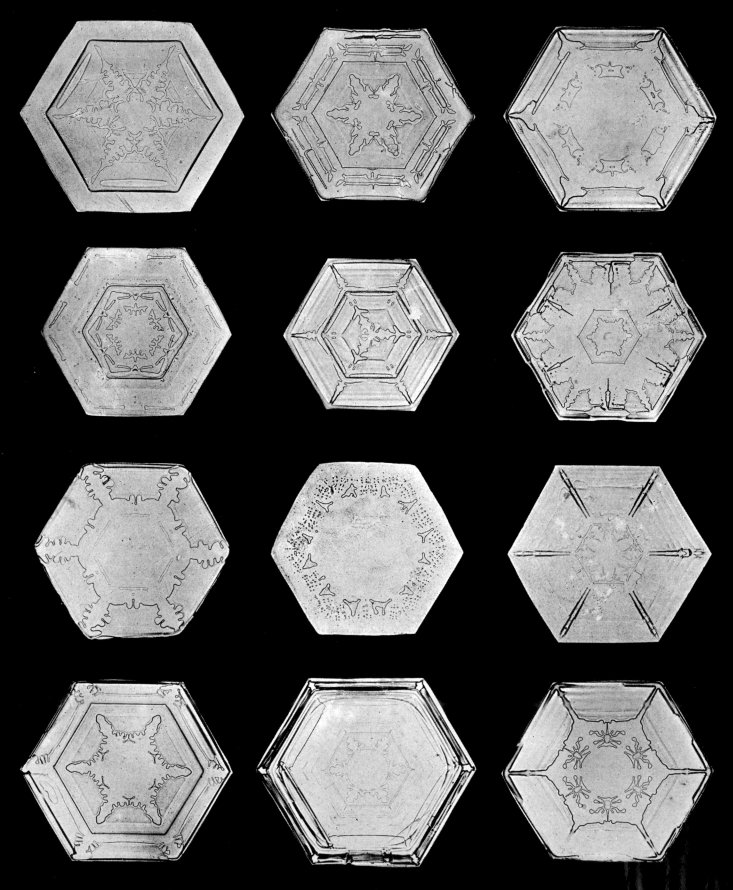

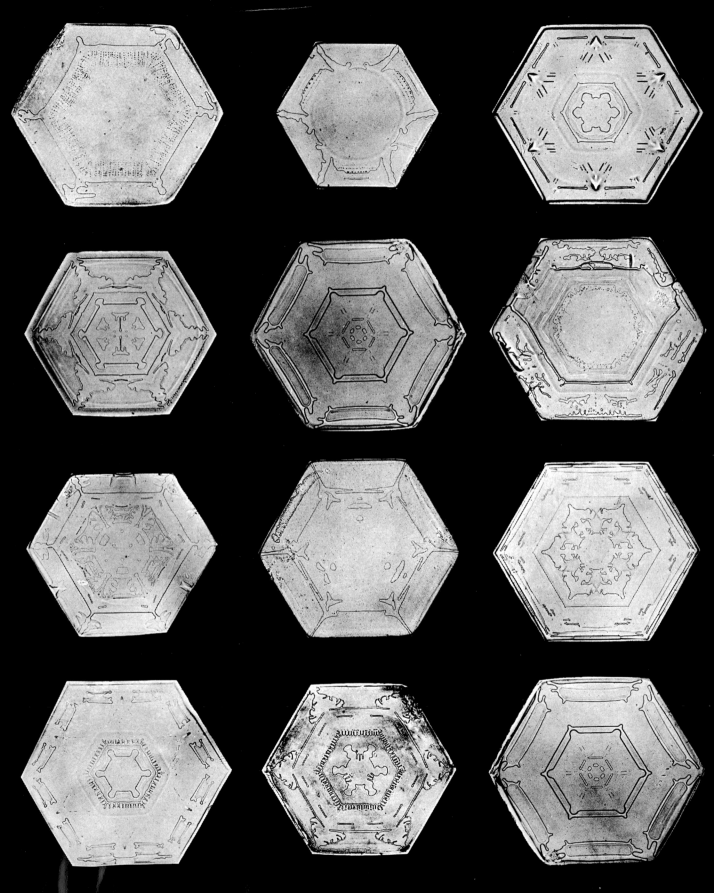

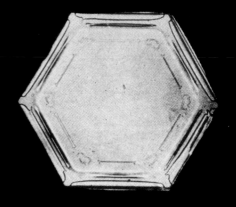
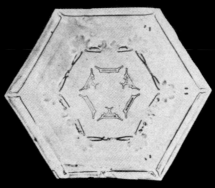
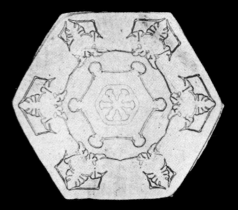
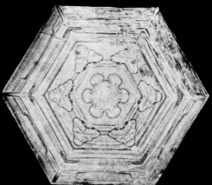
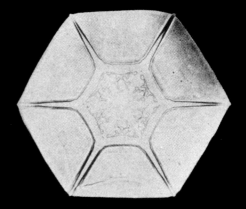
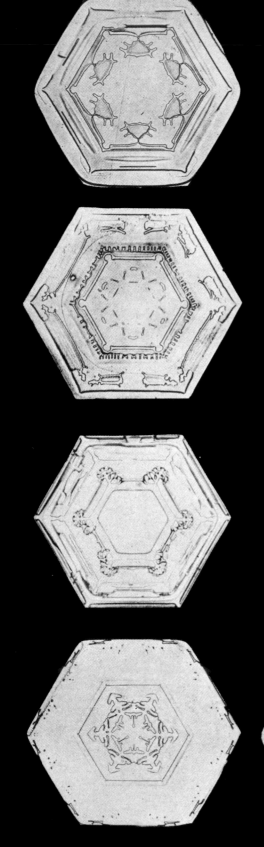
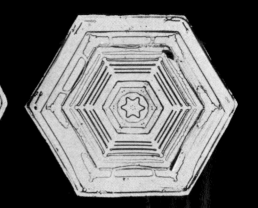

26

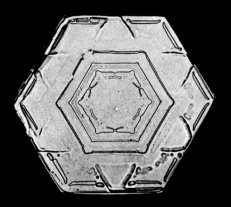 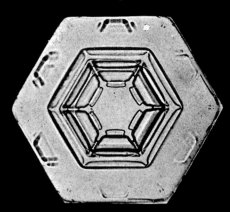

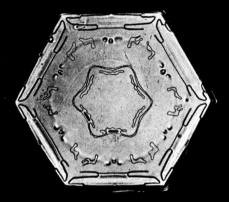 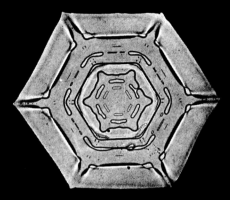

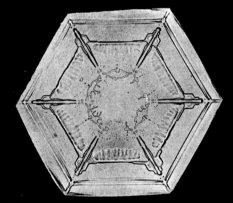 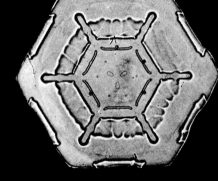 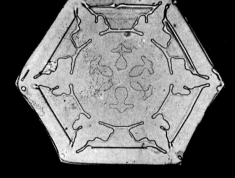

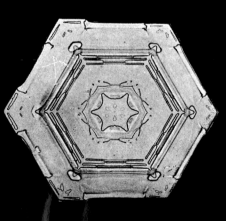 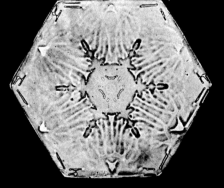 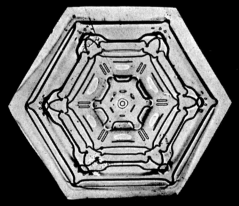

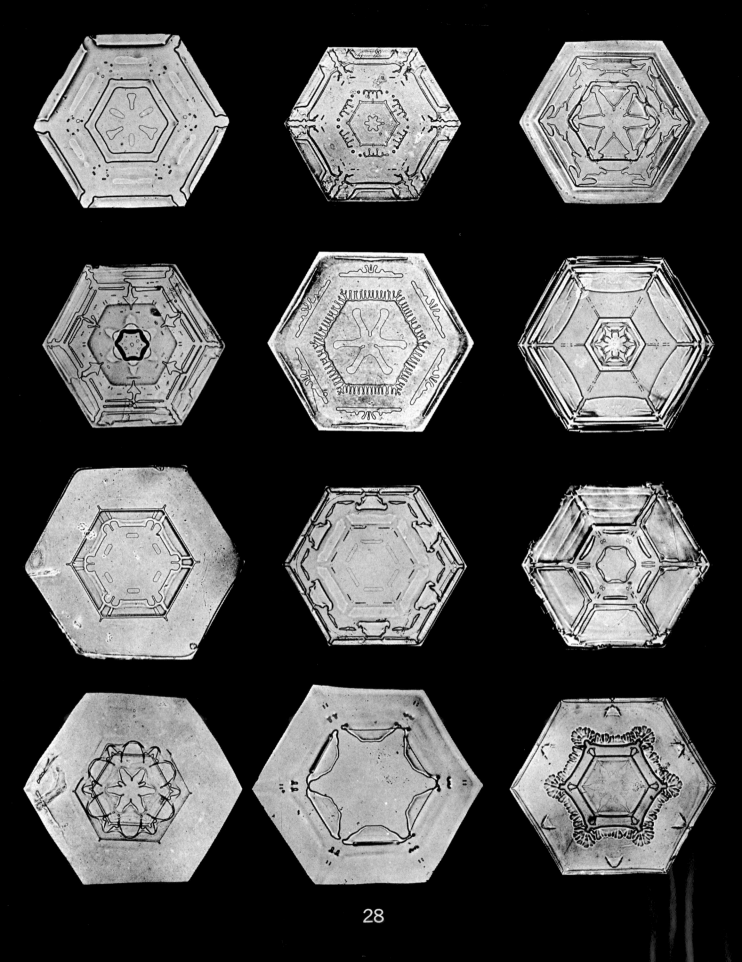

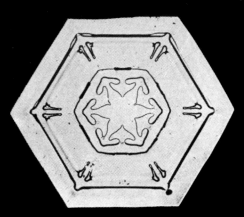 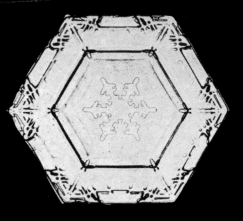 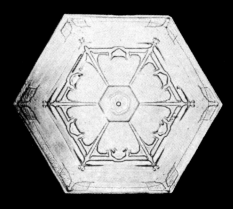

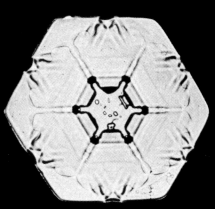 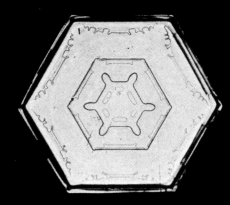 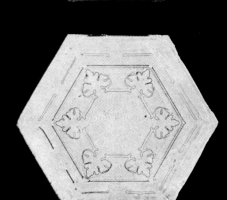

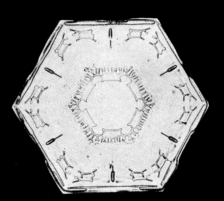 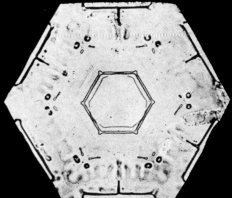 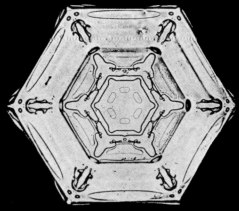

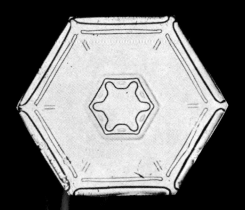

29

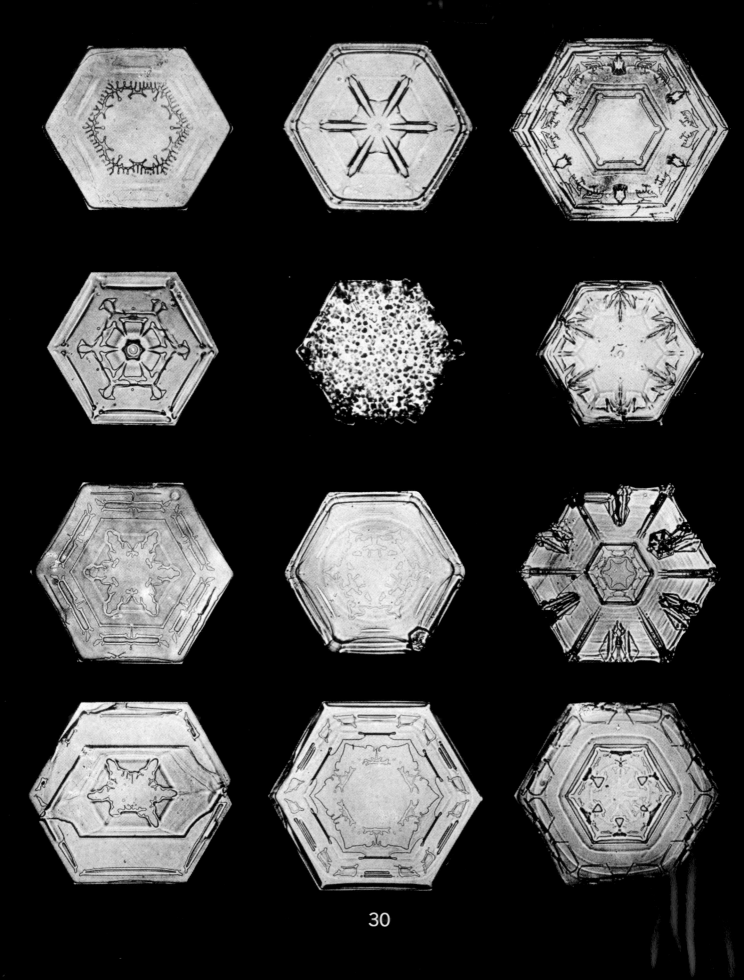

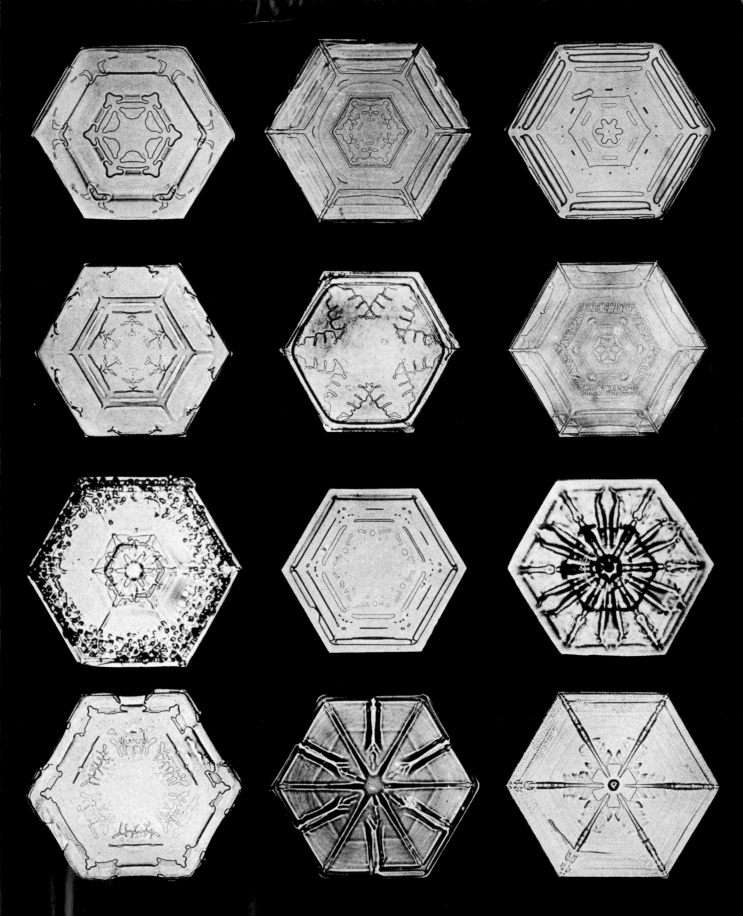

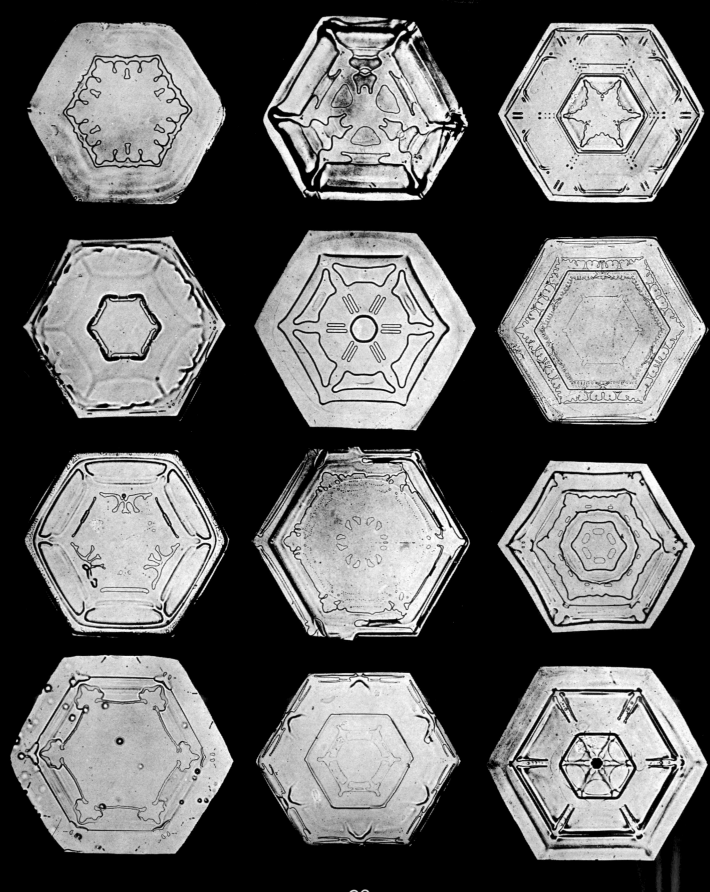

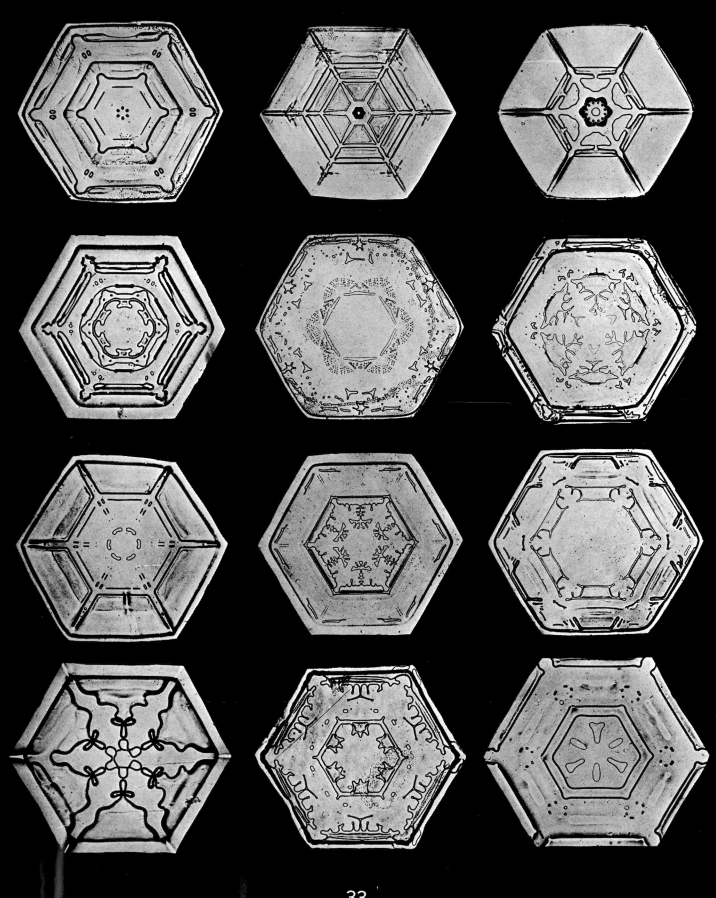

33

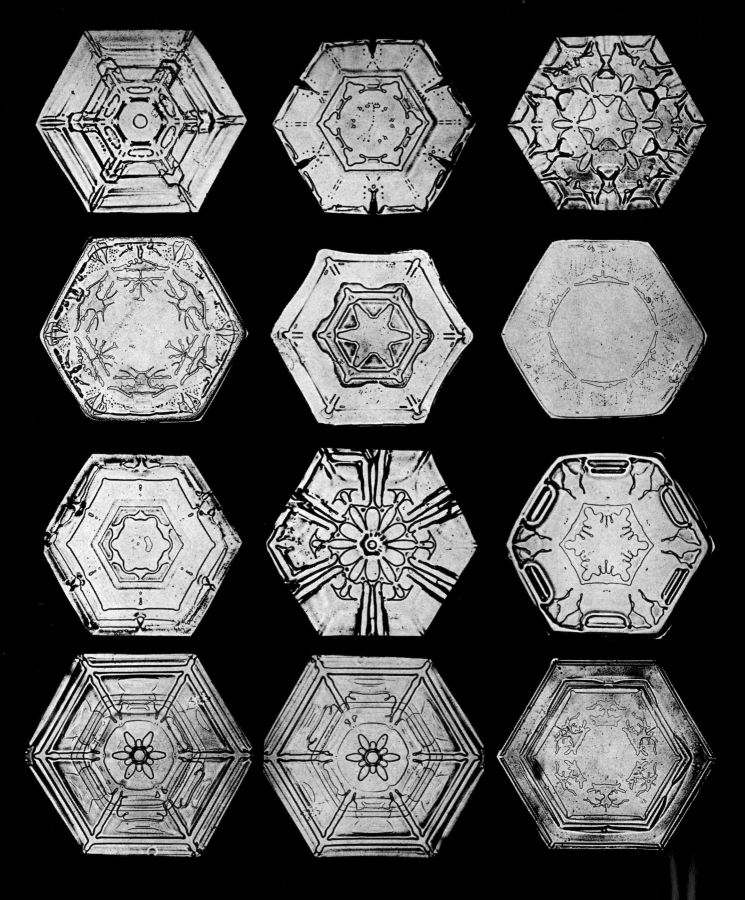

34

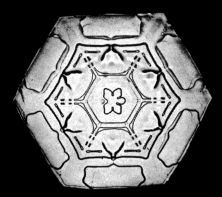 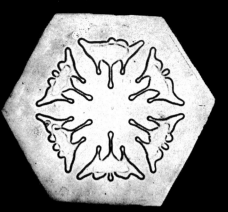 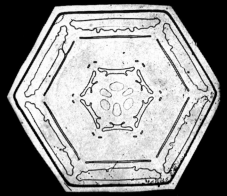

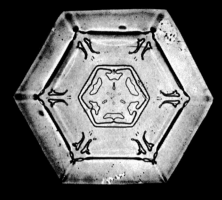 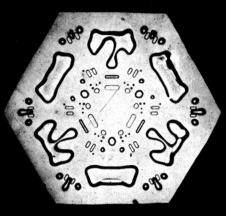 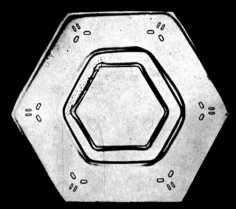

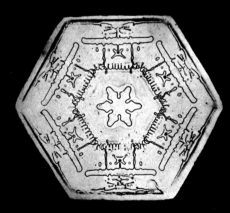 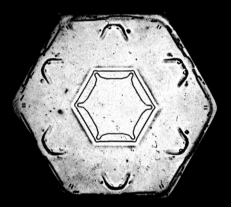 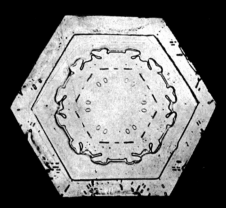

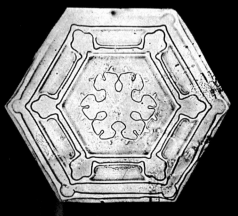 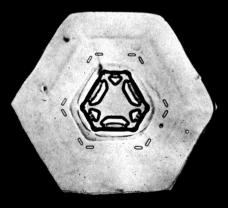 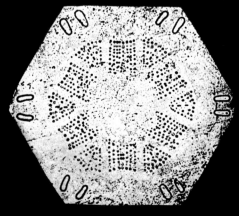

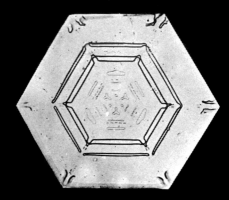 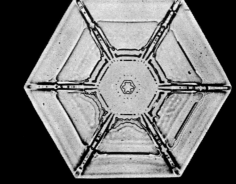 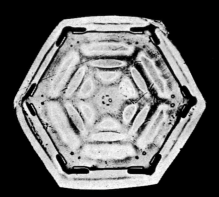

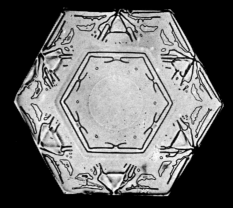 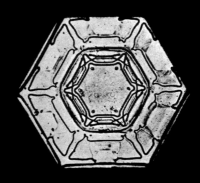 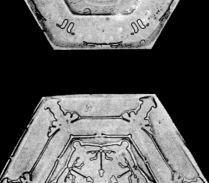

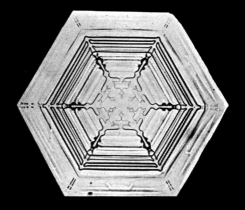 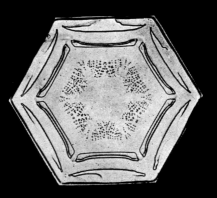 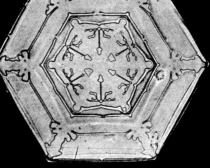

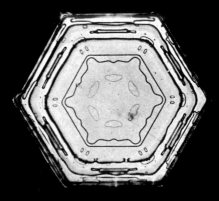 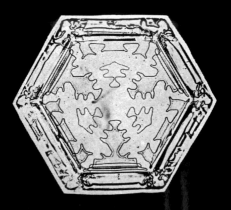

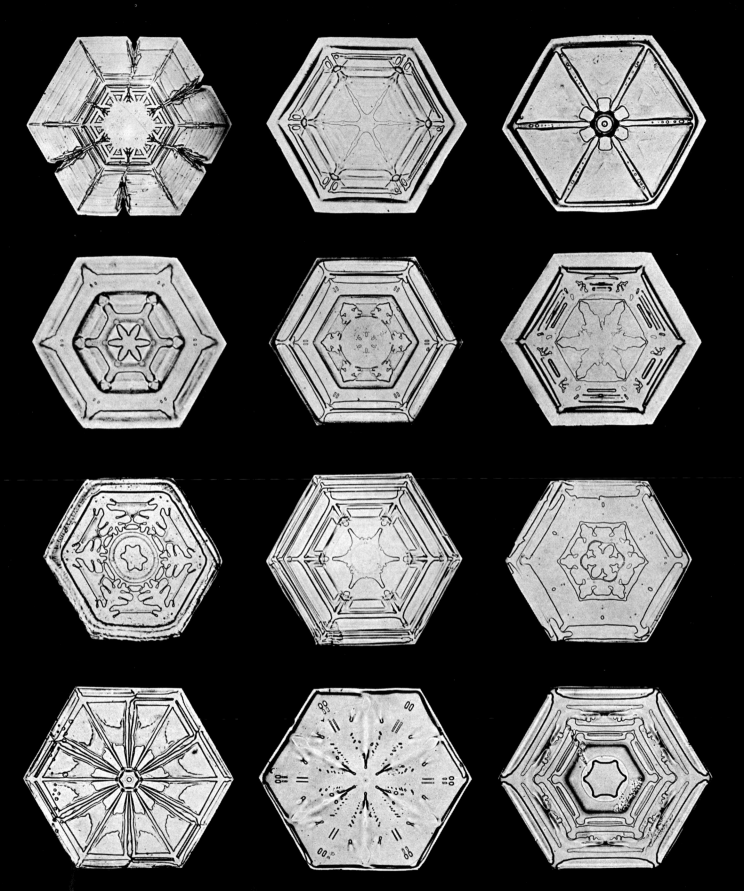

37

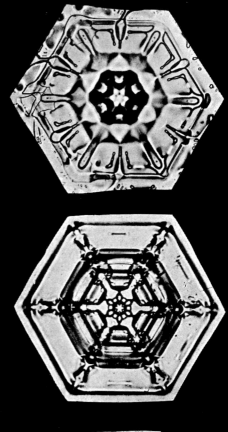
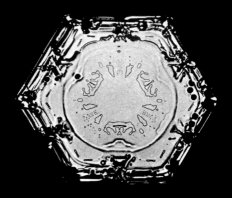
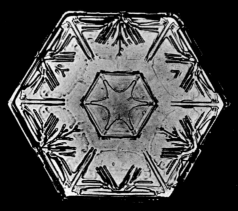
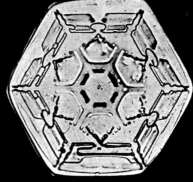
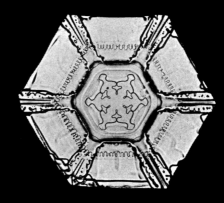
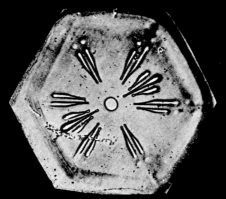
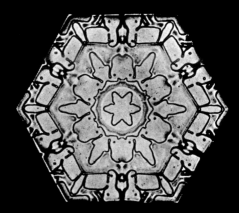
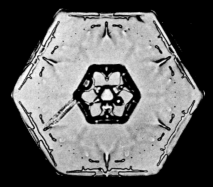
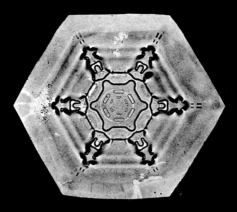
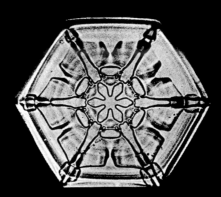
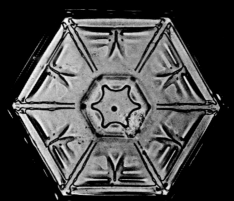

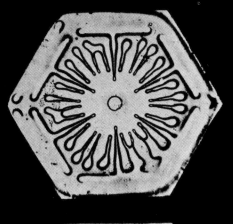 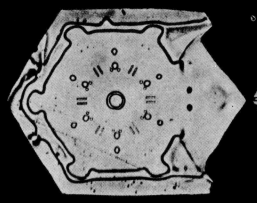

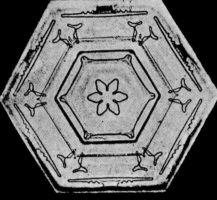 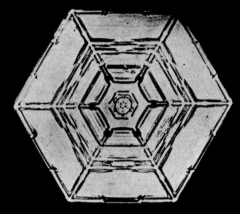 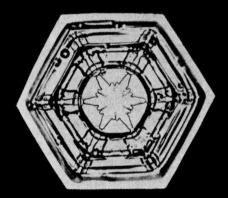

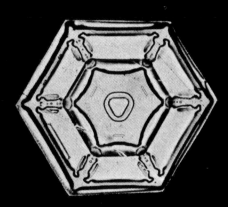 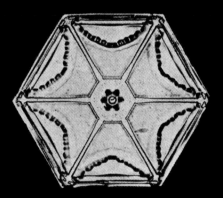 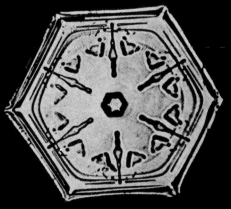

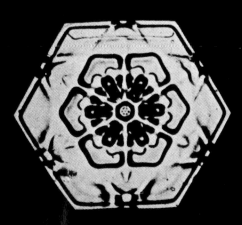 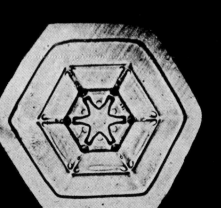

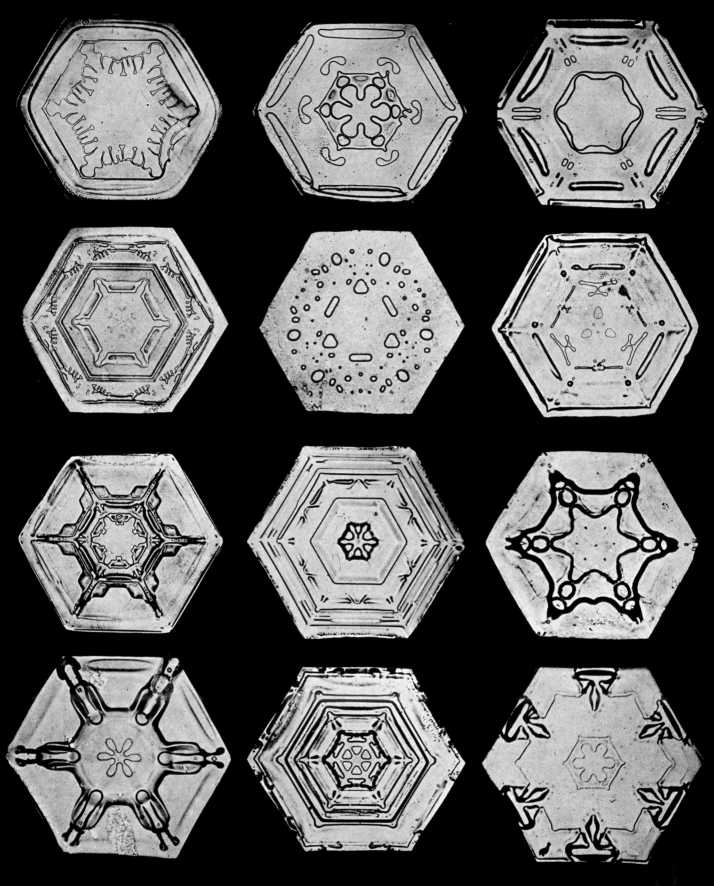

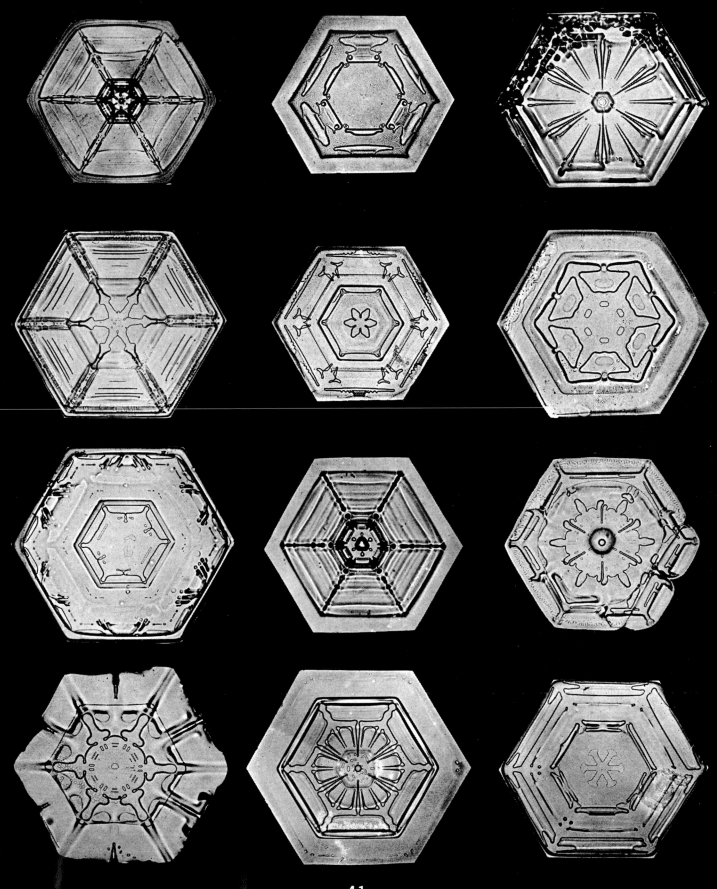

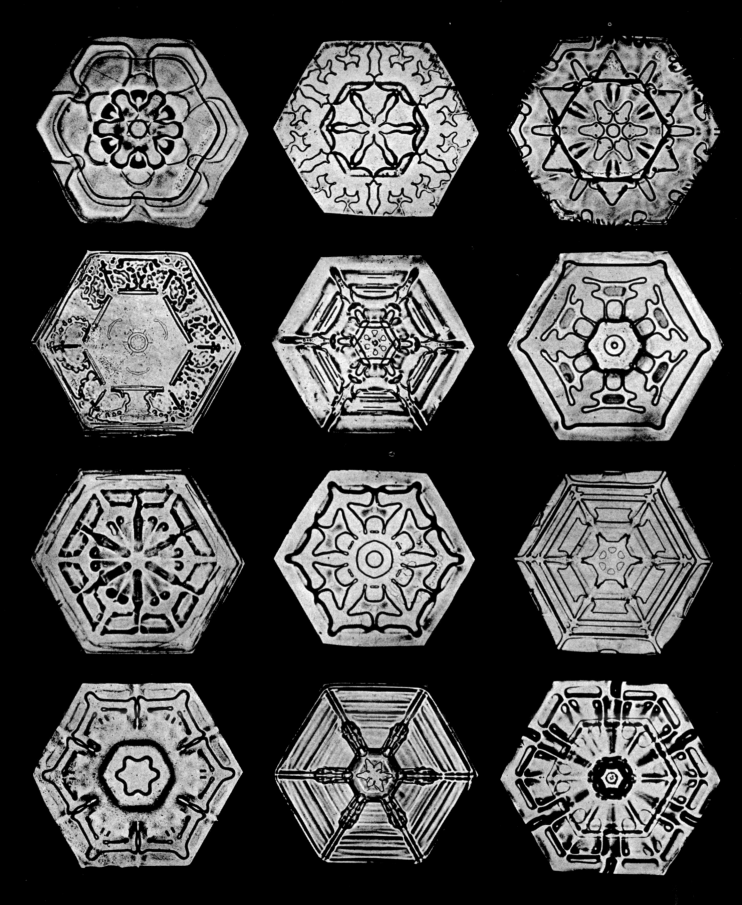

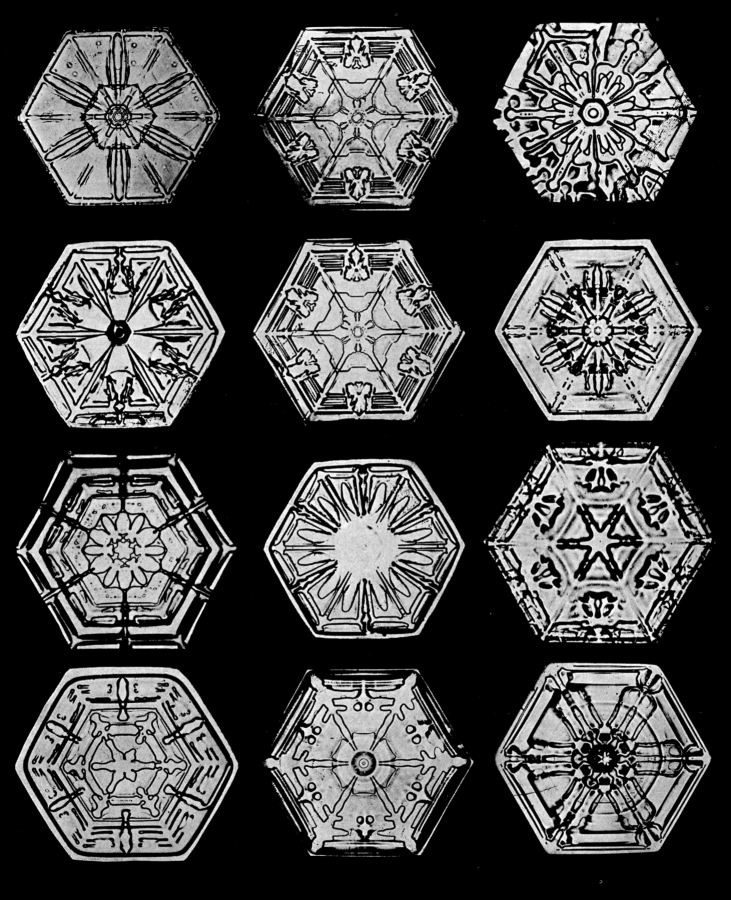

43

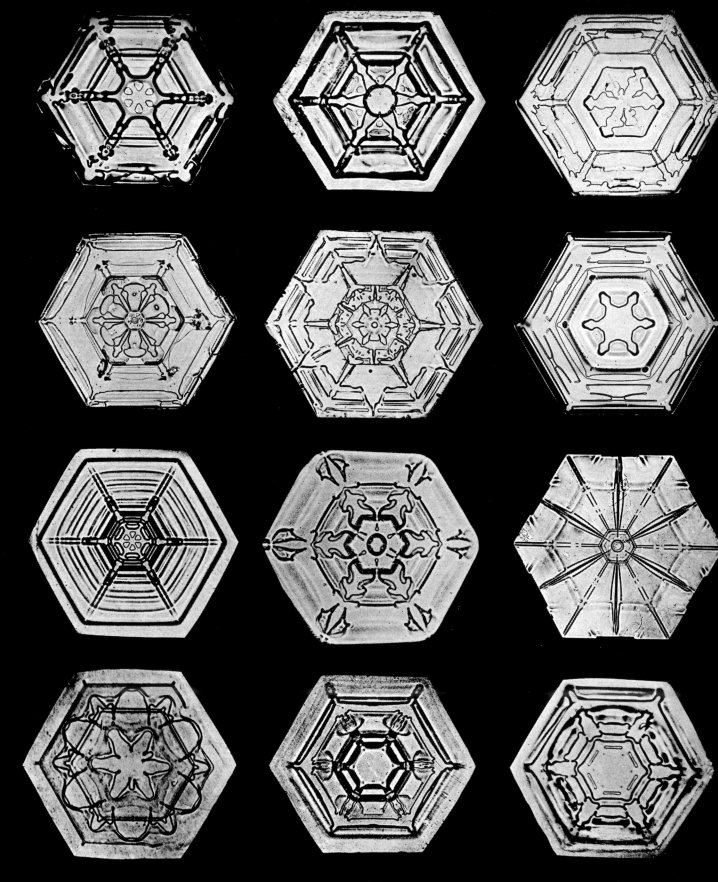

44

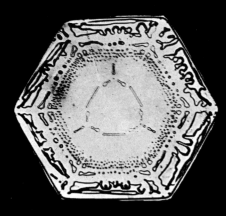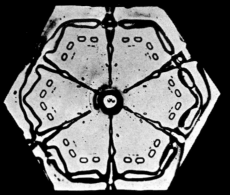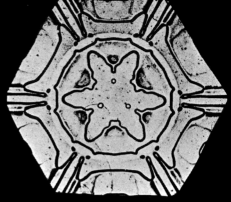
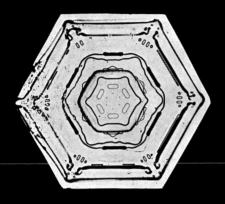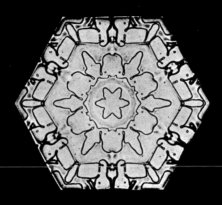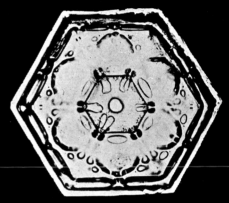
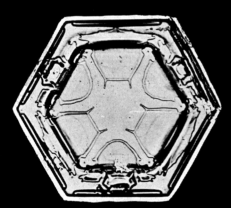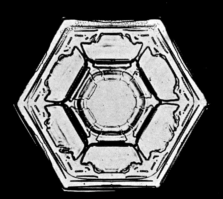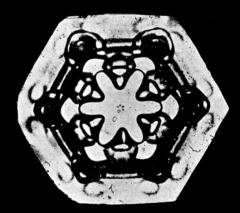
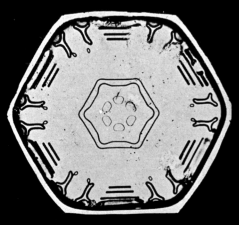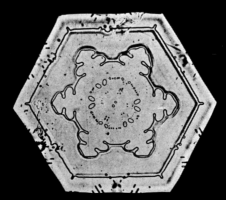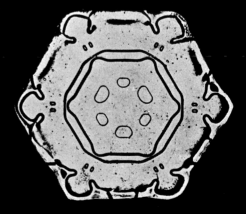

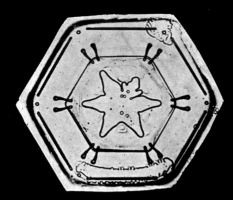 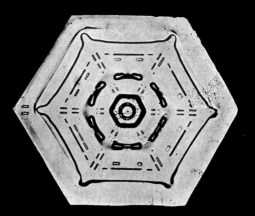 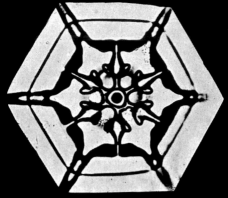

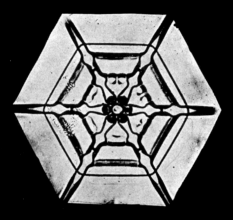 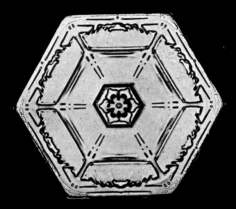 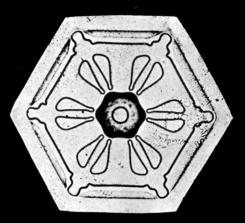

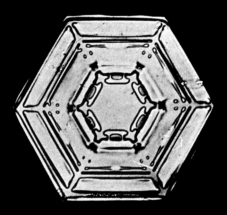 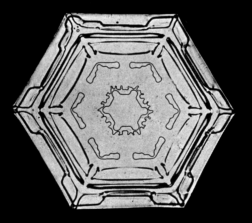 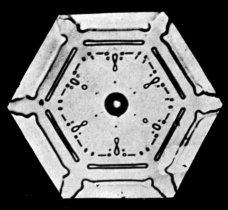

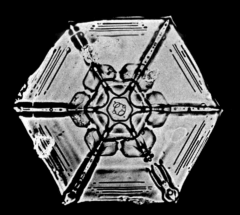 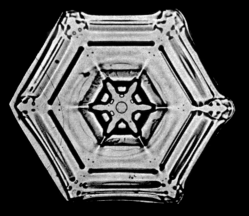 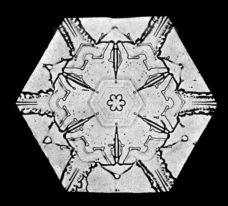

46

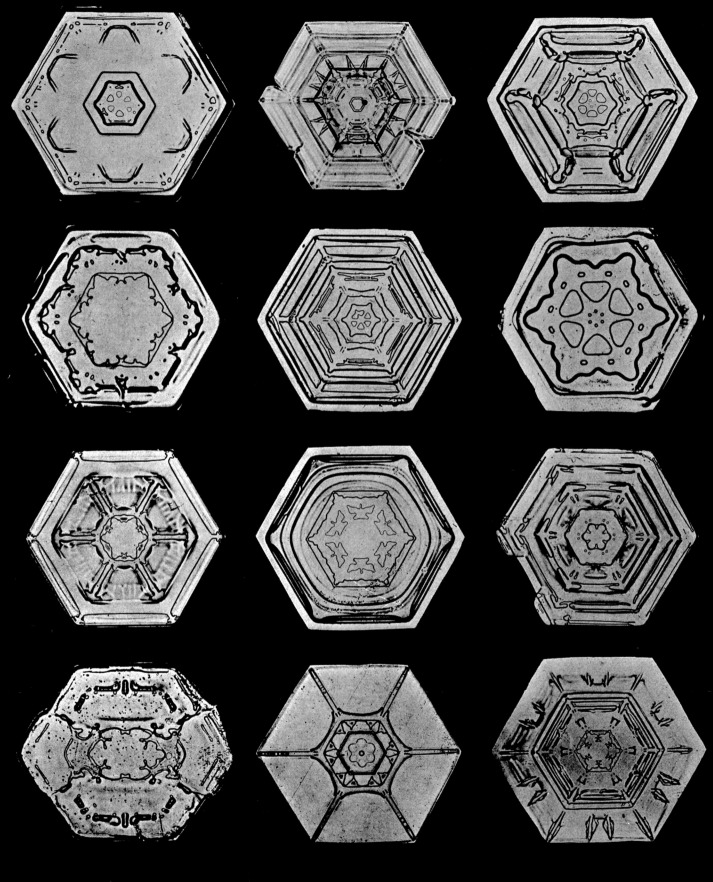

47

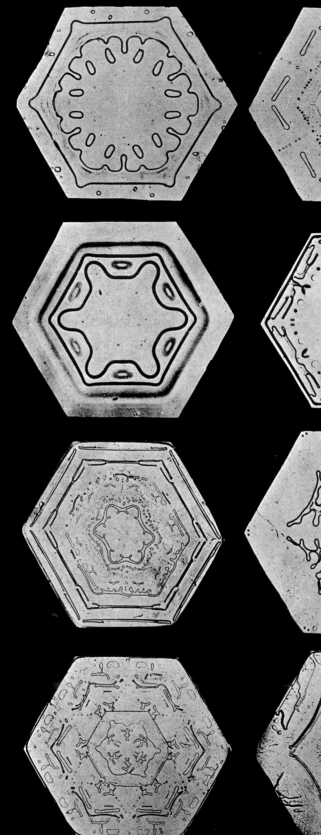
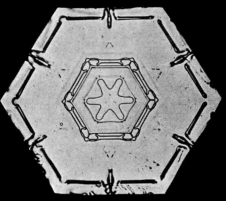
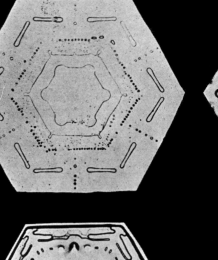
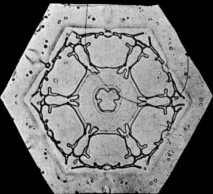
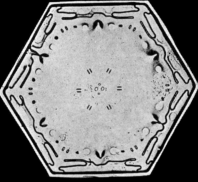
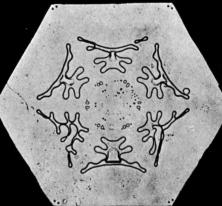
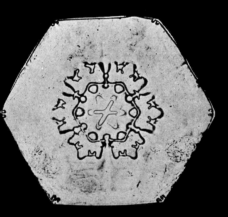
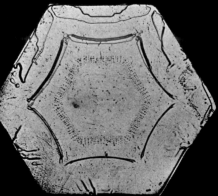
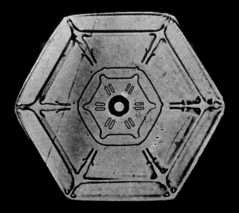

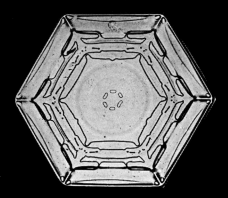
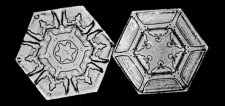
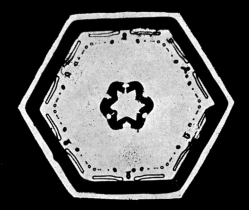
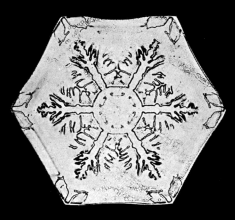
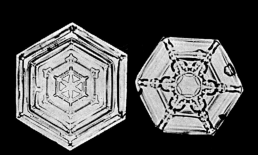
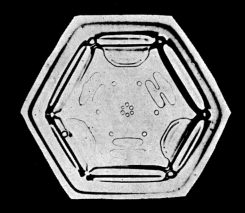
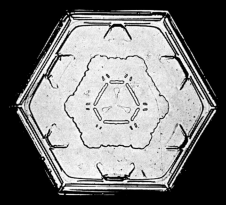
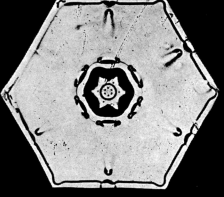
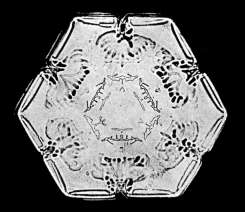
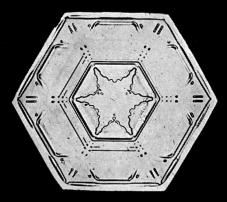
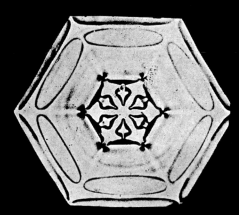

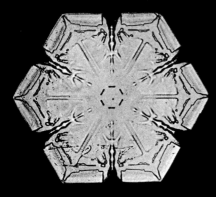
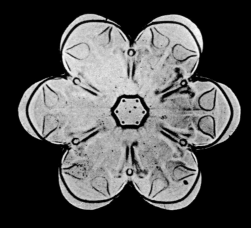
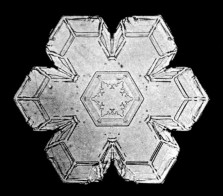
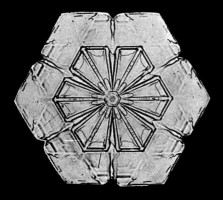
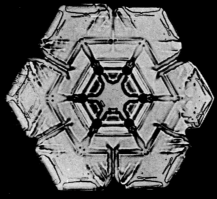
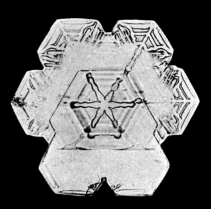
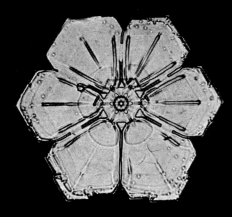
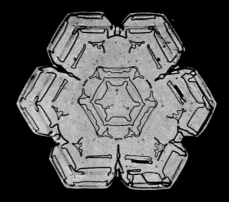
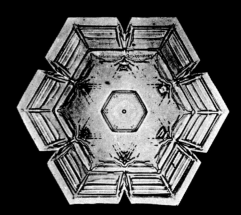
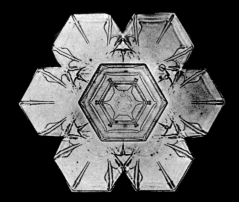
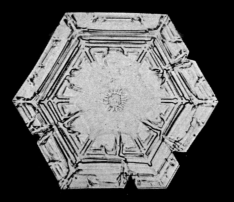
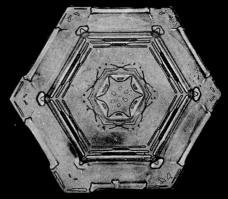

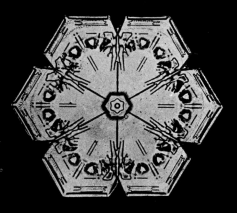 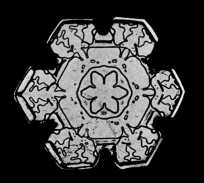 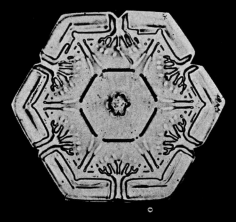

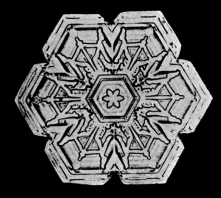 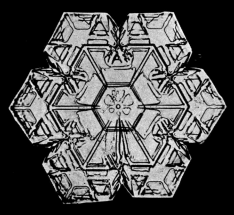 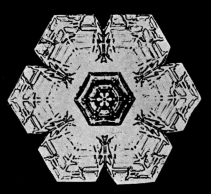

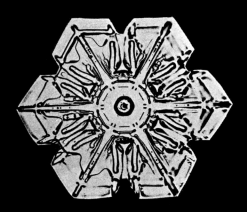 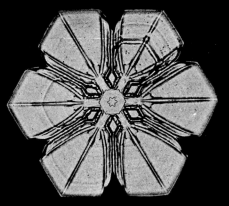 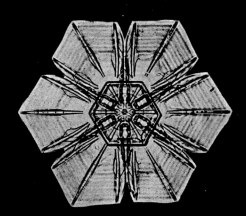

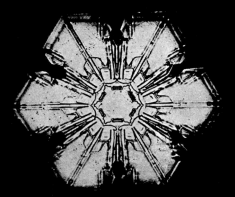 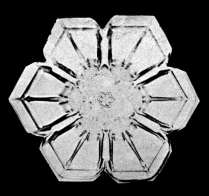 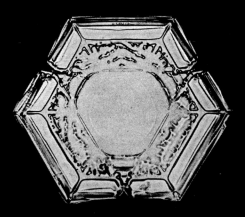

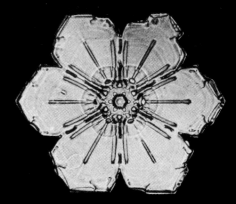
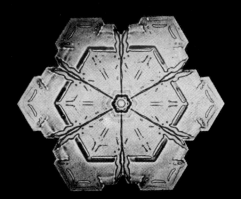
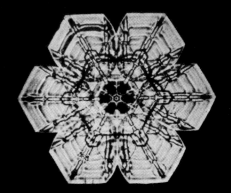
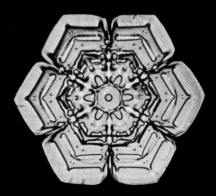
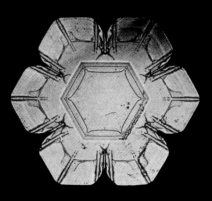
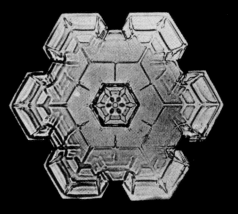
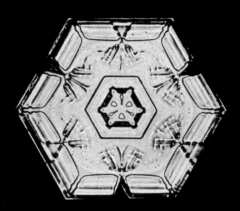
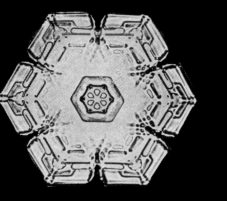
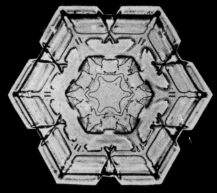
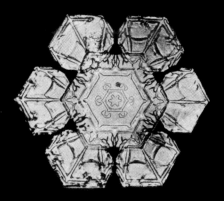

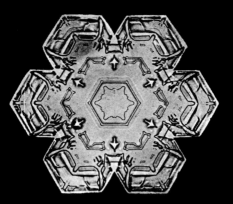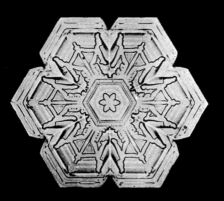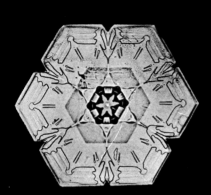
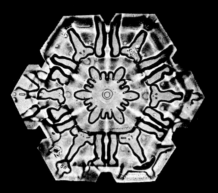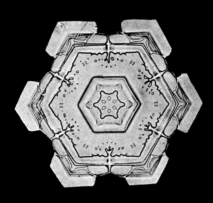
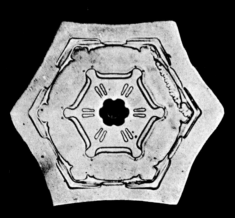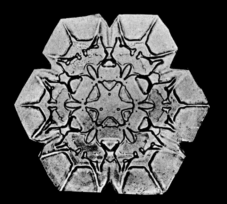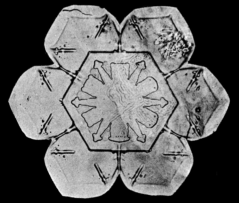
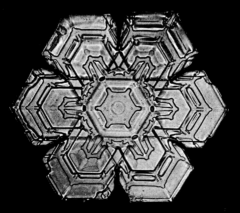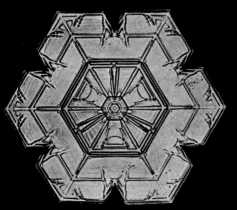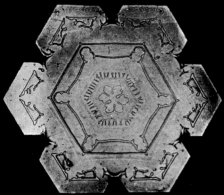

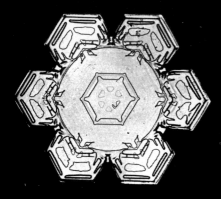
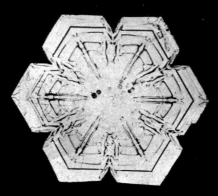
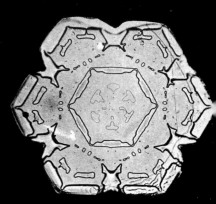
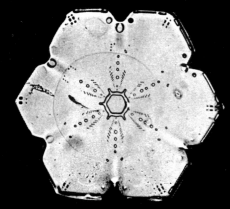
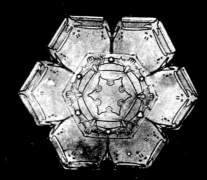
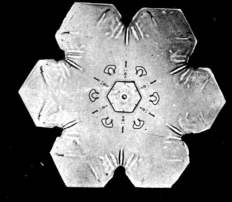
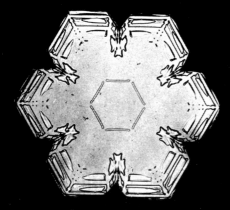
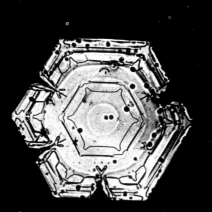
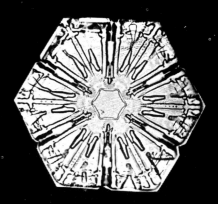
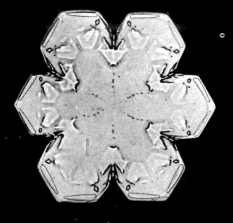
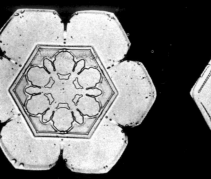
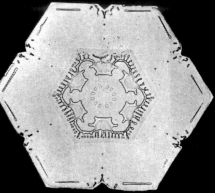

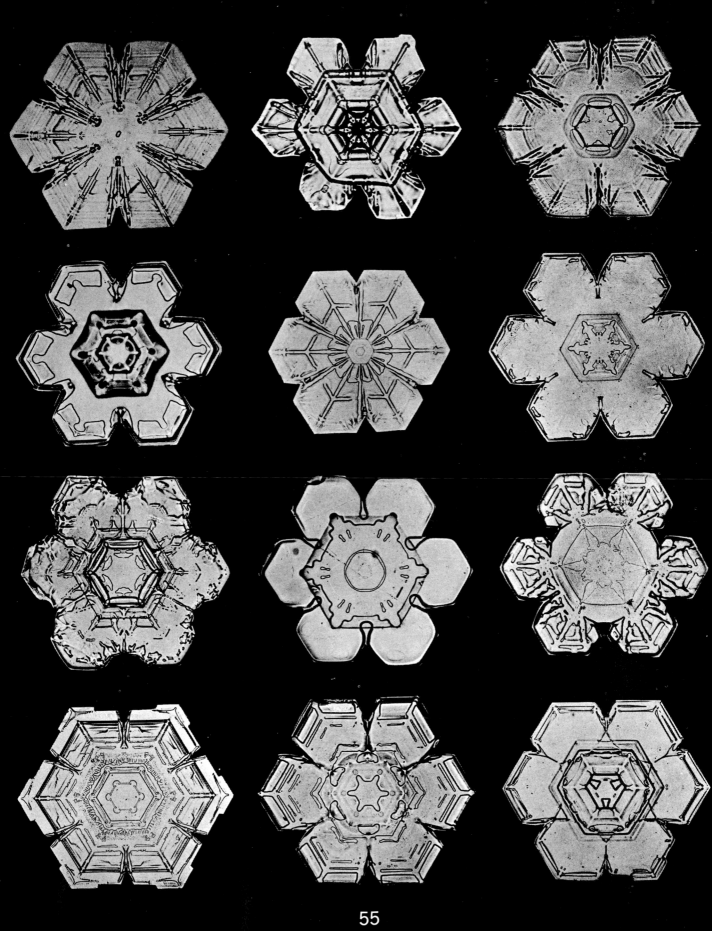

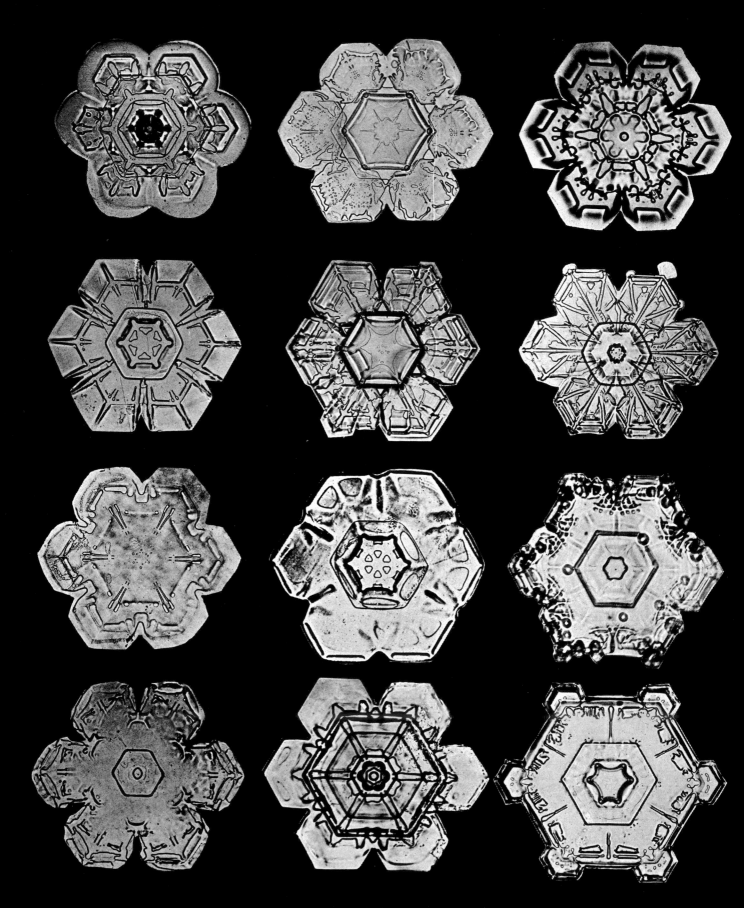

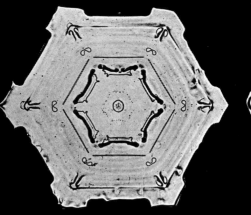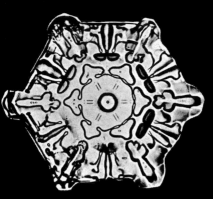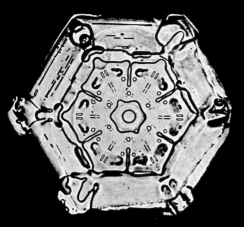
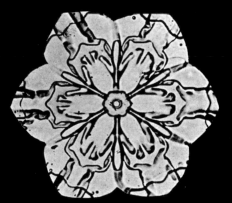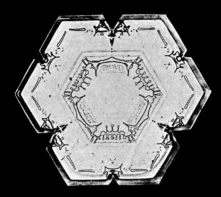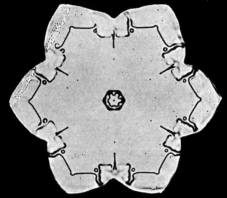
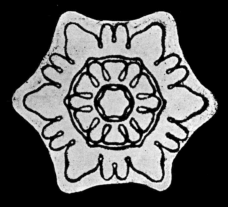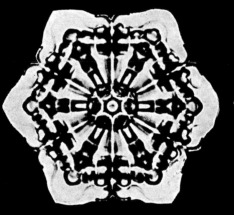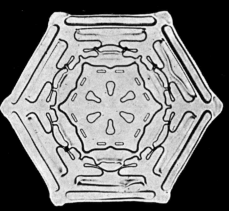
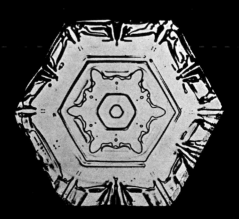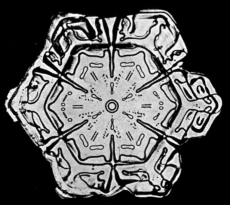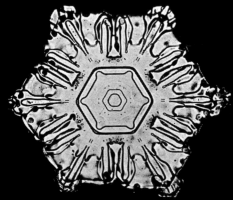

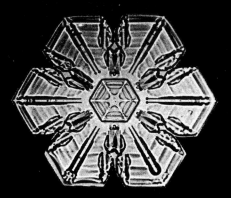 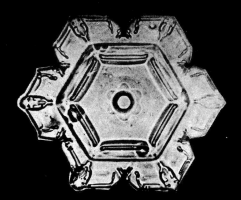 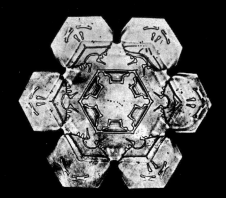

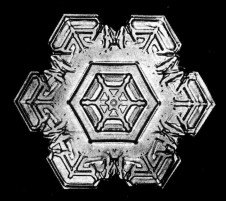 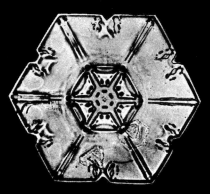

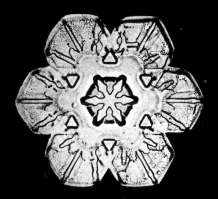 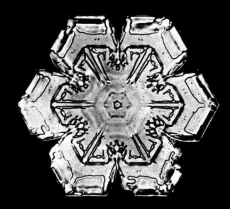

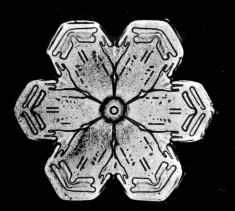 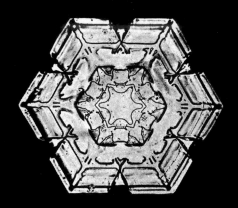

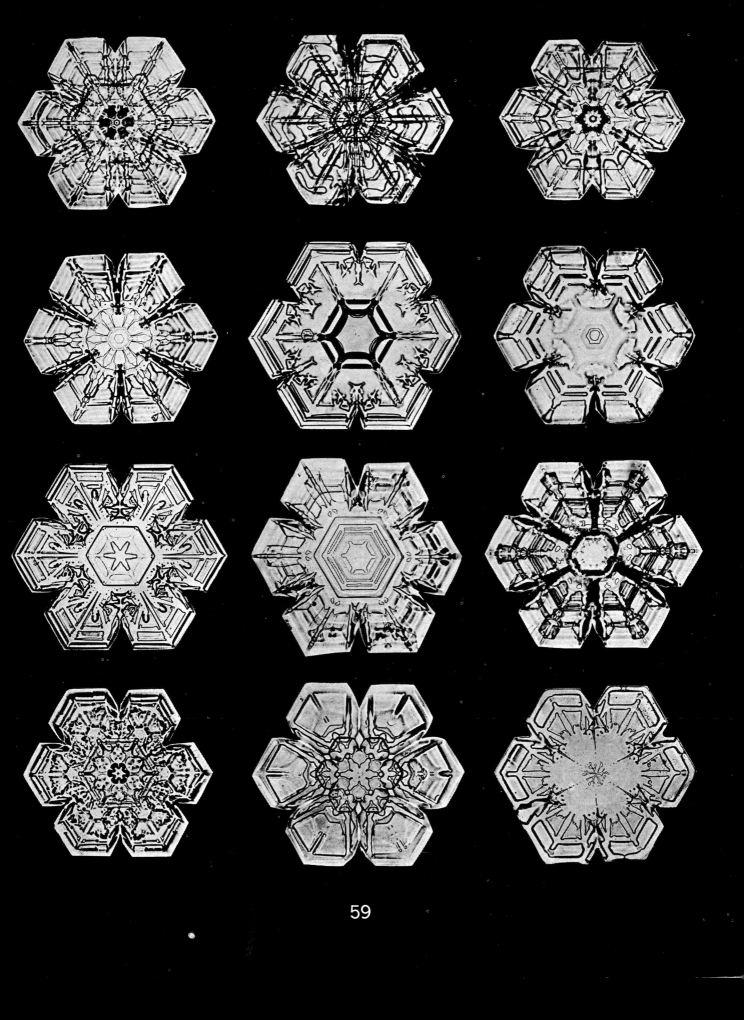

59

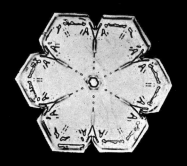 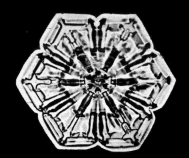 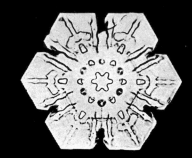

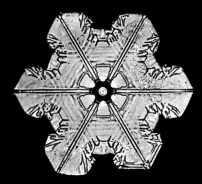 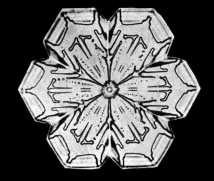 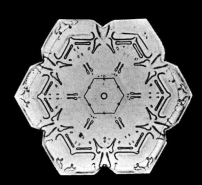

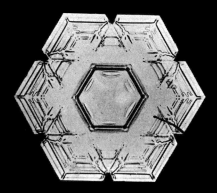 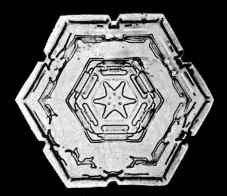 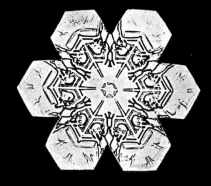

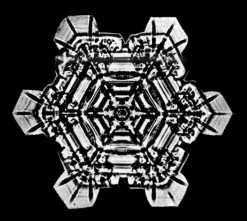 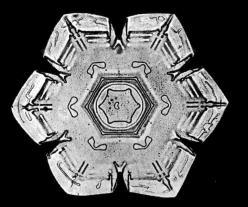 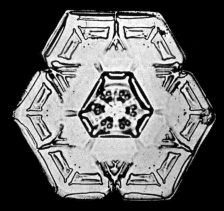

60

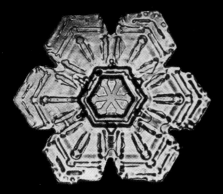 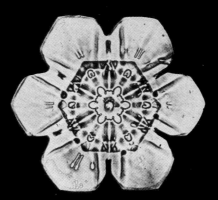 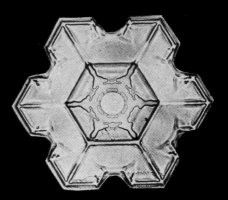

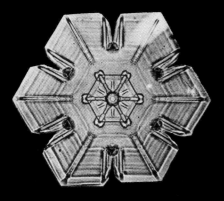 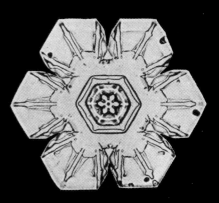

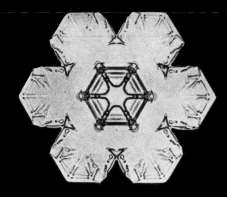 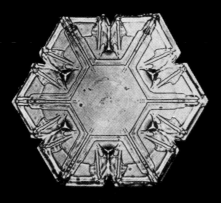 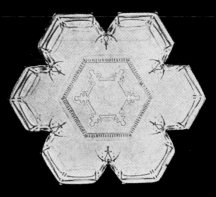

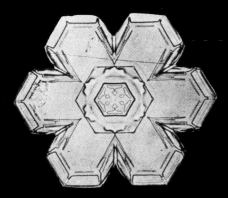 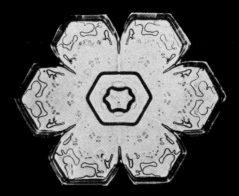

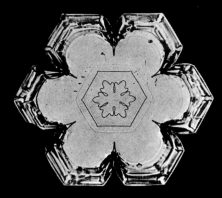
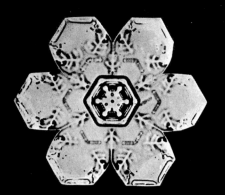
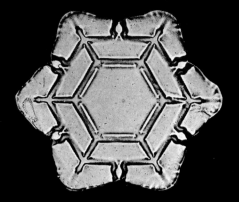
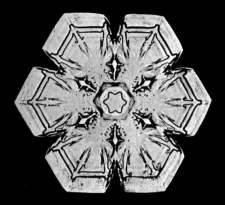
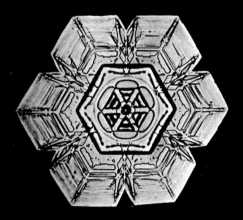
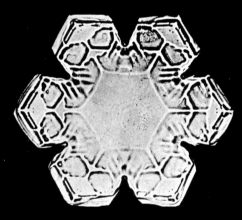
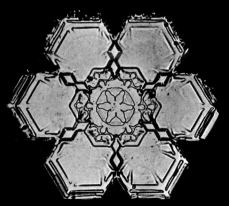
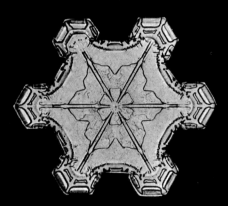
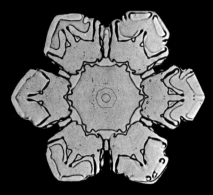
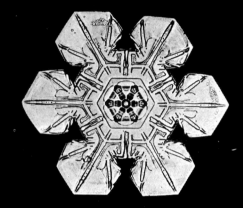
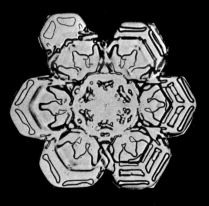
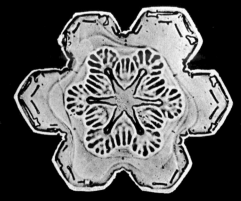

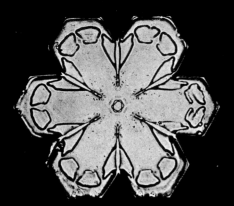 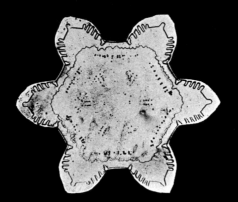 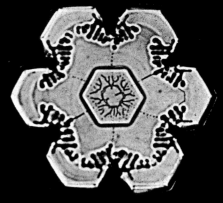

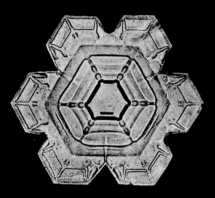 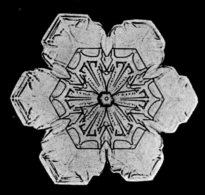 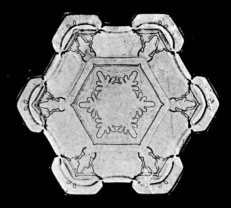

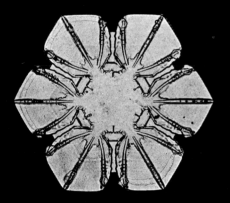 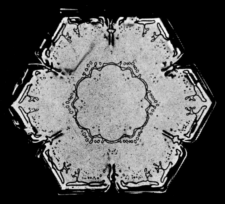 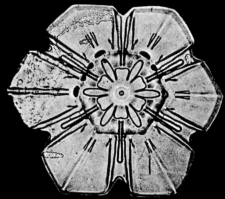

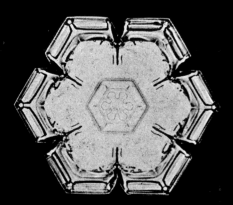 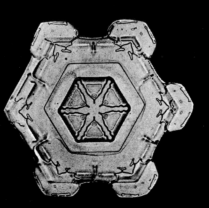 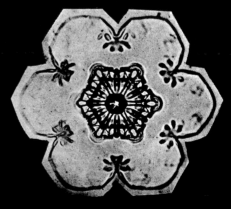

63 °

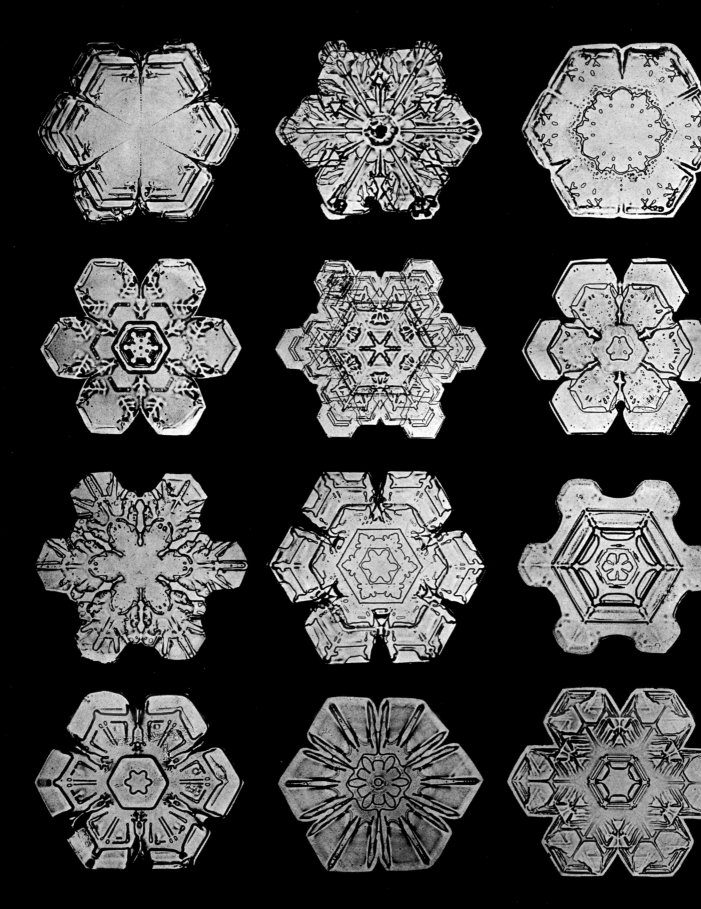

64

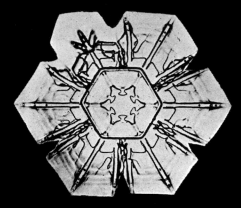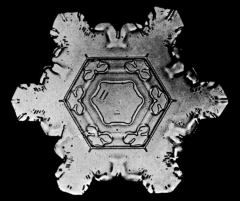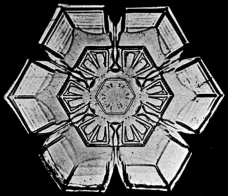
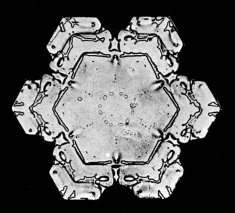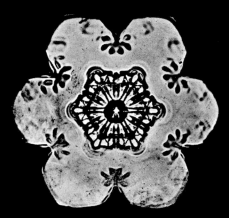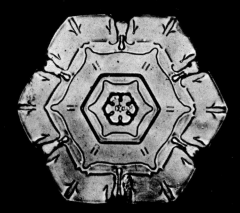
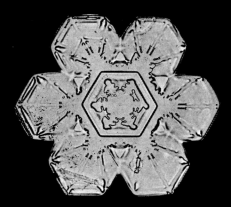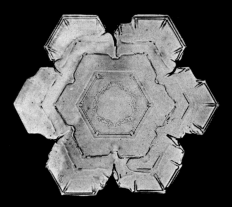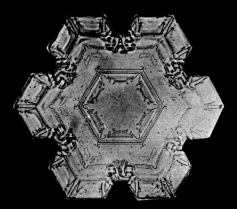
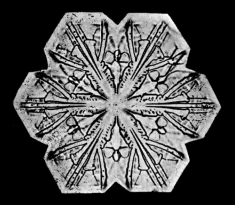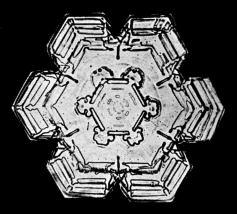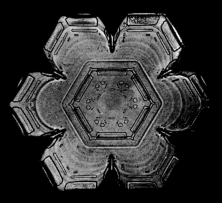

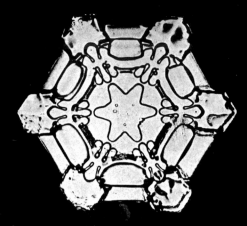 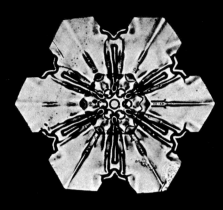 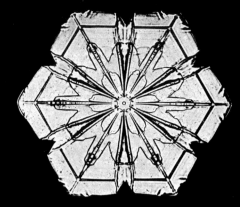

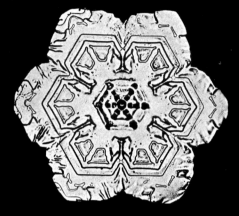 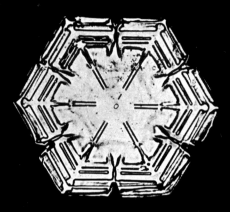 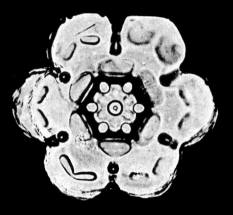

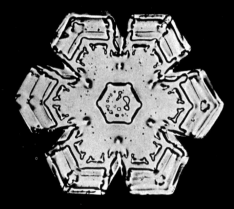 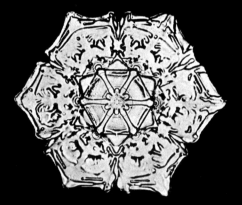 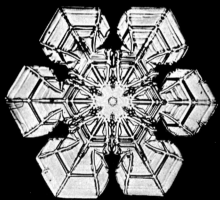

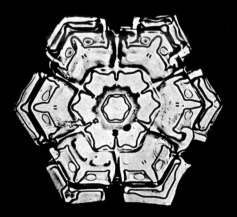 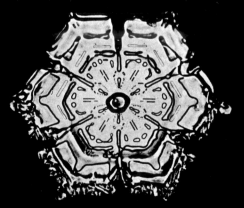 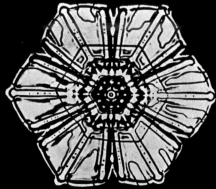

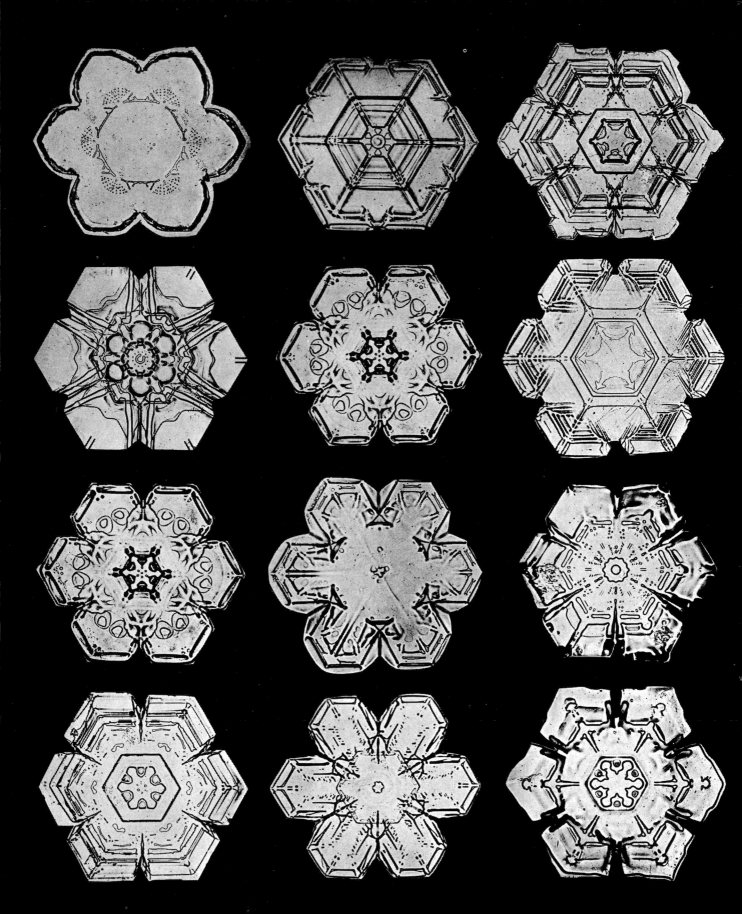

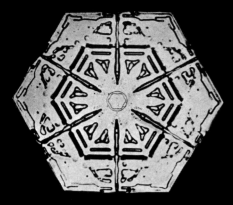 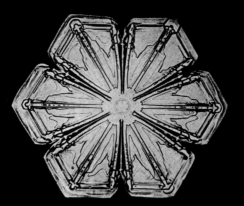 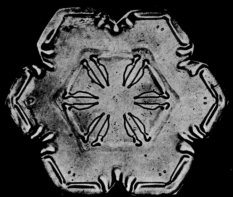

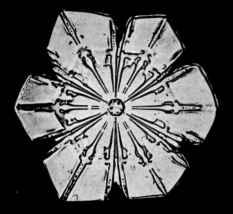 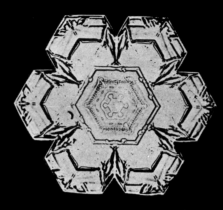 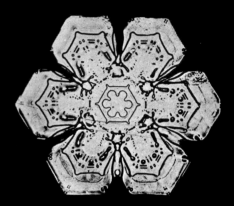

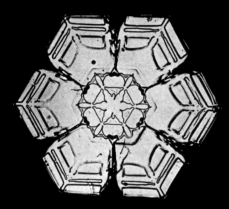 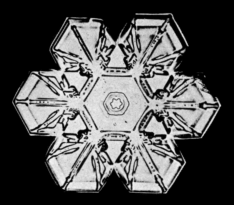 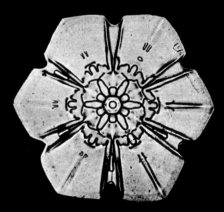

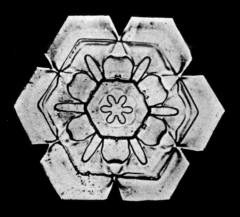 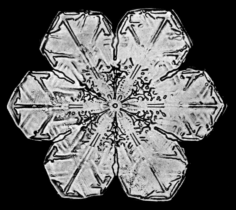 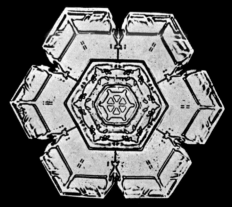

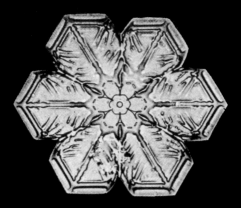
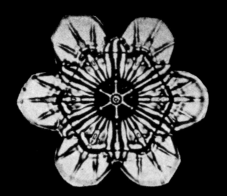
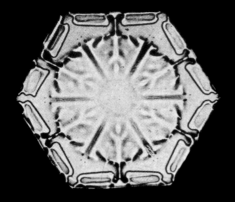
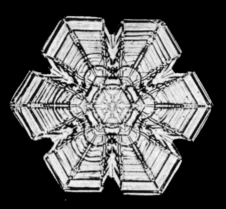
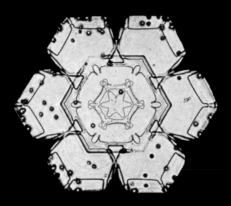
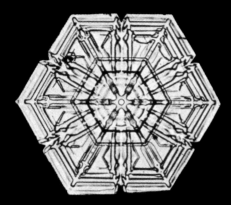
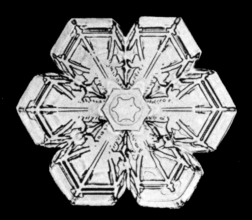
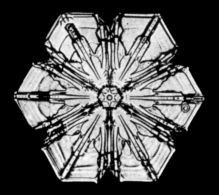
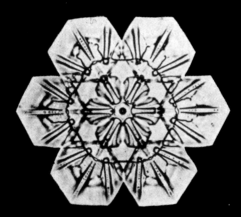
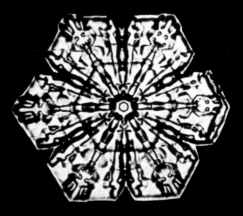
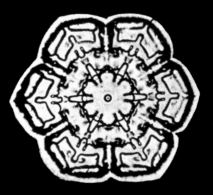
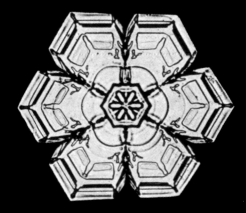

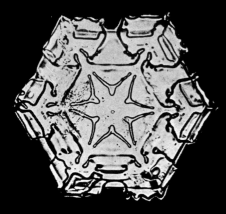 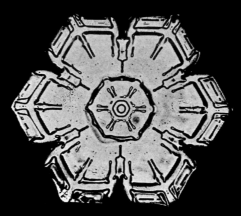 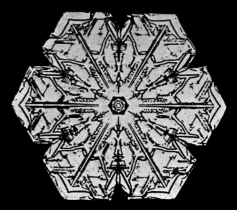

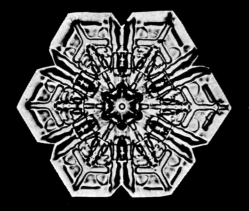 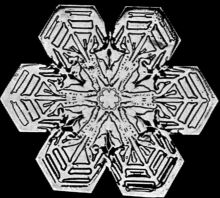 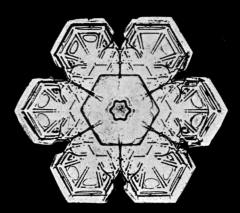

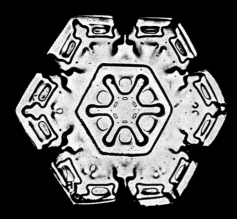 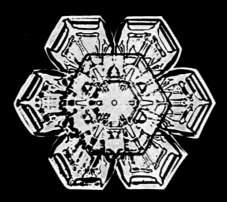 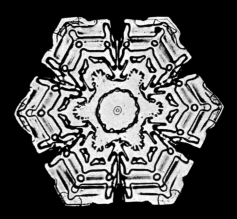

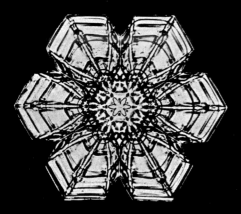 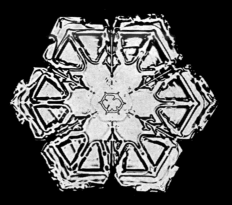 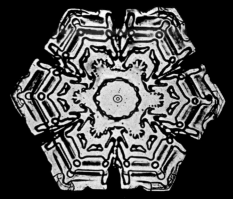

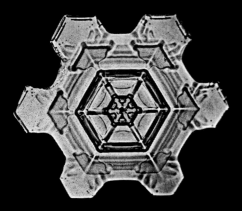
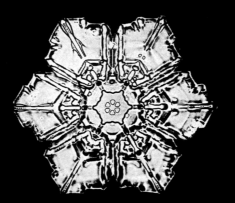
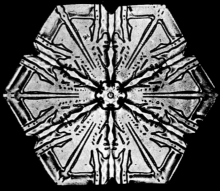
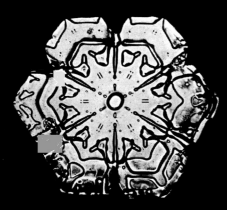
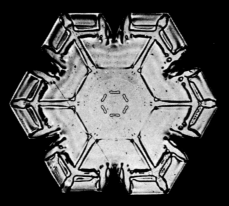
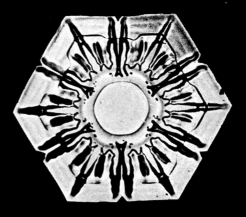
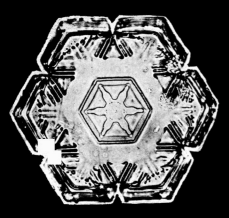
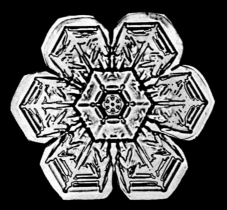
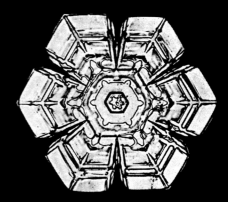
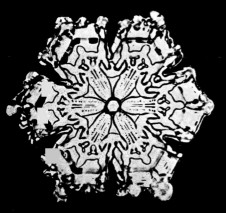
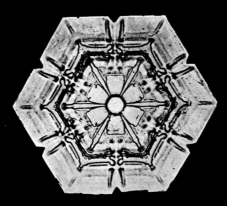
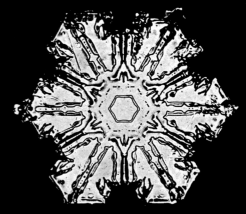

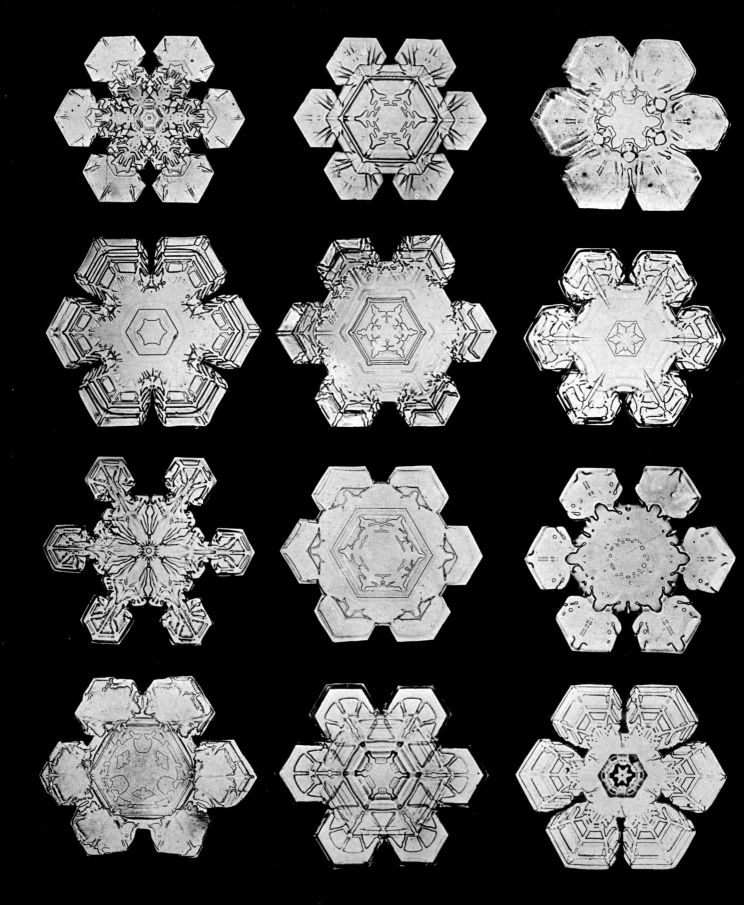

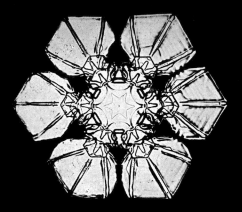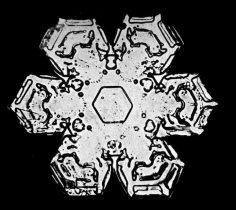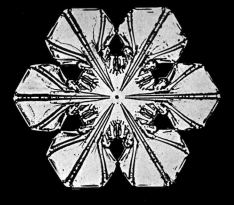
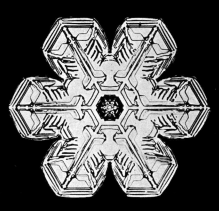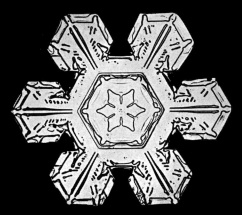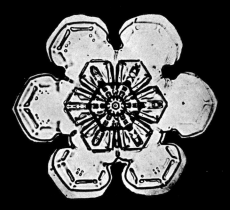
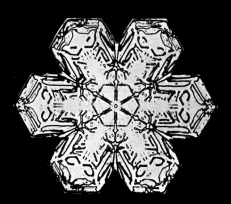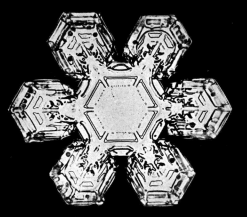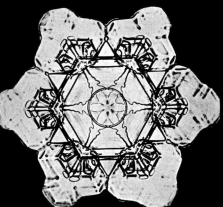
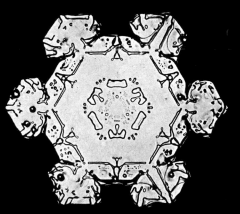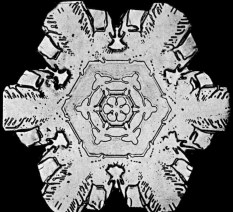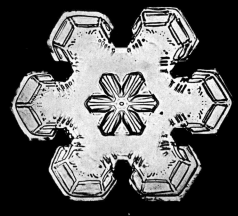

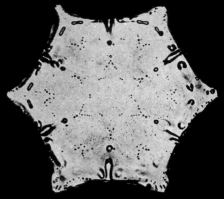 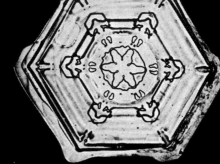 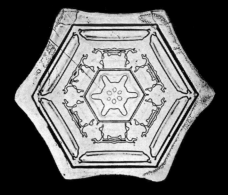

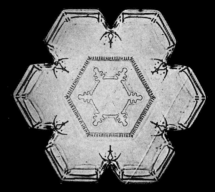 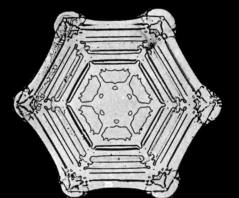 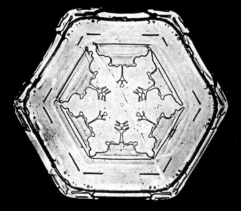

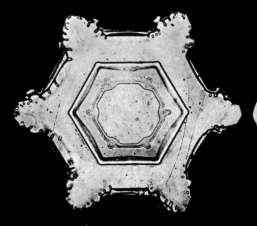 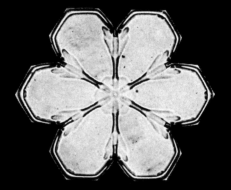 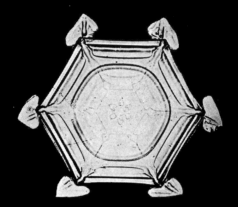

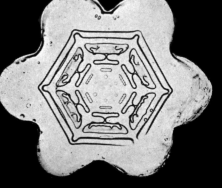 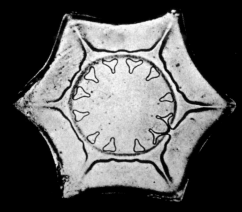

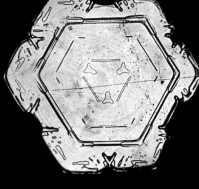
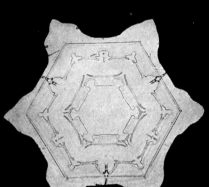
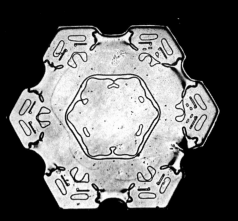
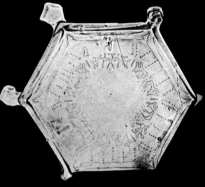
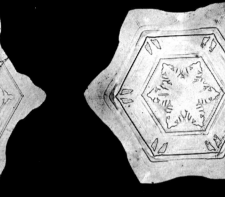
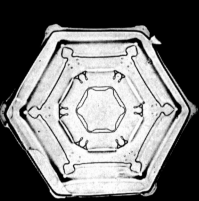

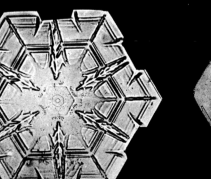
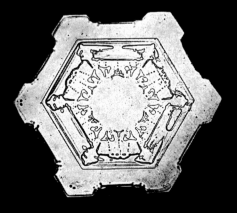

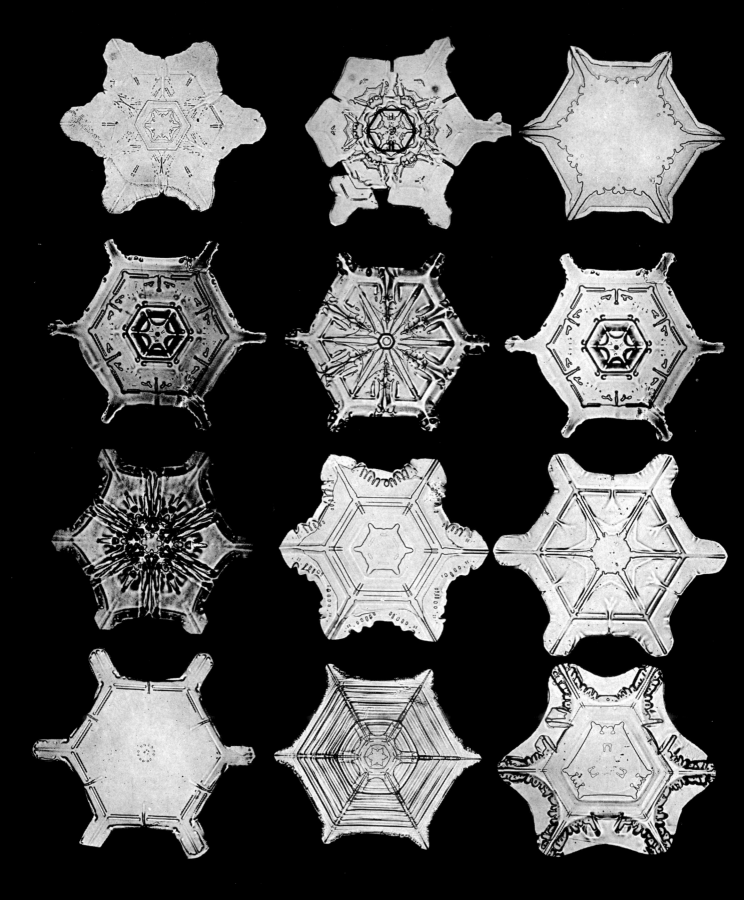

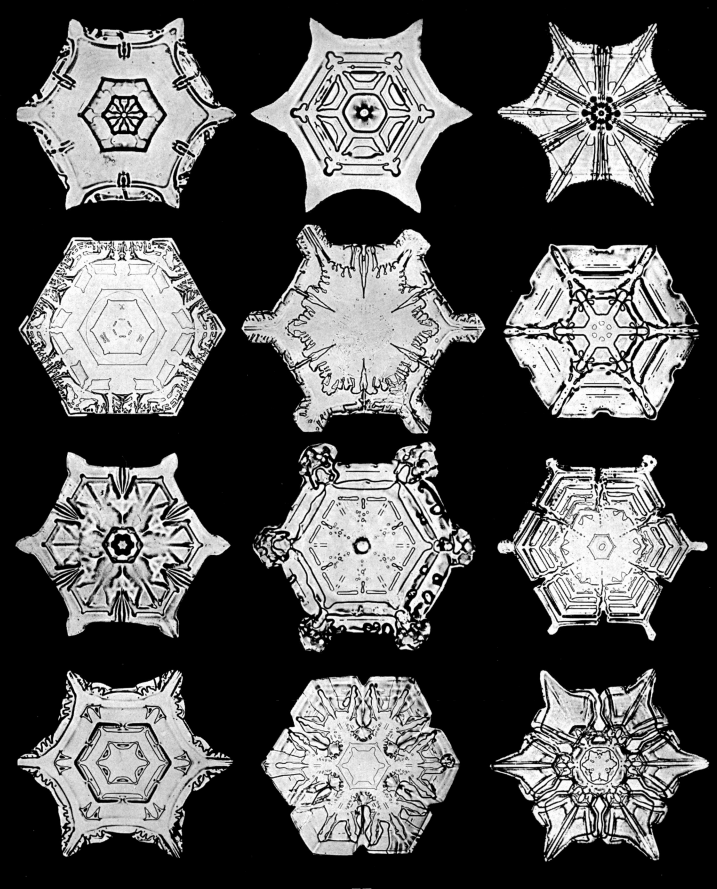

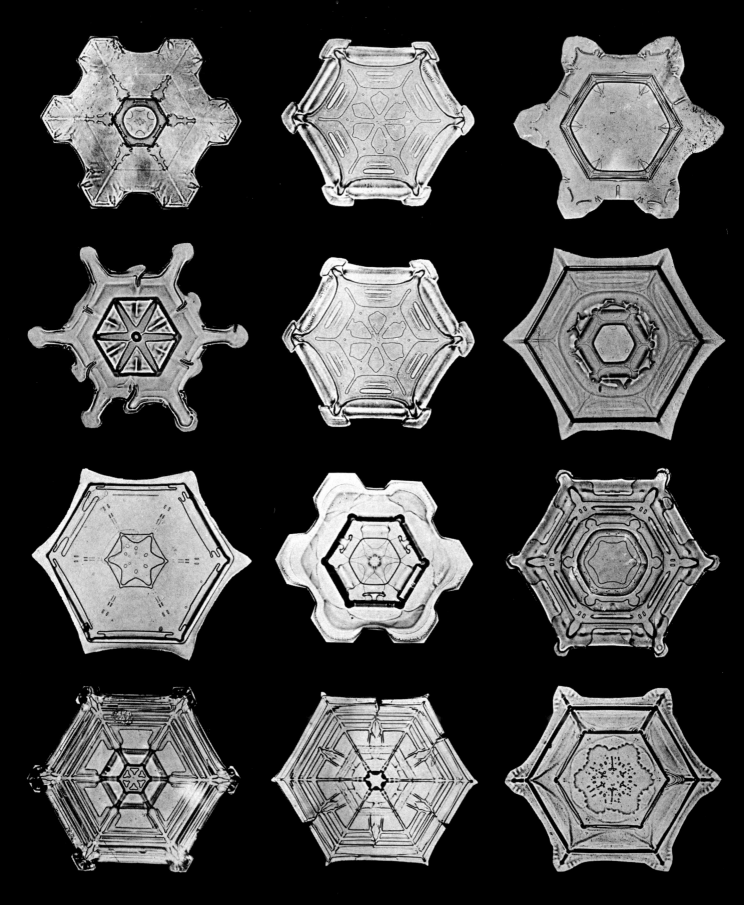

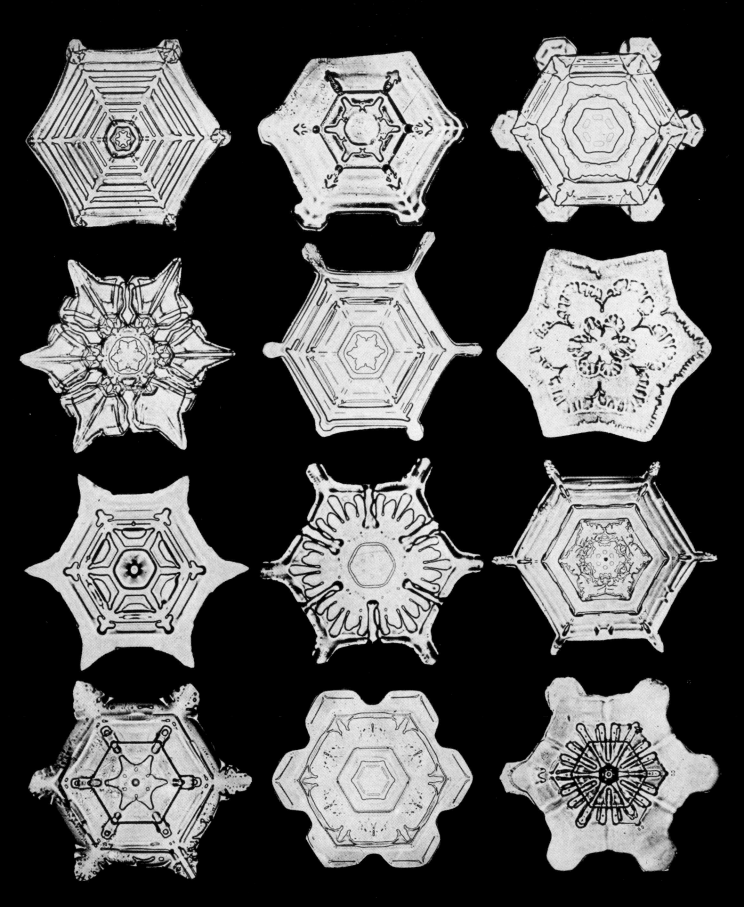

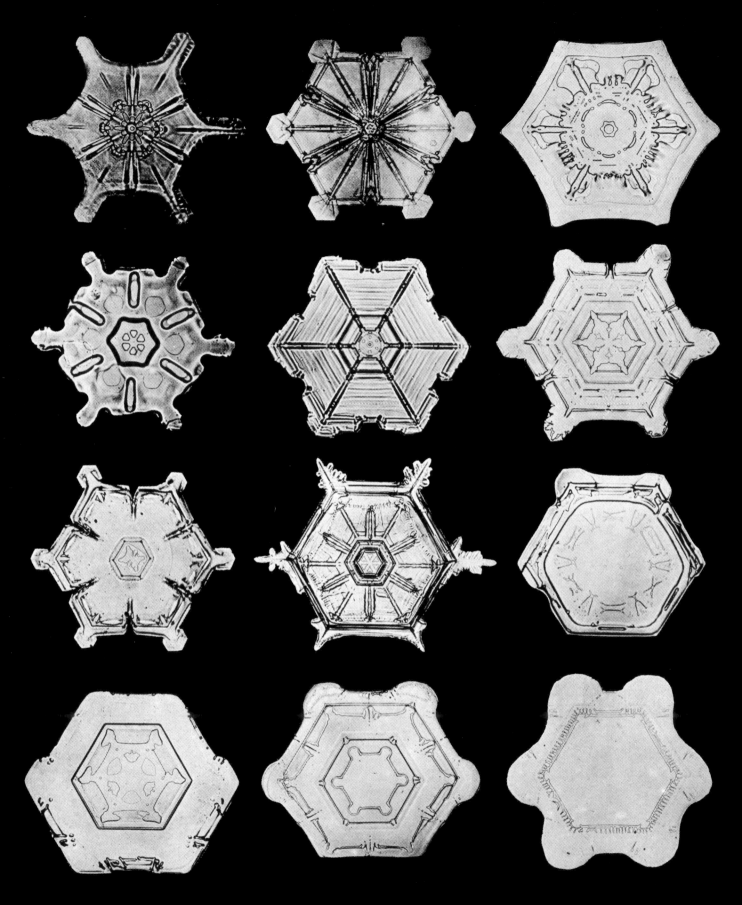

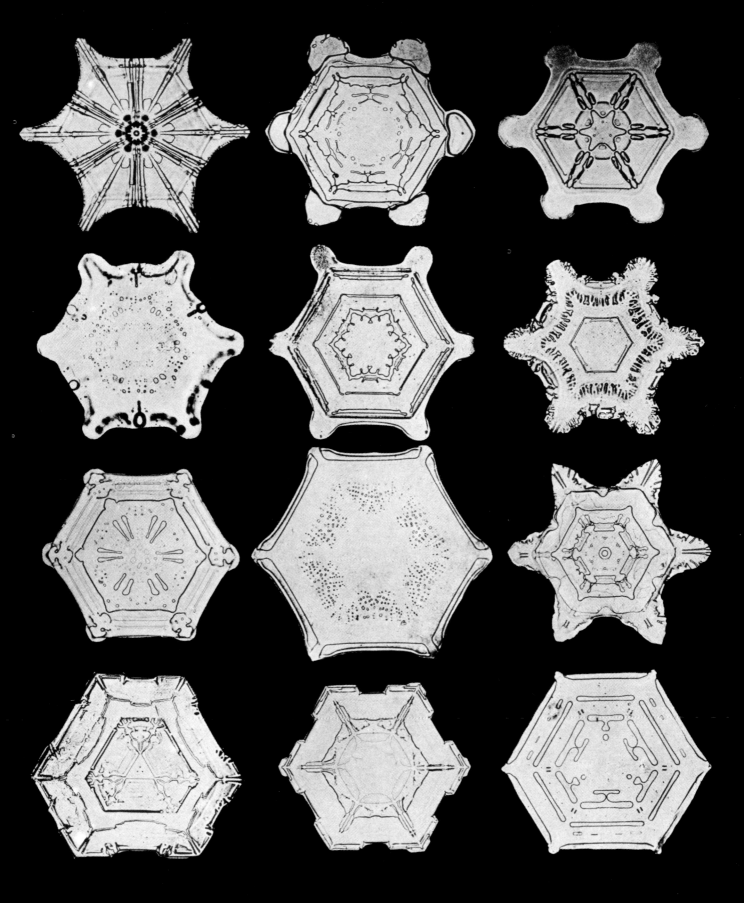

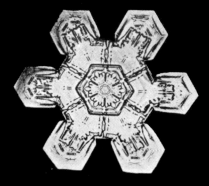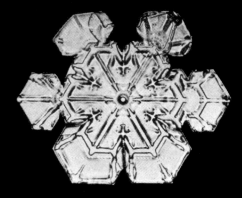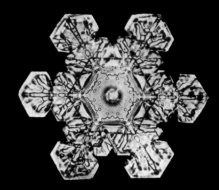

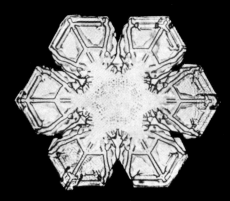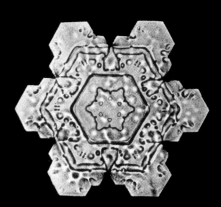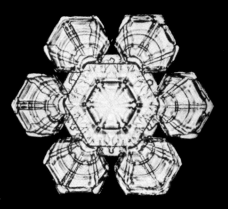

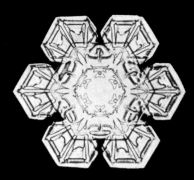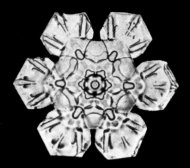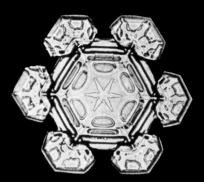

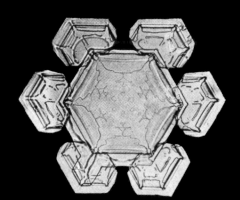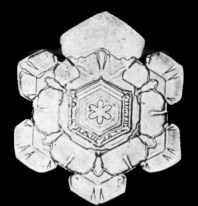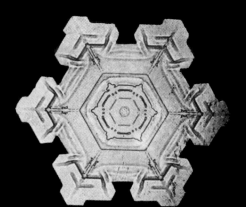

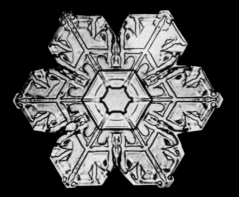 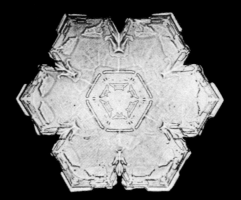 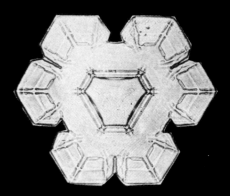

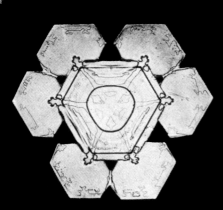 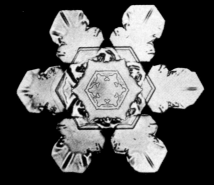 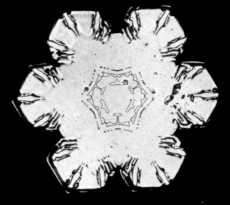

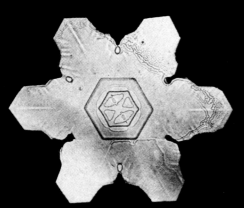 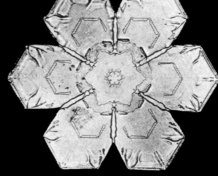 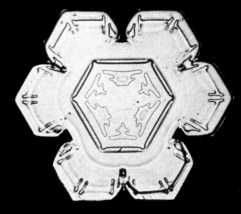

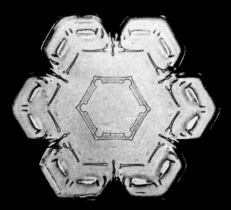 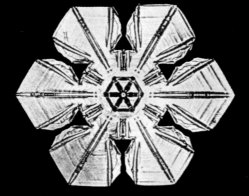 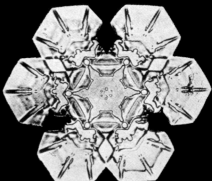

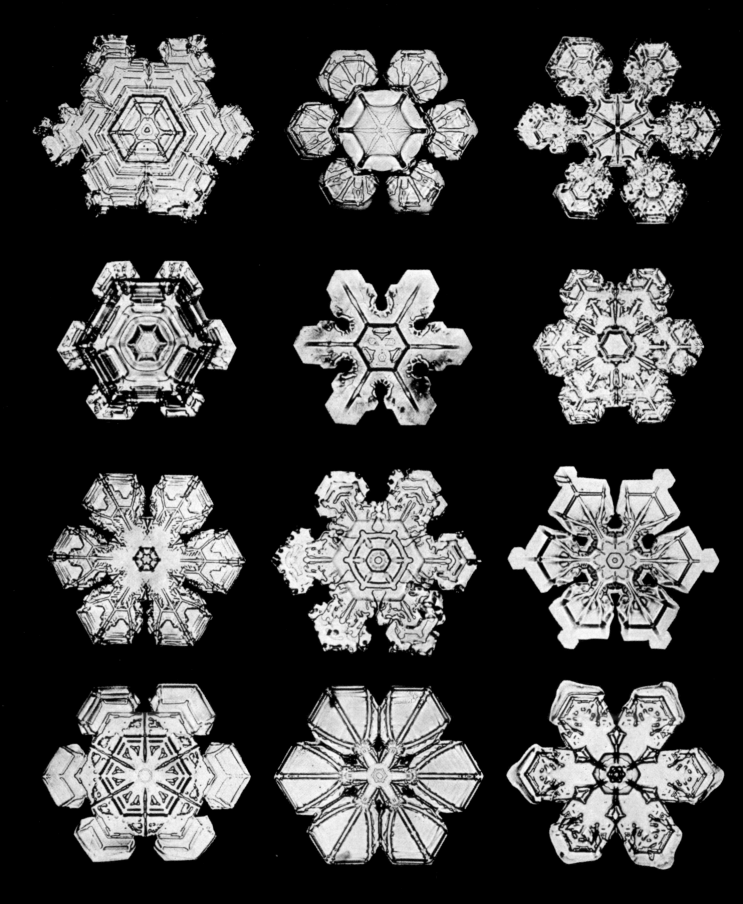

84

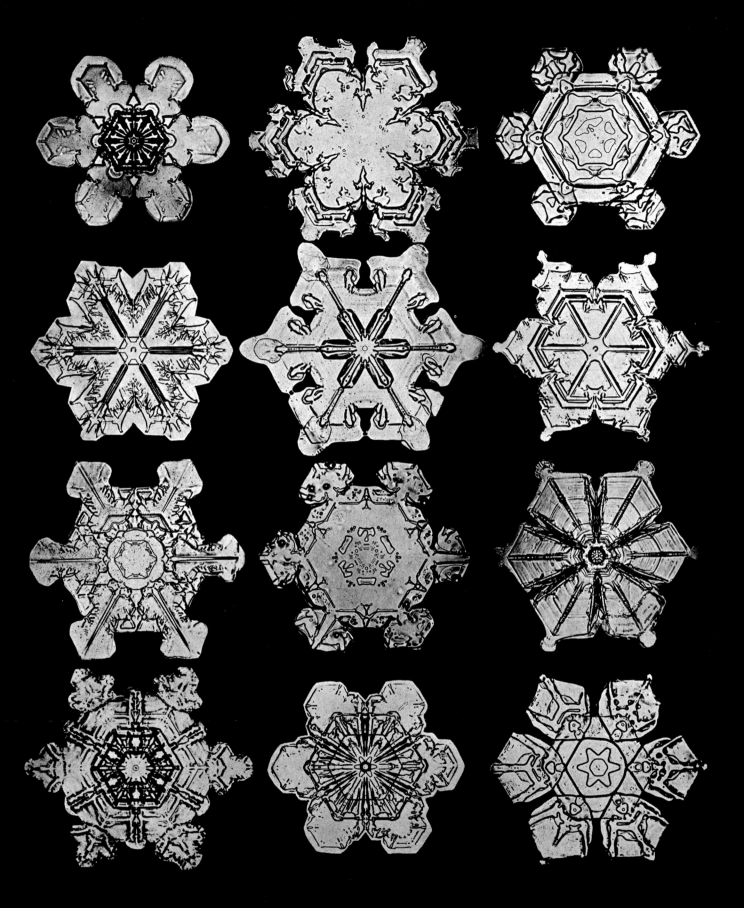

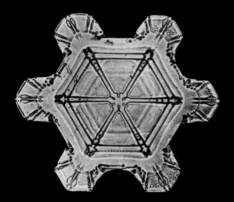 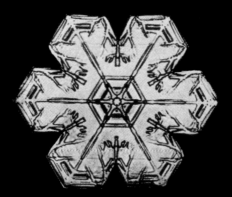 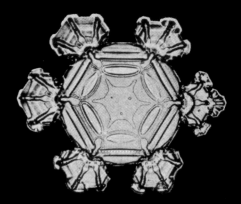

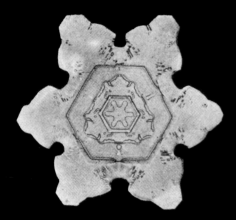 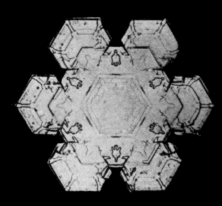 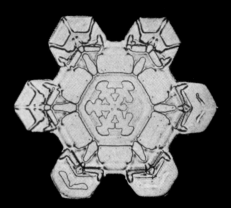

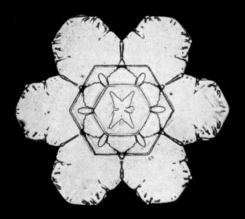 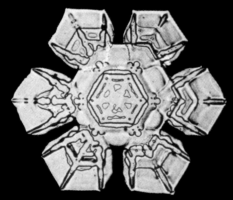 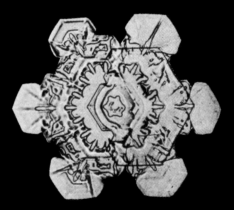

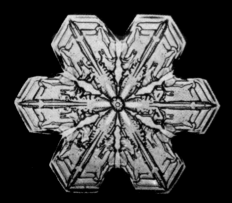 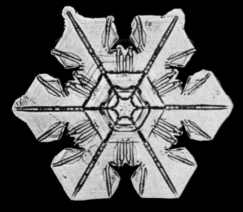 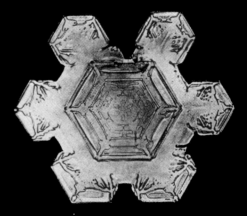

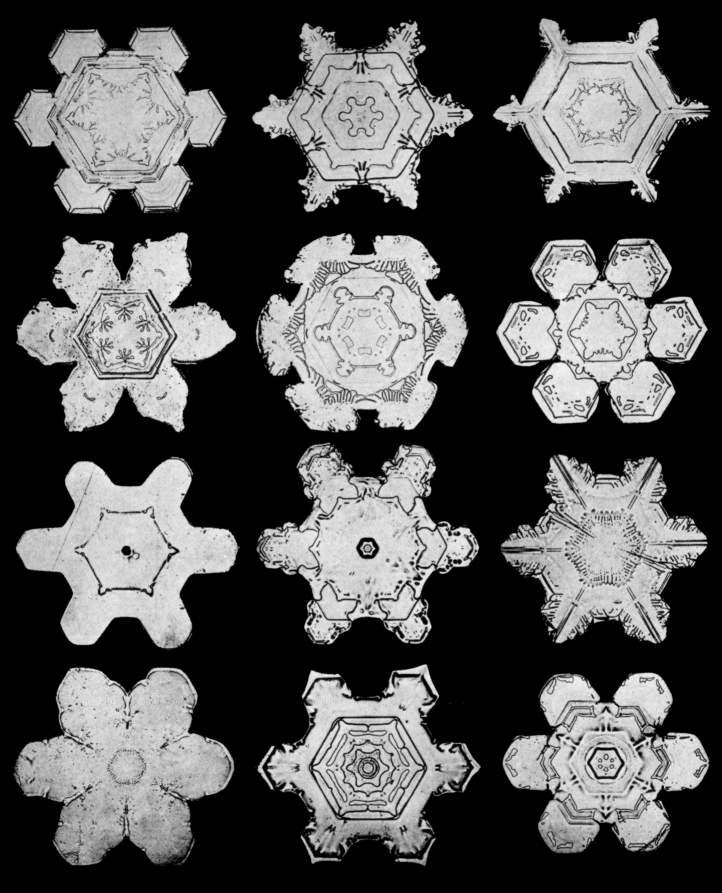

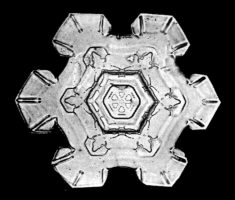 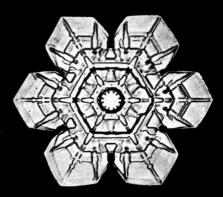 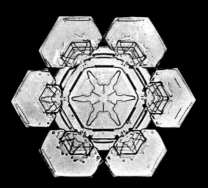

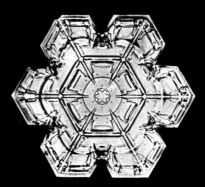 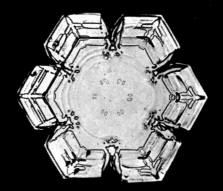 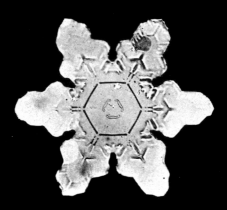

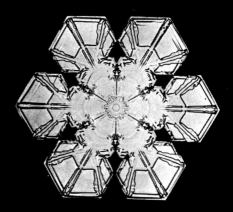 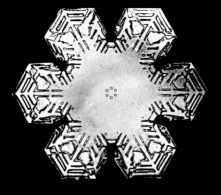

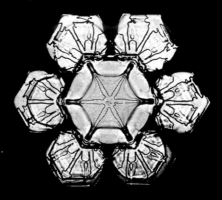 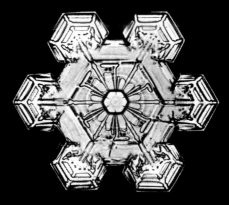 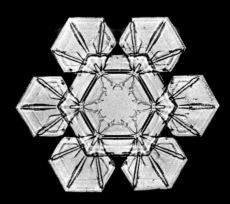

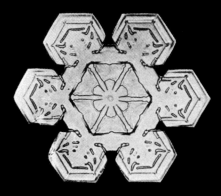
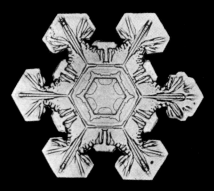
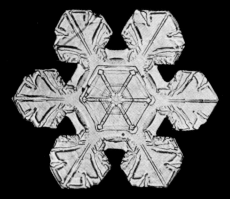
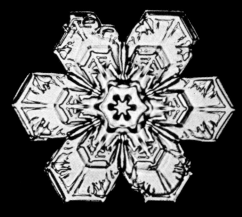
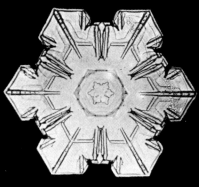
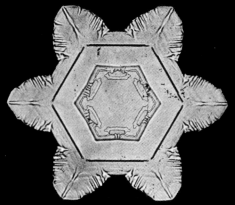
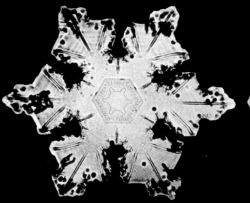
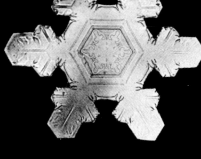
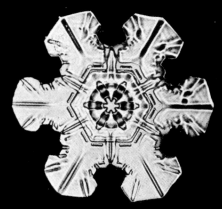
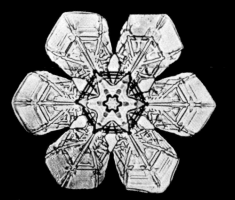
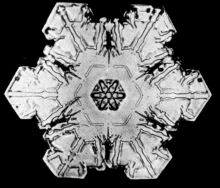

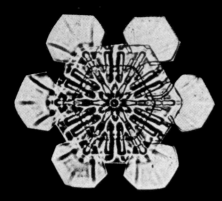 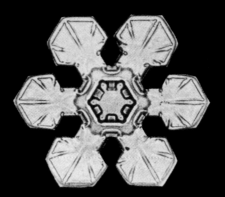 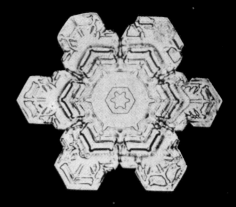

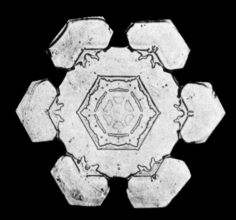 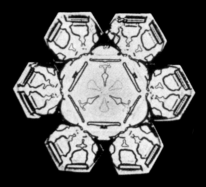 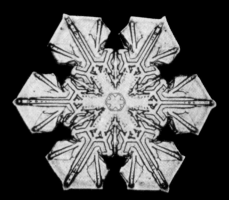

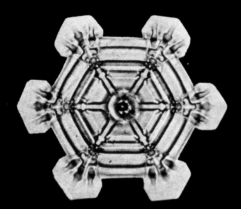 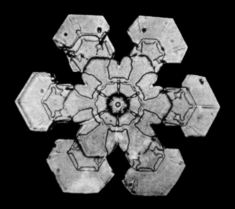 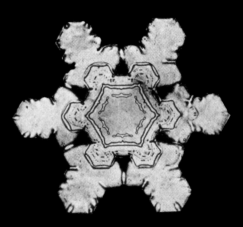

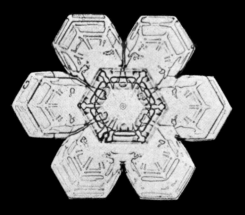 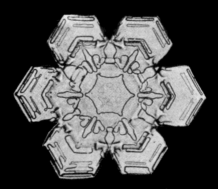 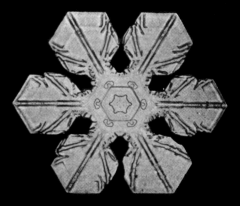

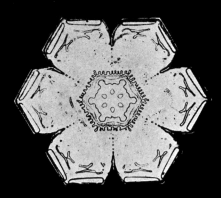
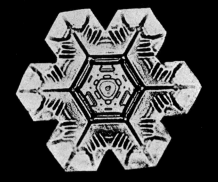
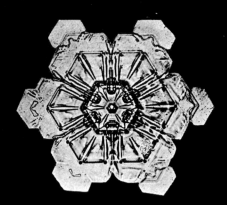
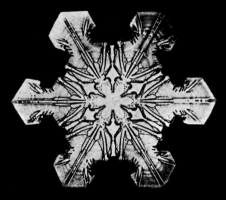
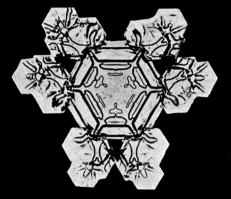
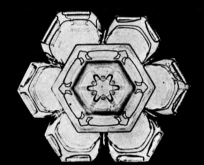
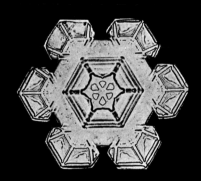
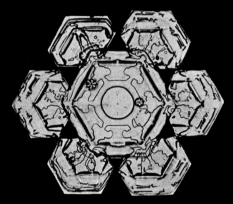
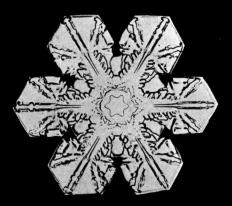
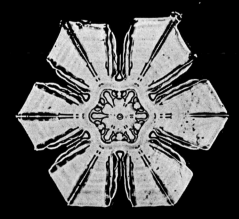
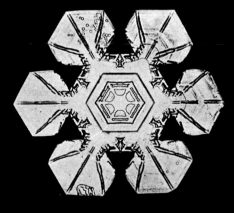

91

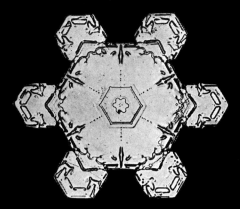 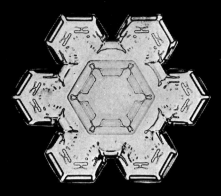 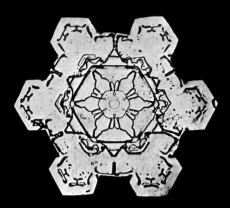

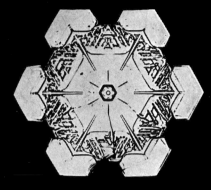 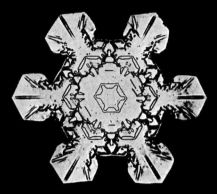 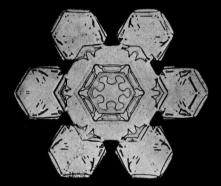

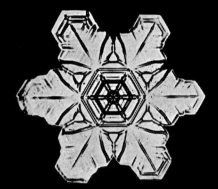 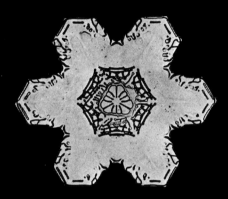 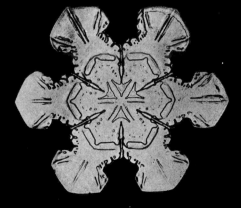

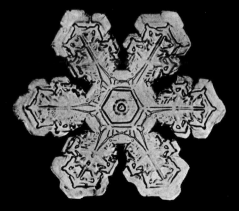 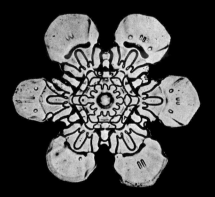 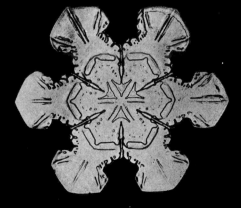

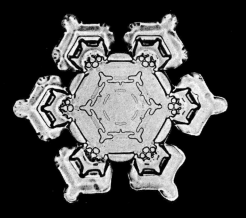
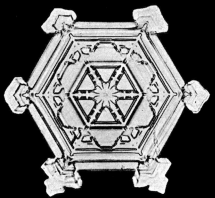
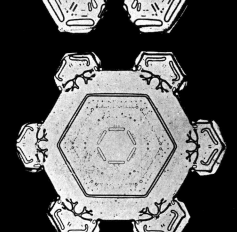
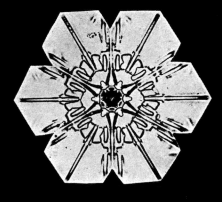
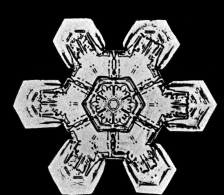
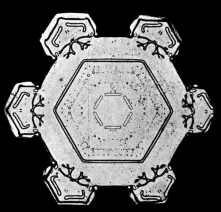
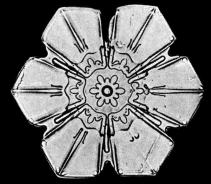
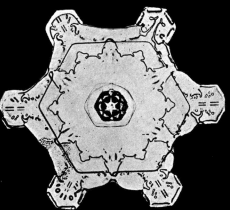
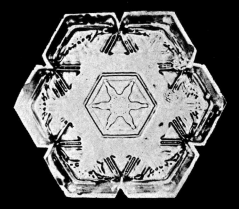
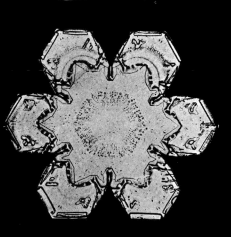
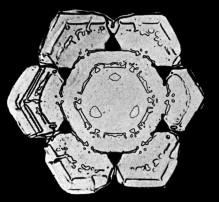

93

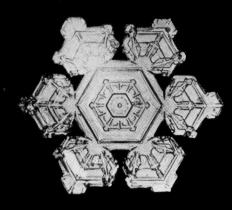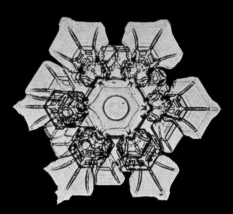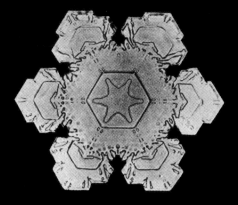

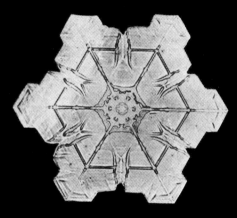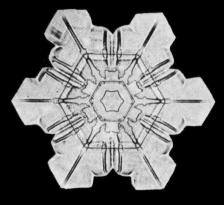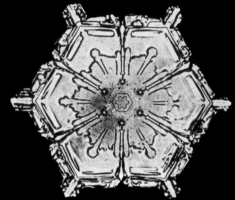

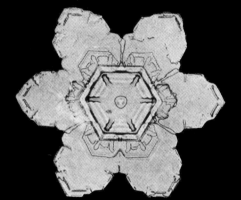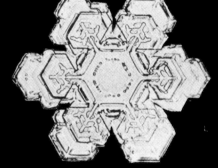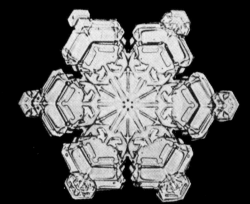

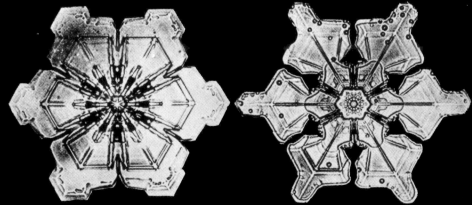

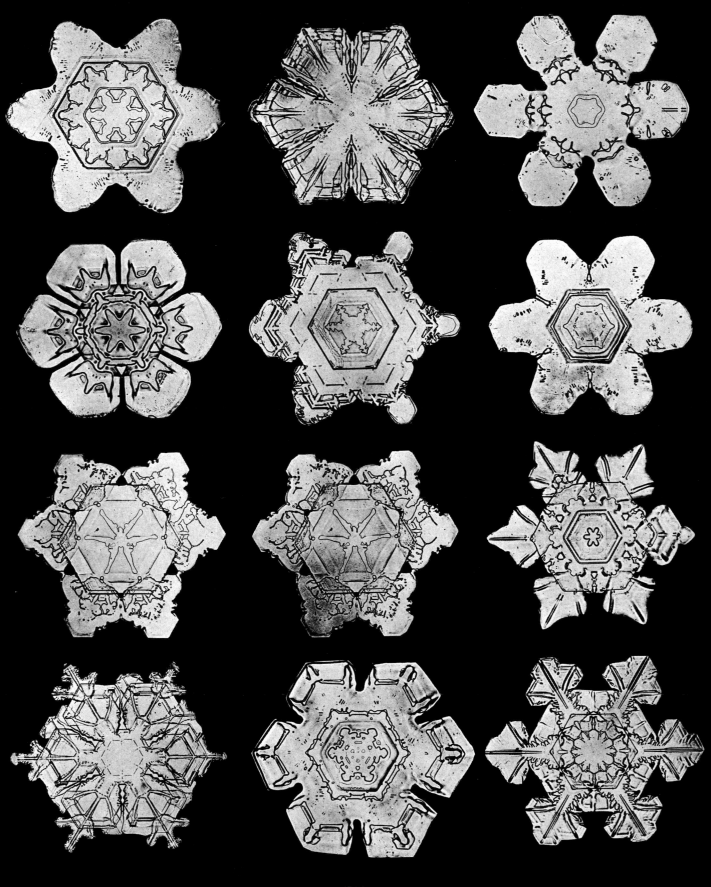

95

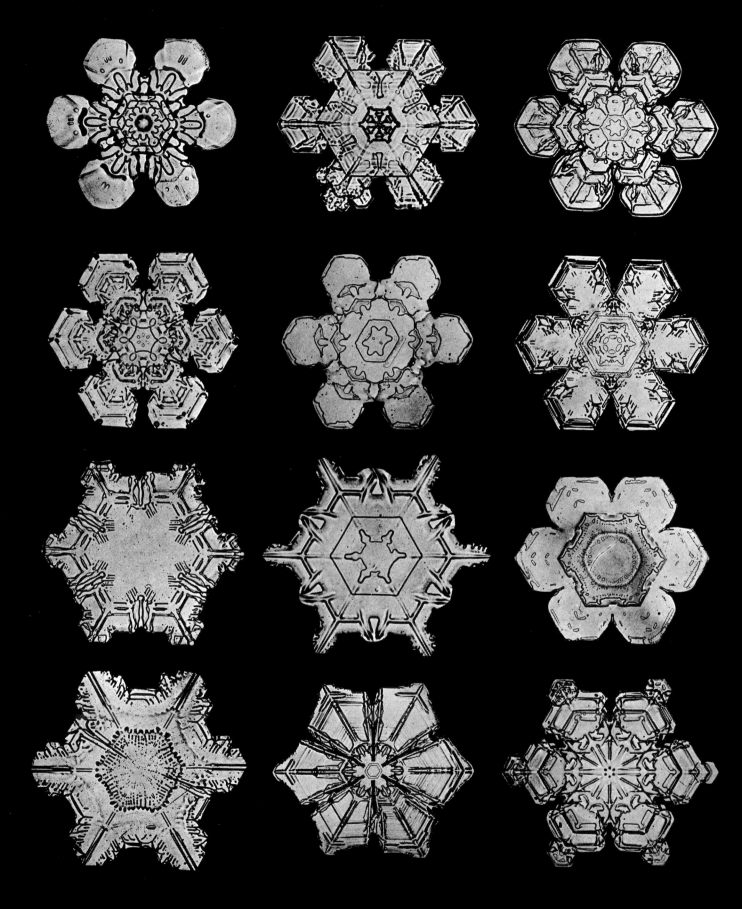

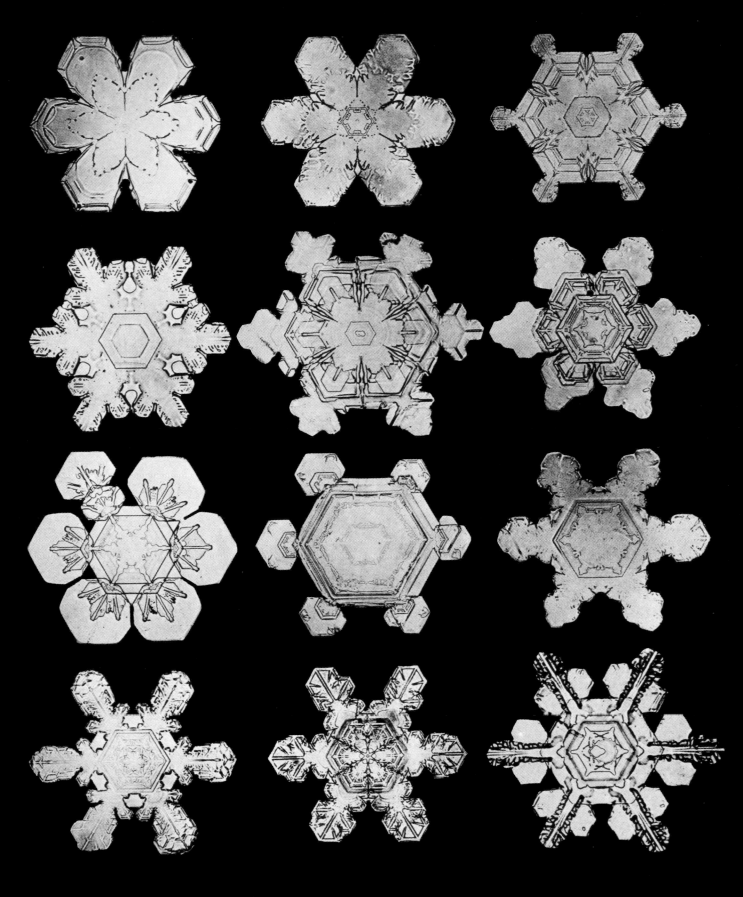

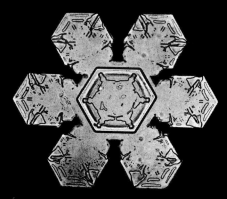
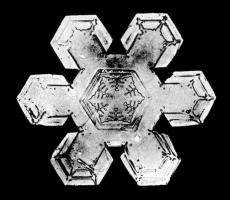
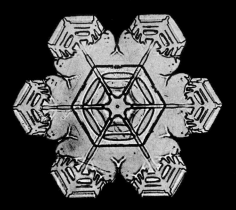
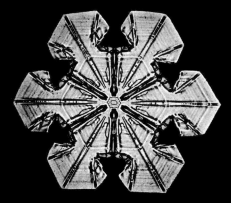
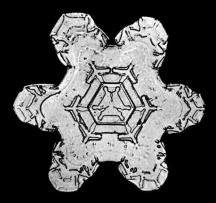
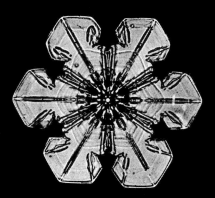
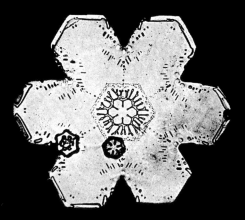
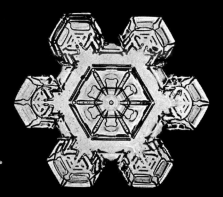
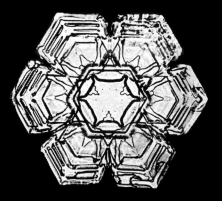
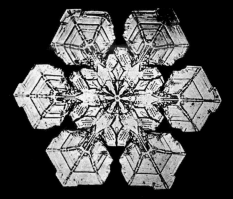

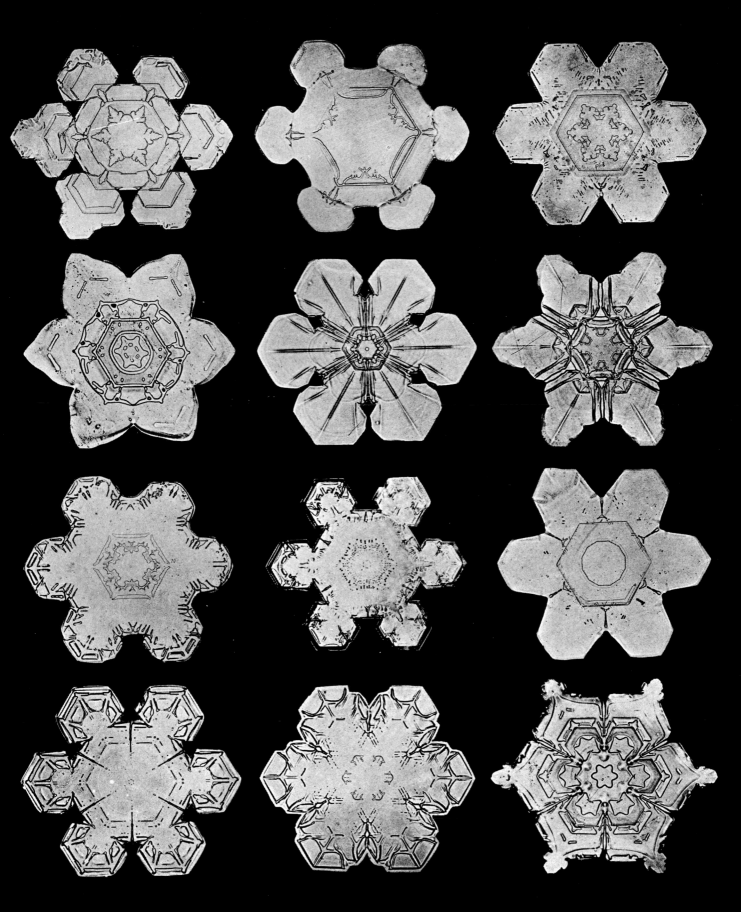

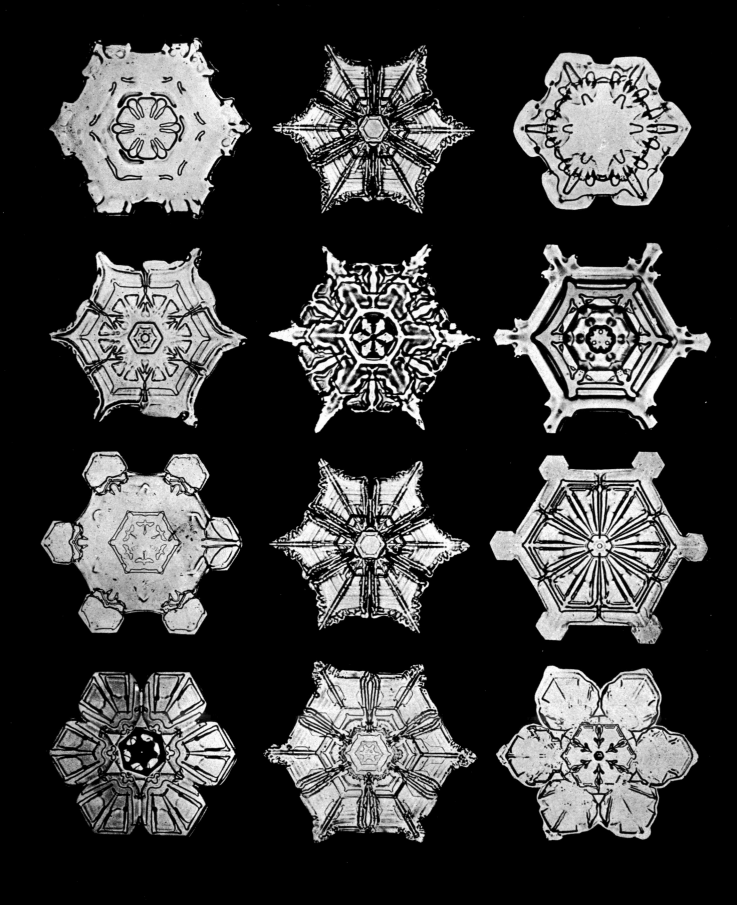

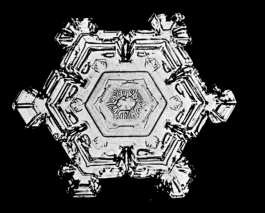
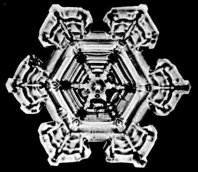
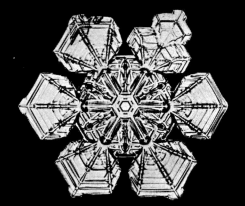

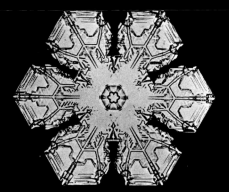
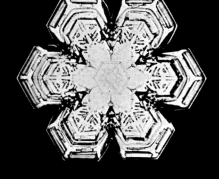
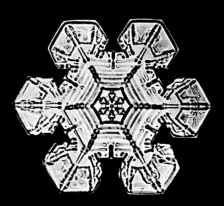

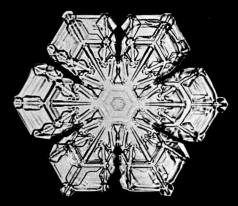
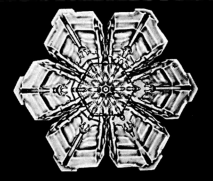
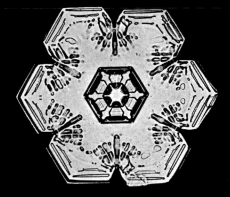

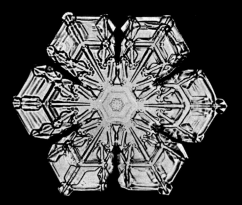
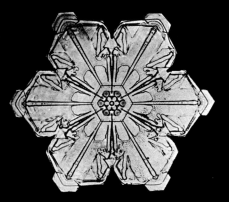
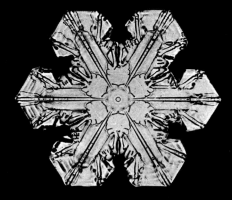

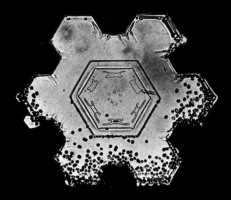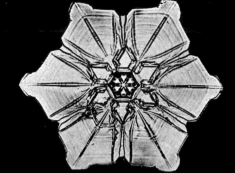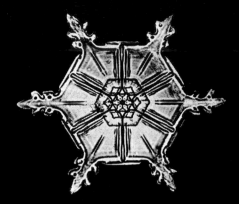

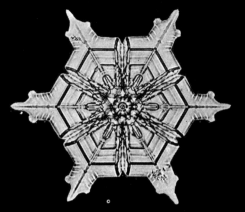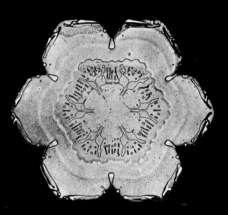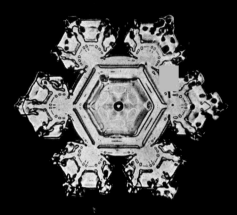

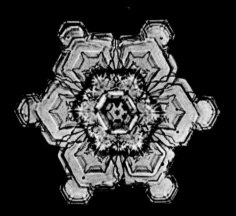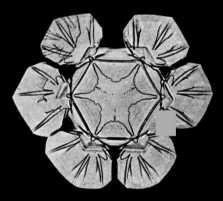

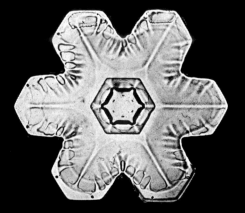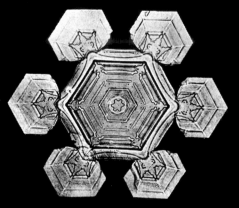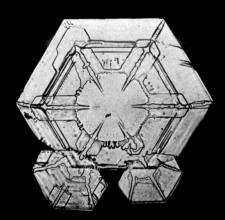

102

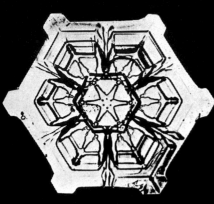
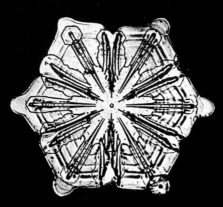
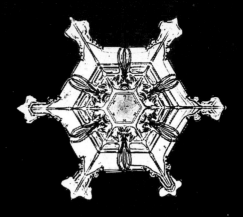
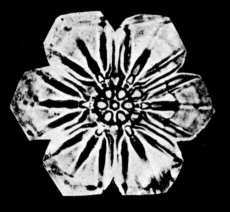
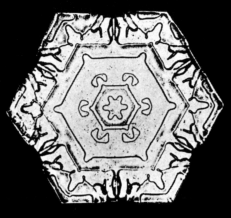
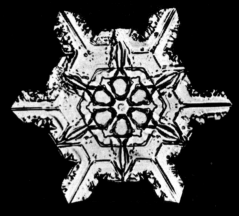
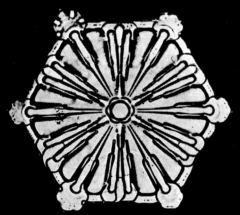
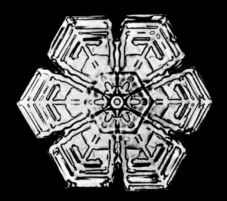
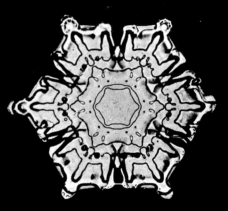
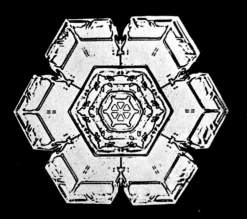
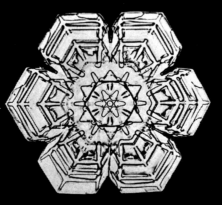
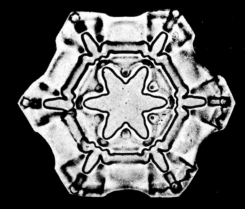

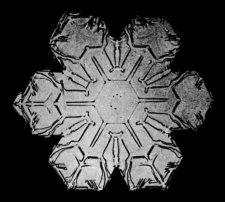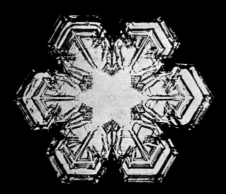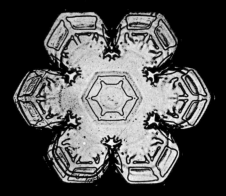
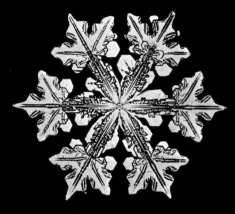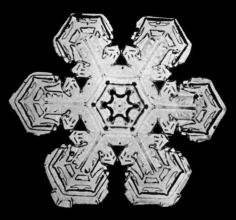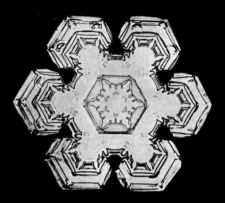
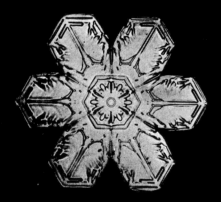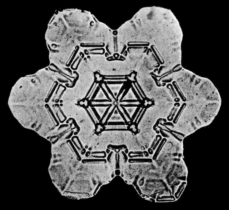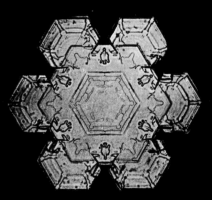
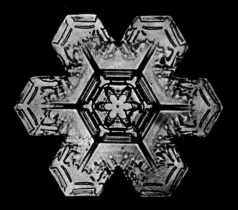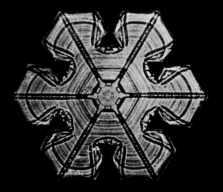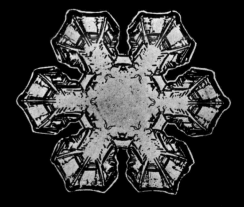

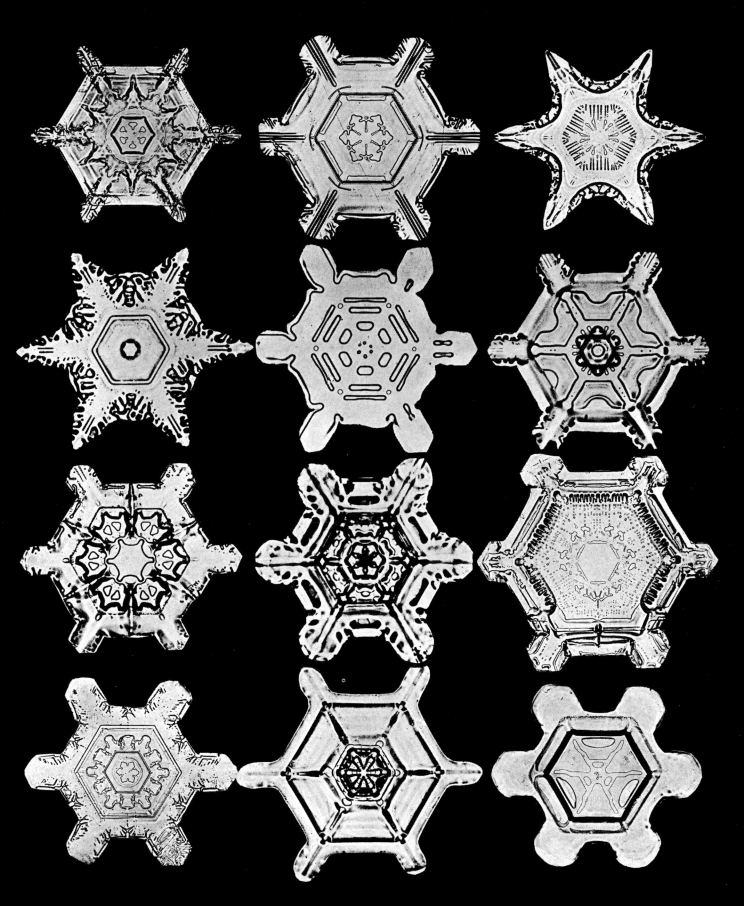

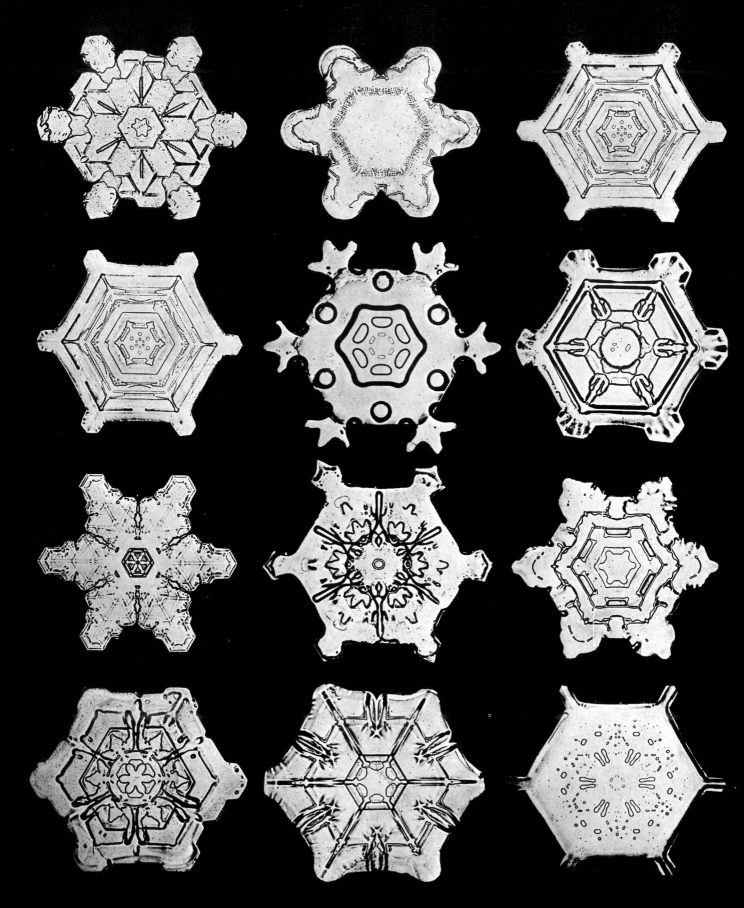

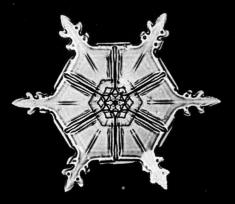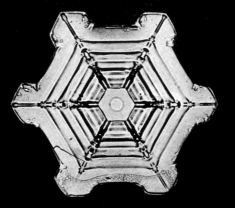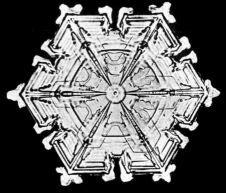

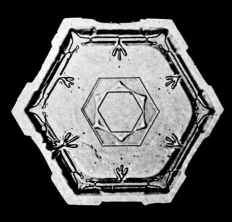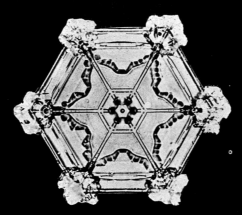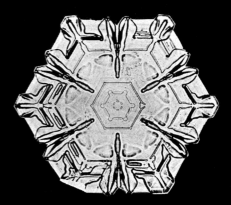

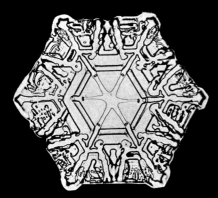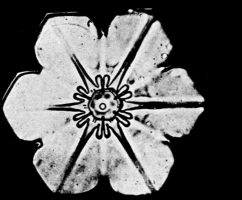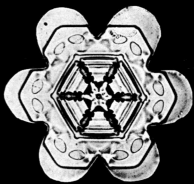

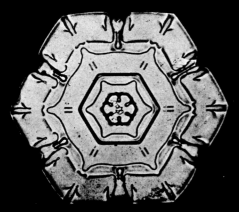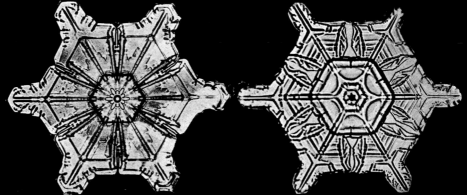

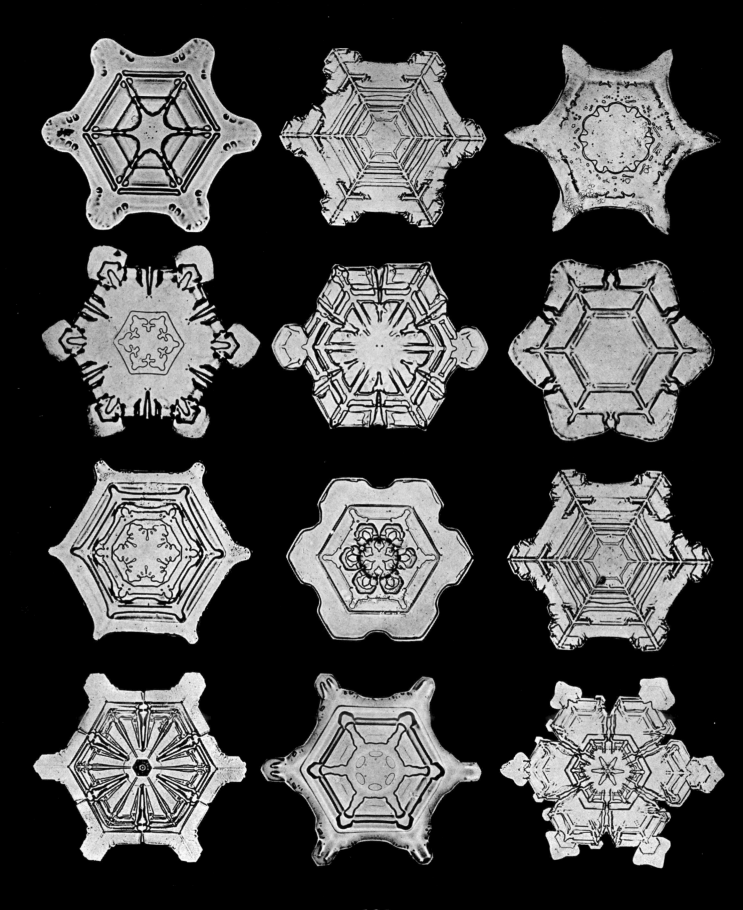

108

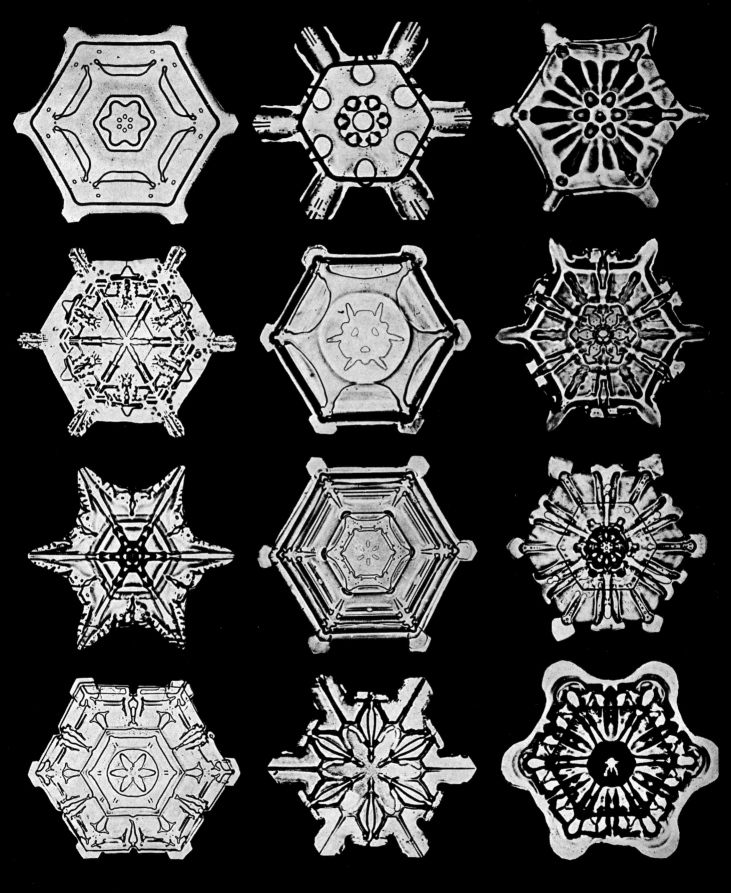

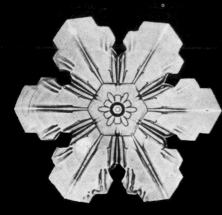 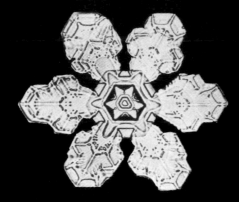 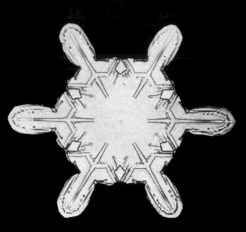

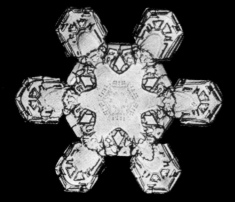 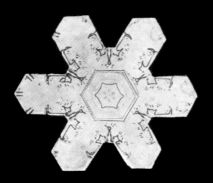 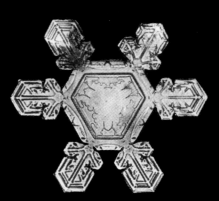

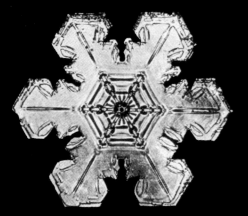 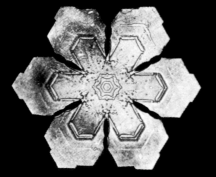 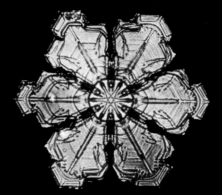

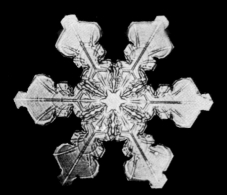 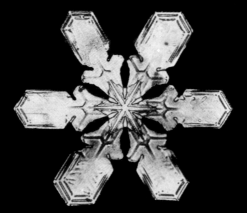 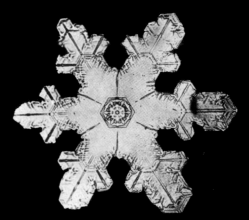

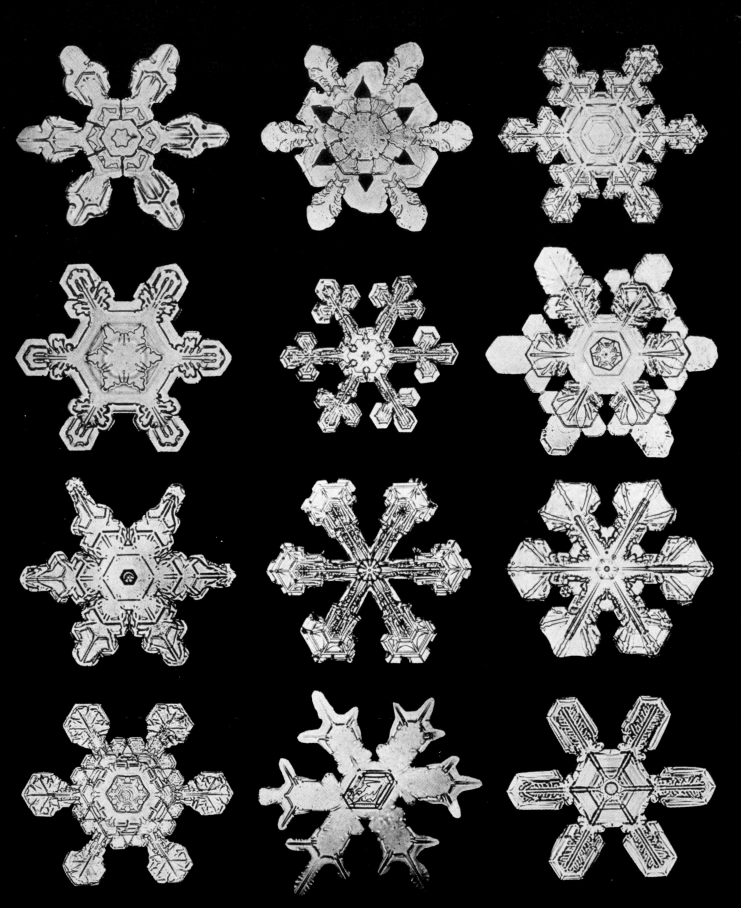

111

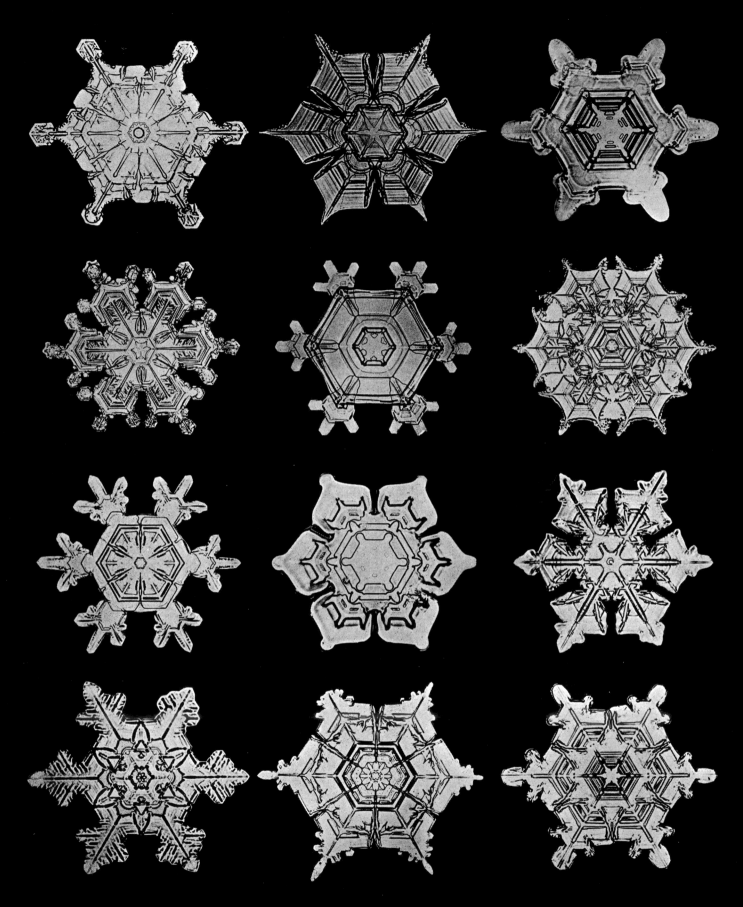

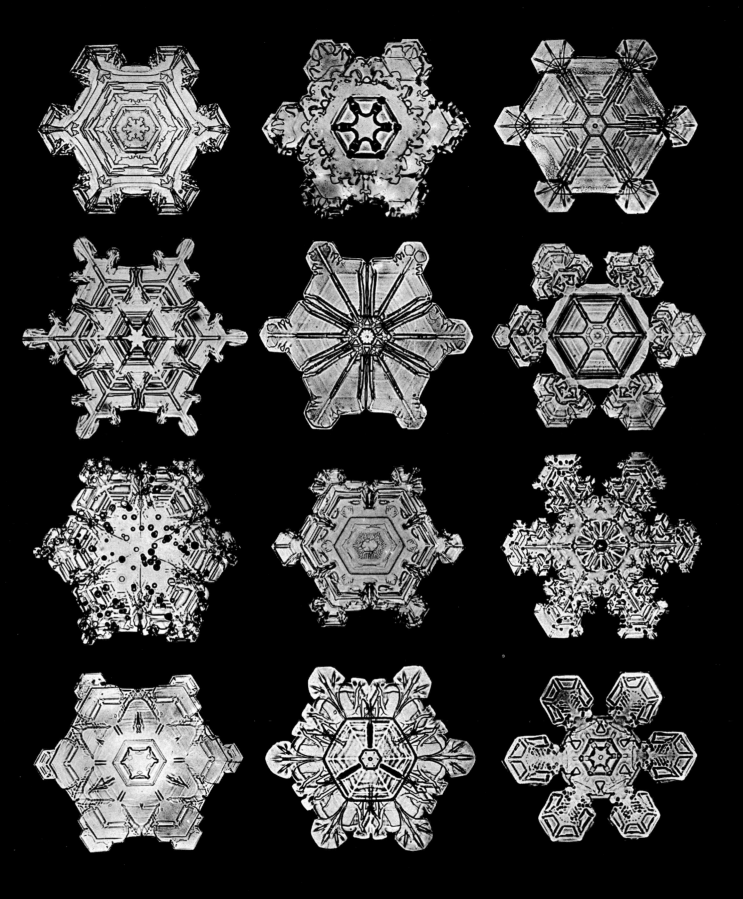

113

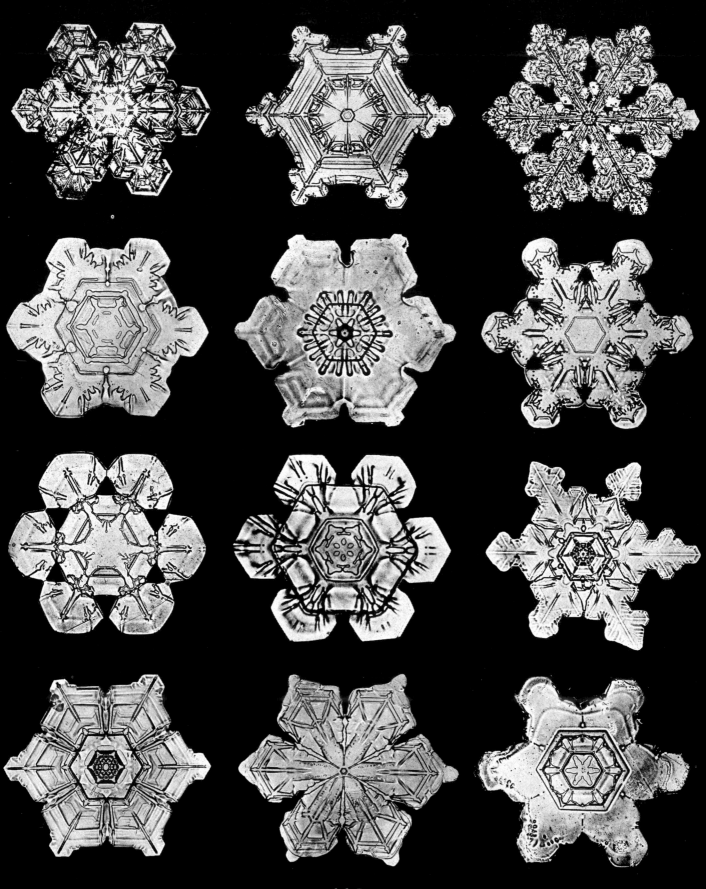

114

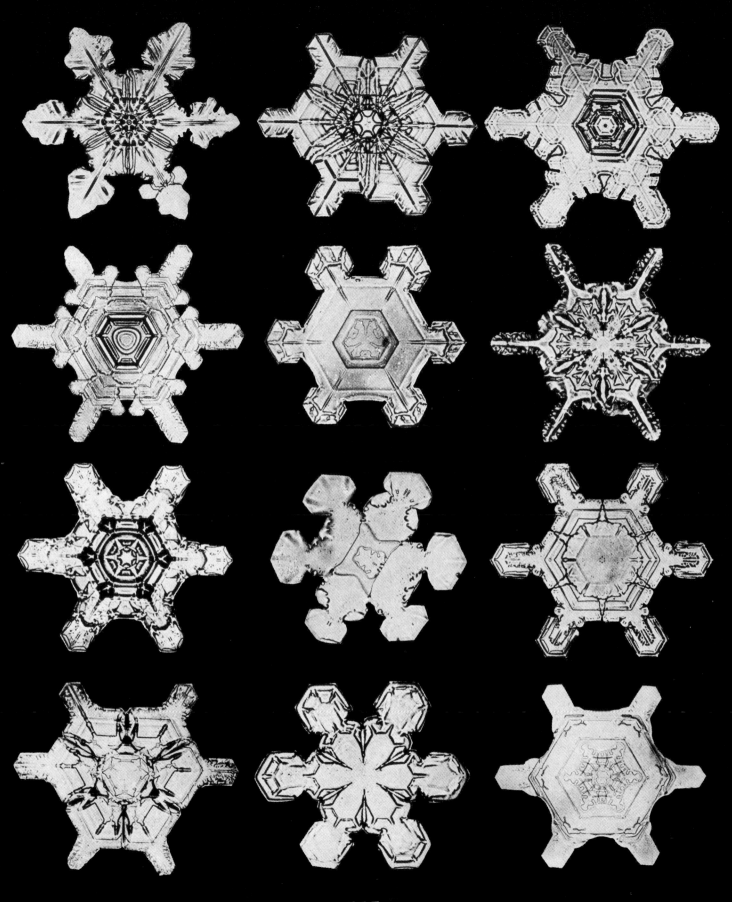

115

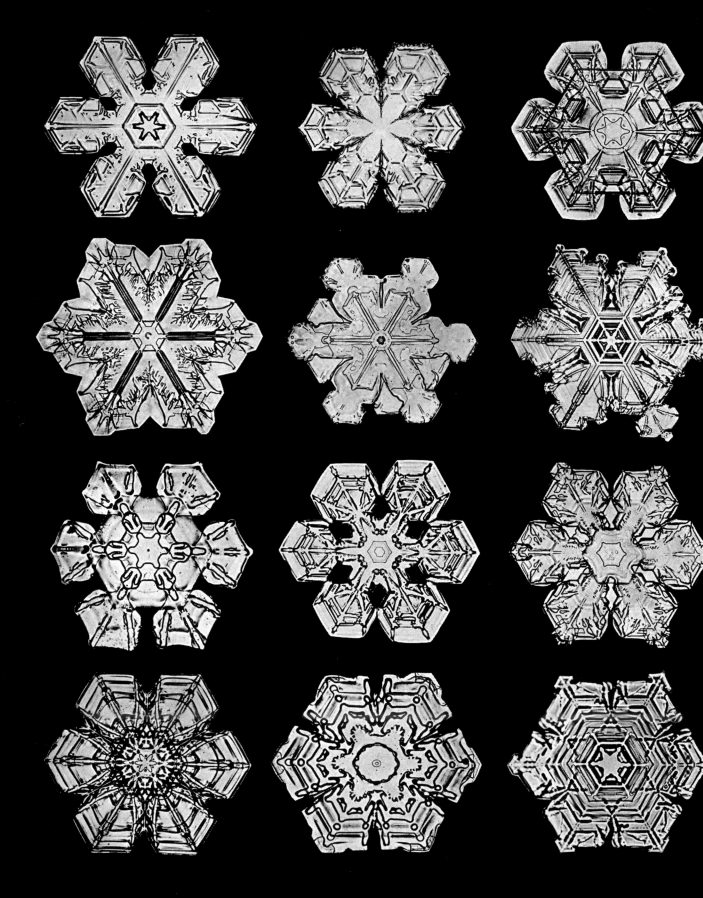

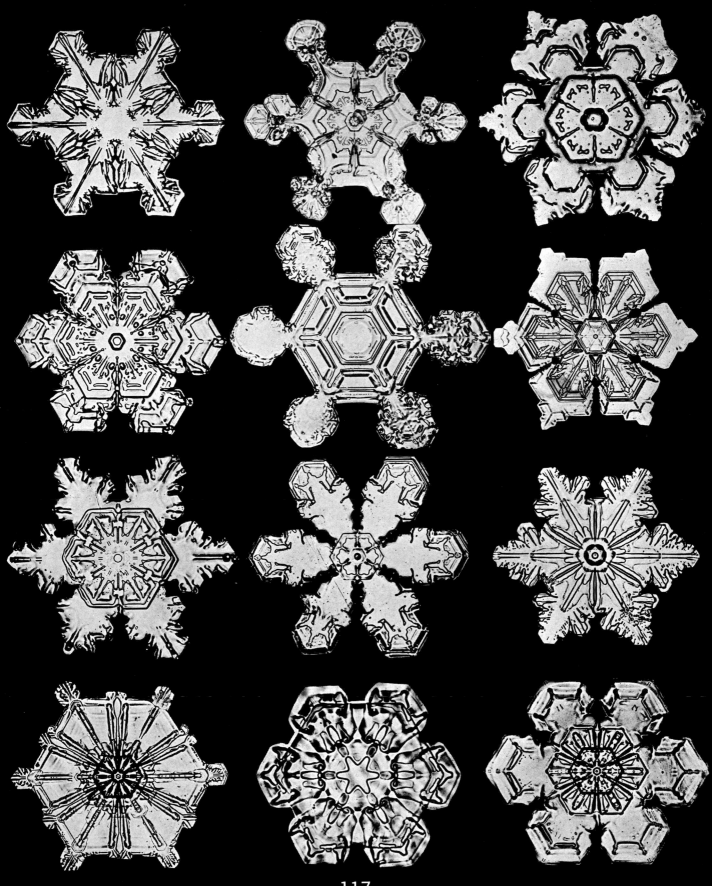

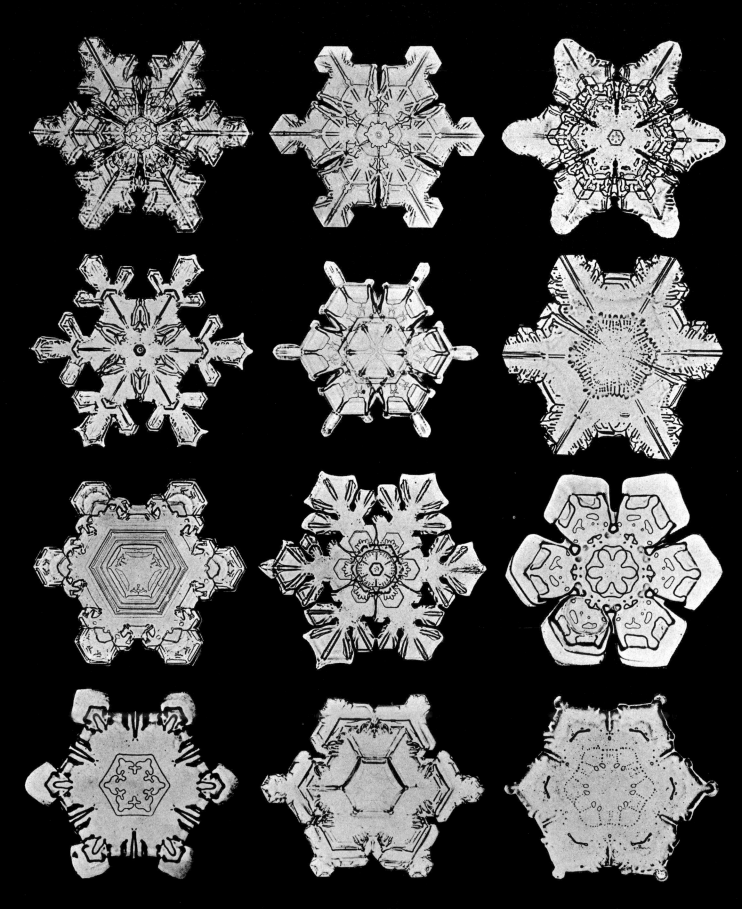

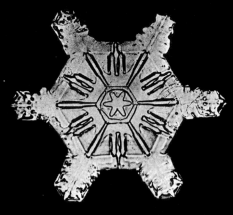
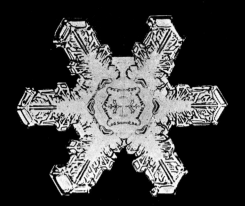
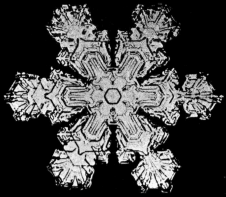
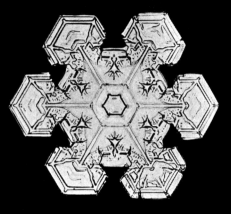
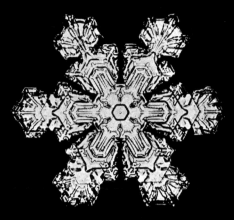
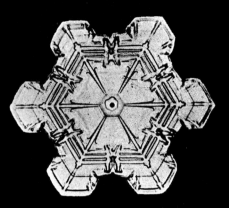
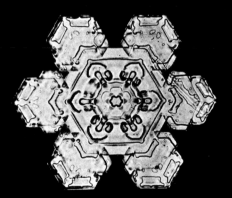
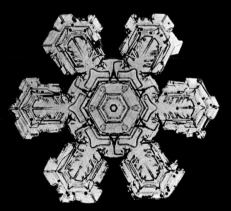
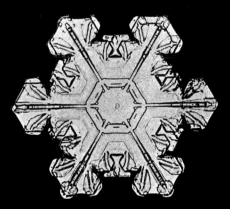
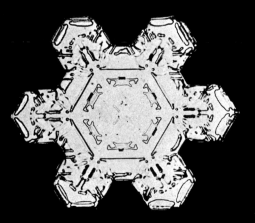
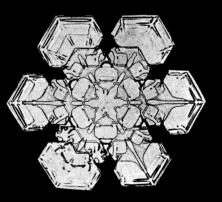
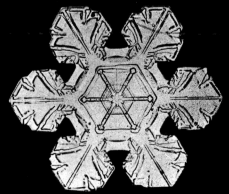

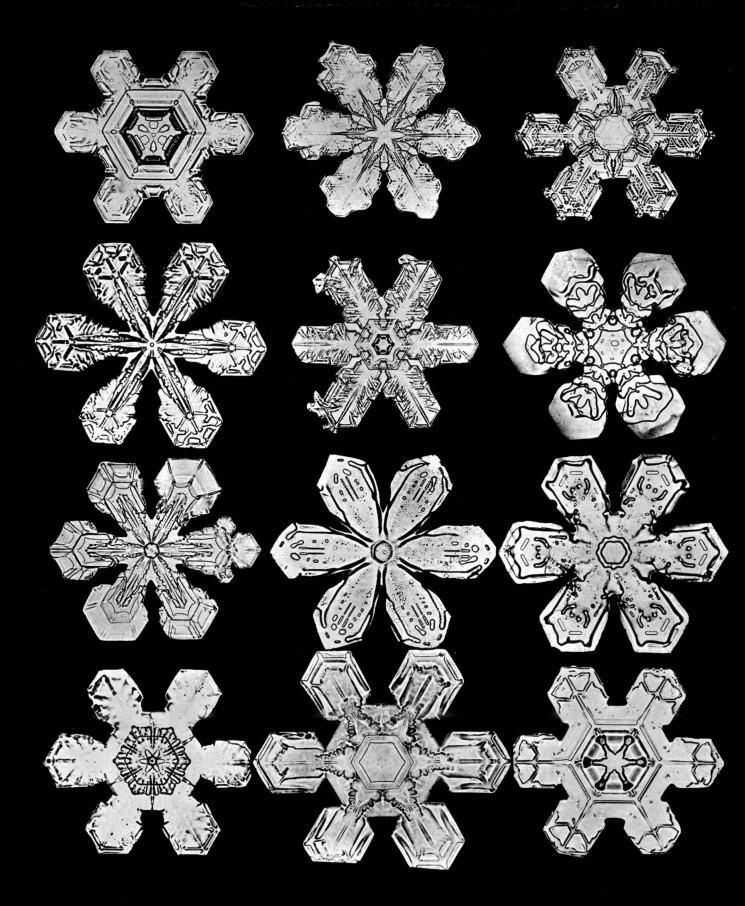

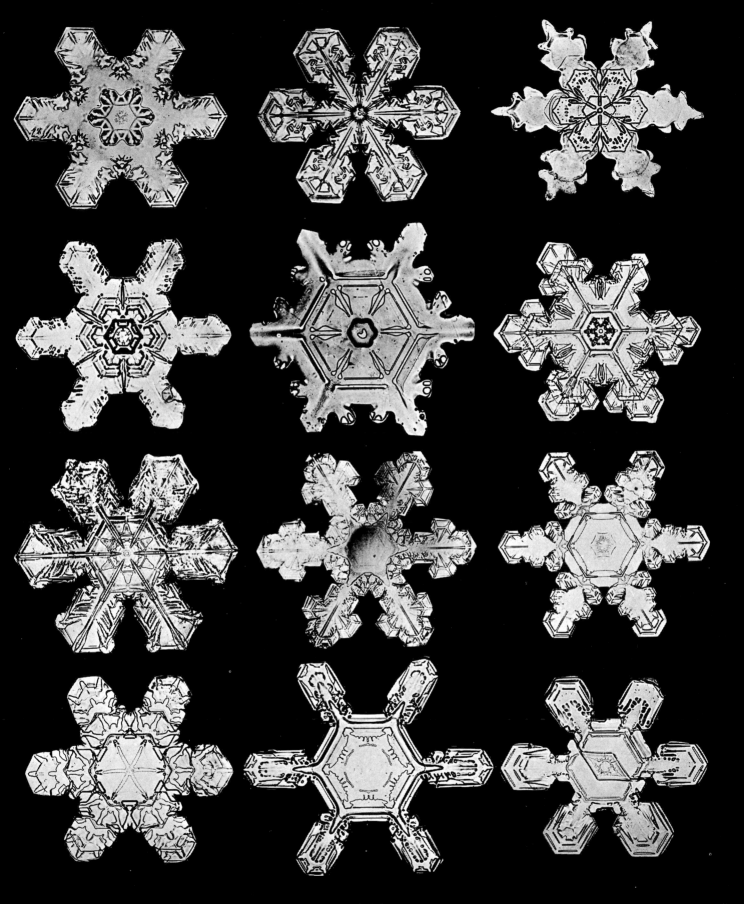

121

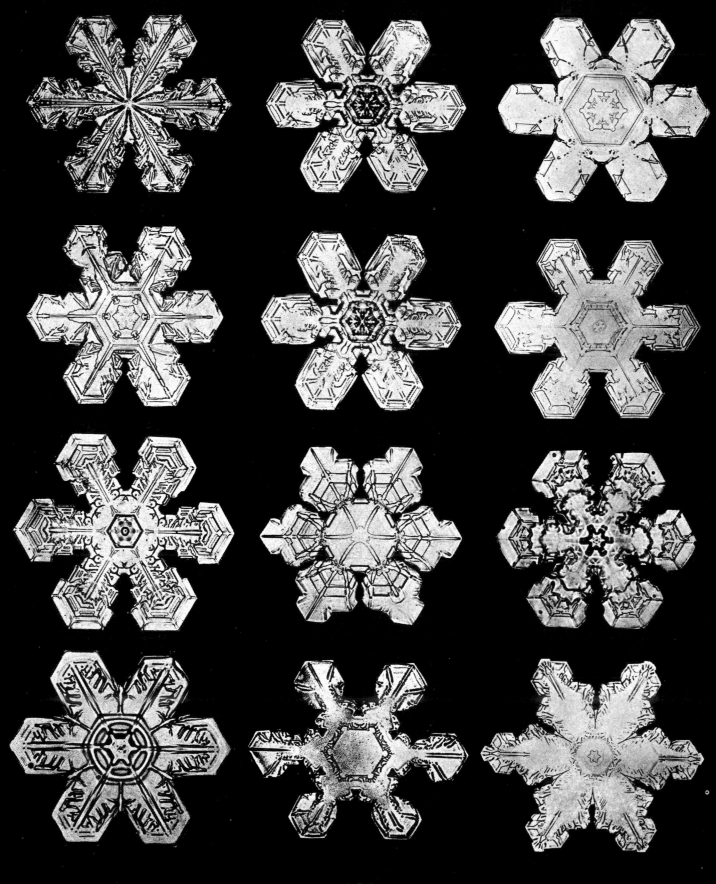

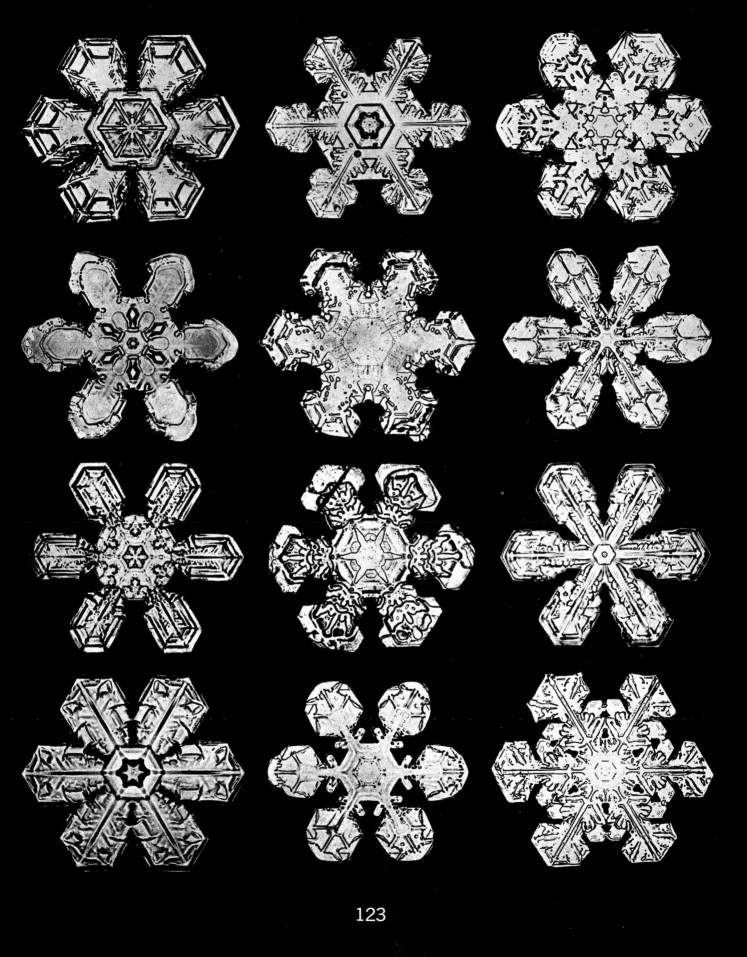

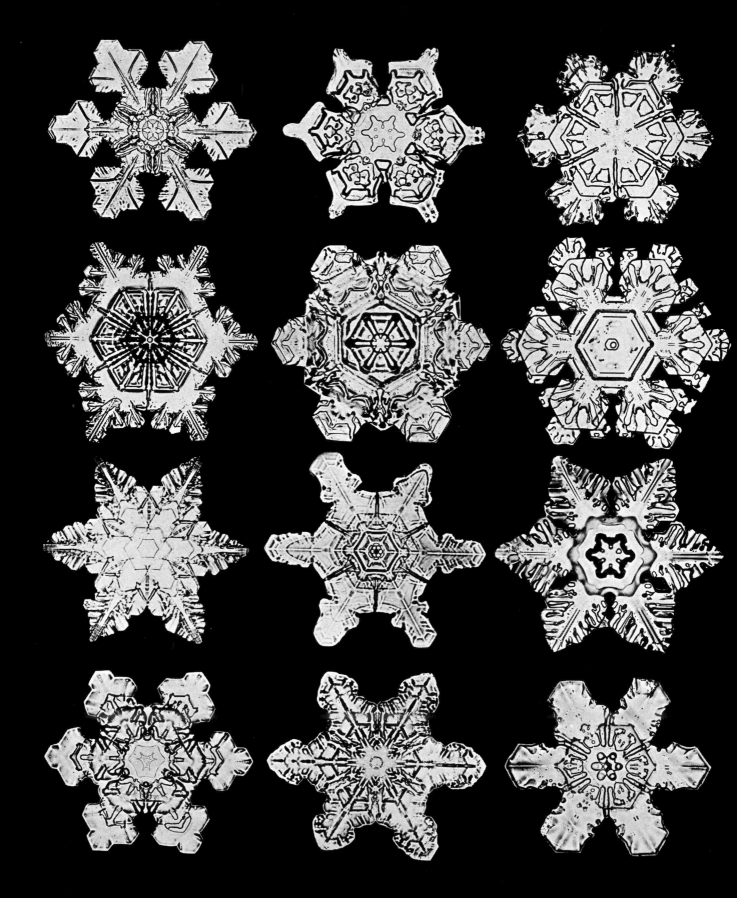

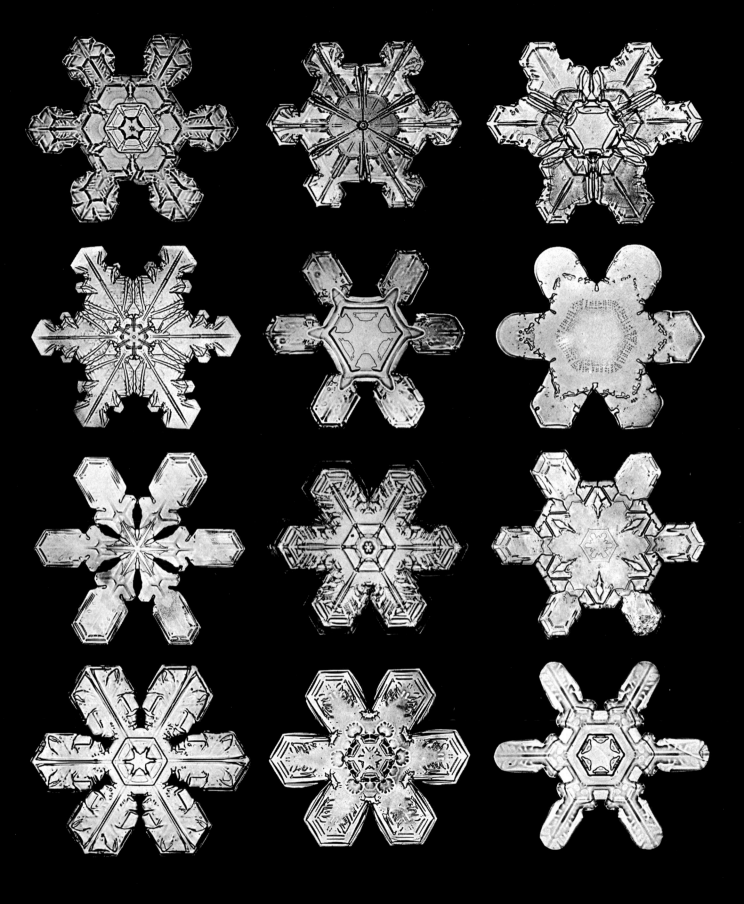

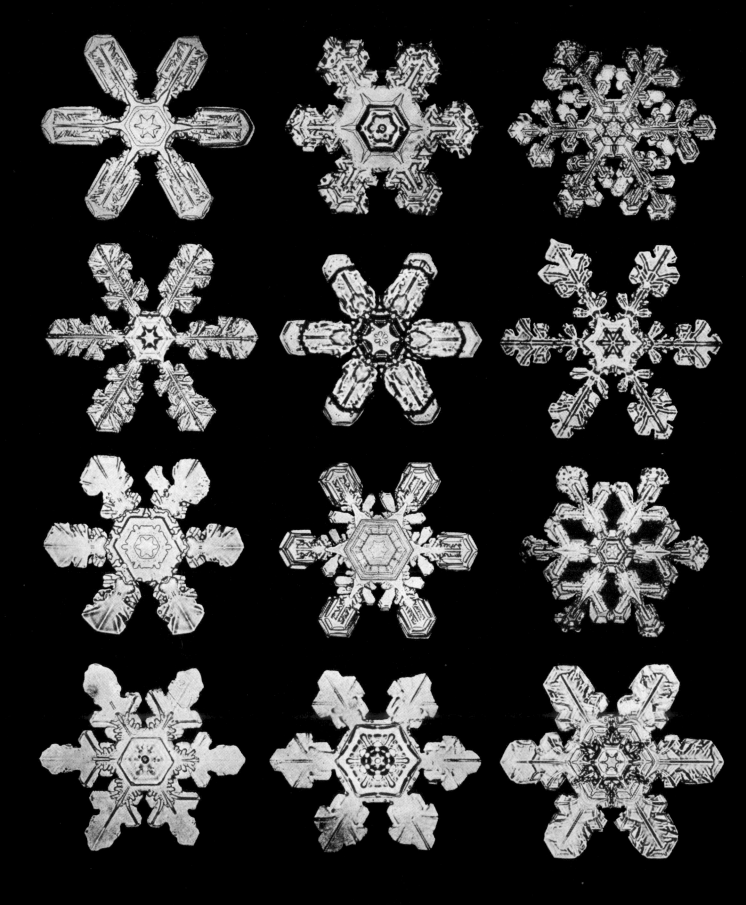

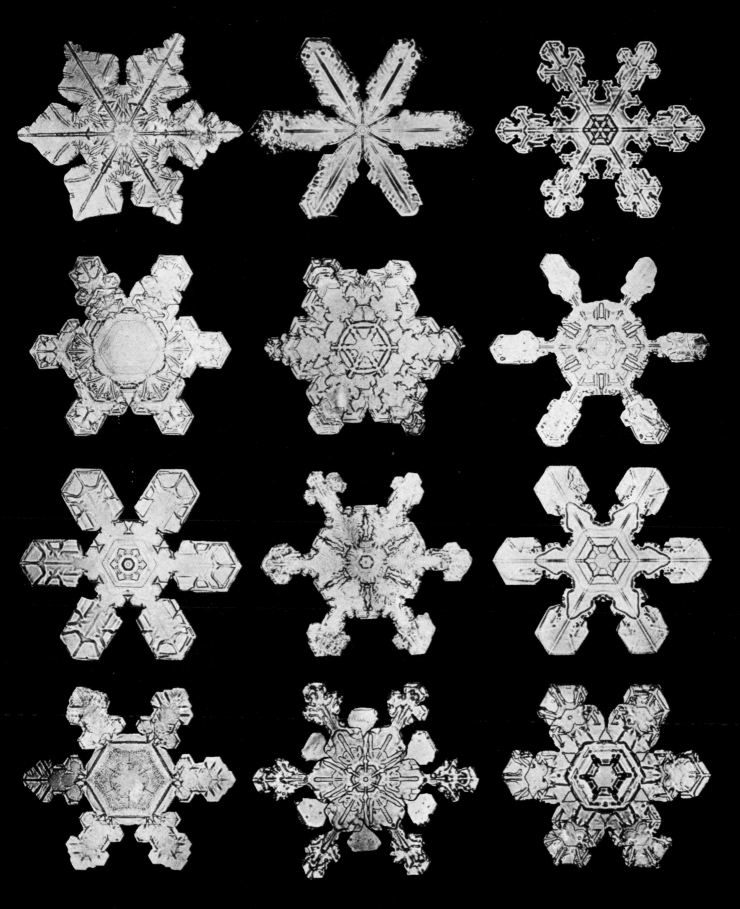

127

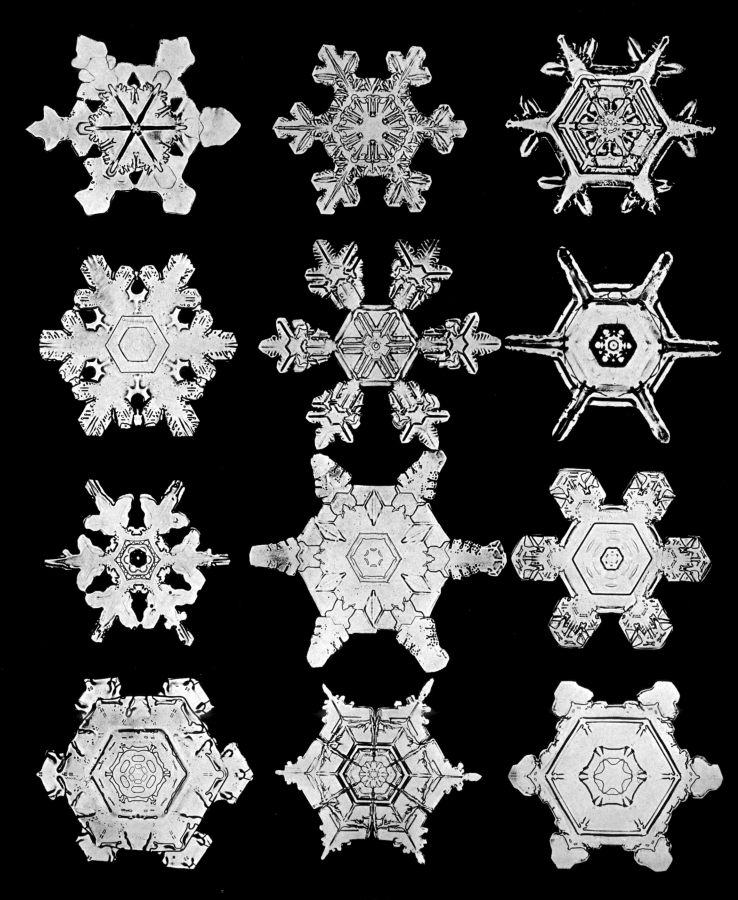

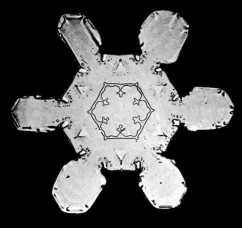
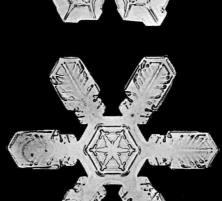
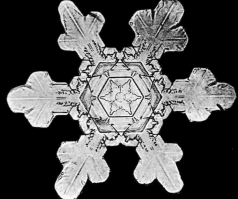

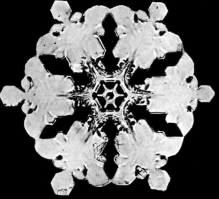
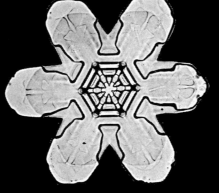
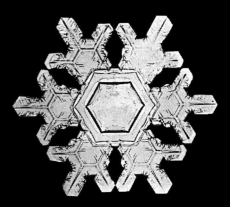

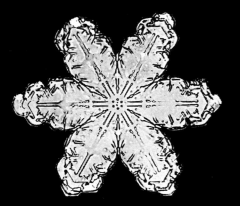
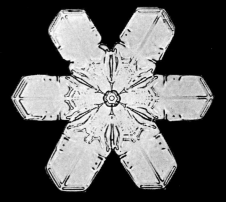

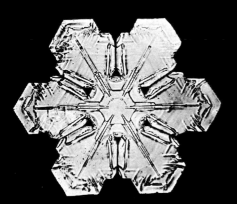
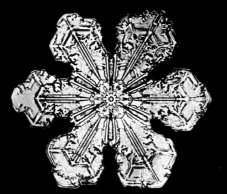
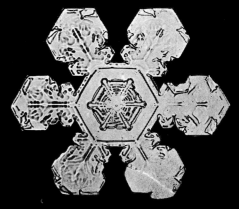

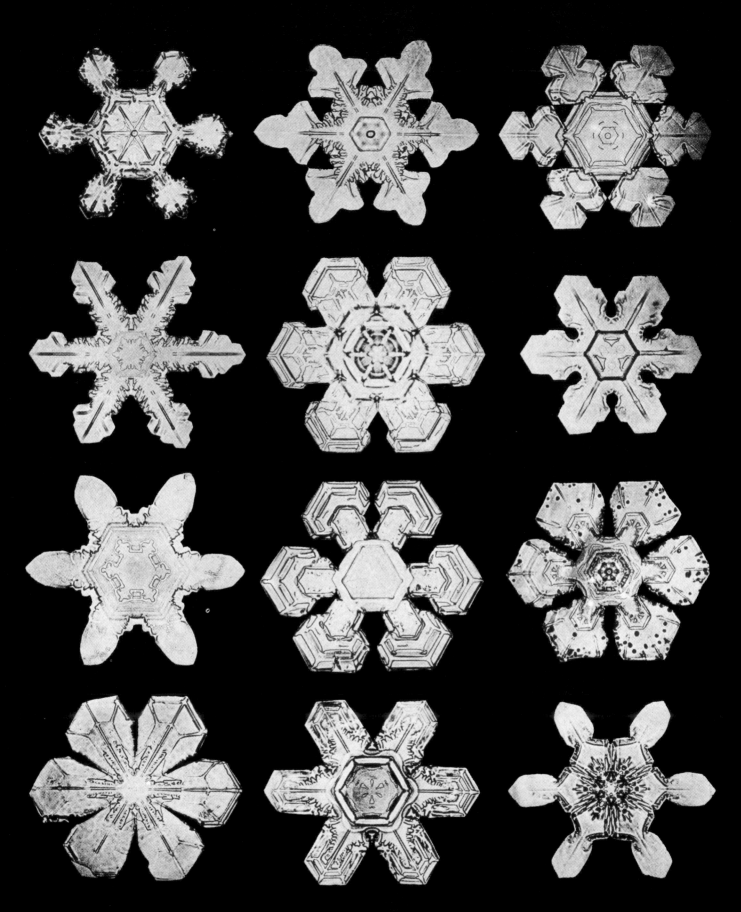

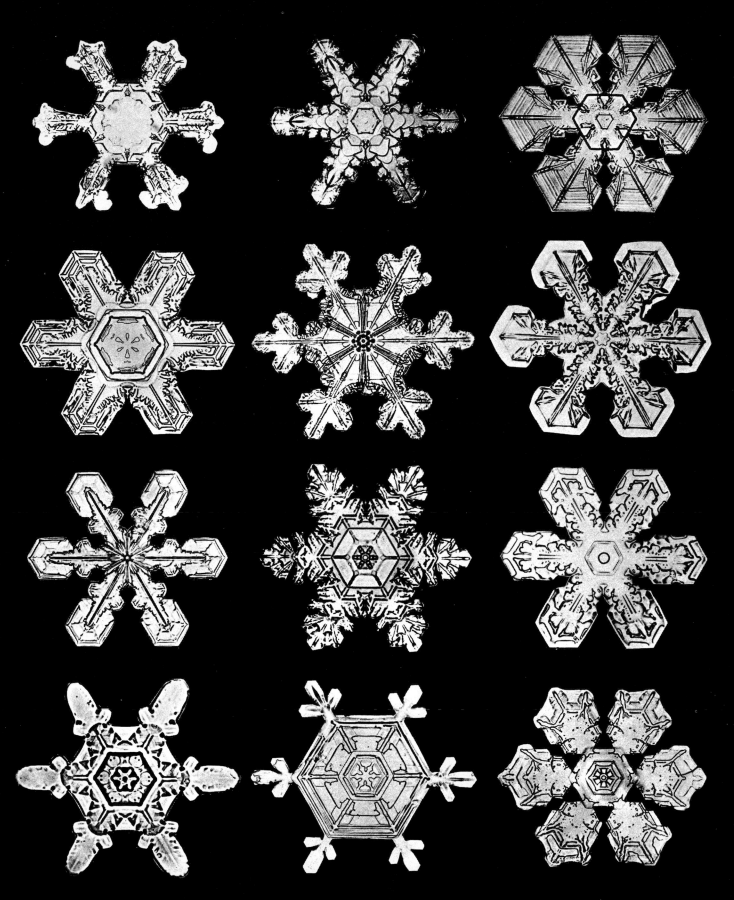

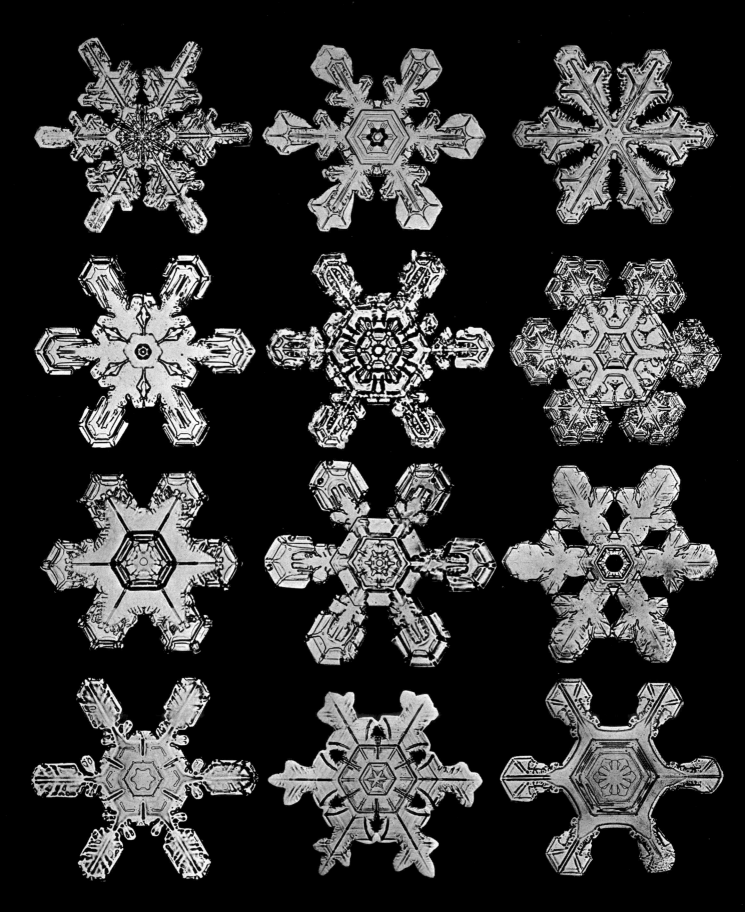

132

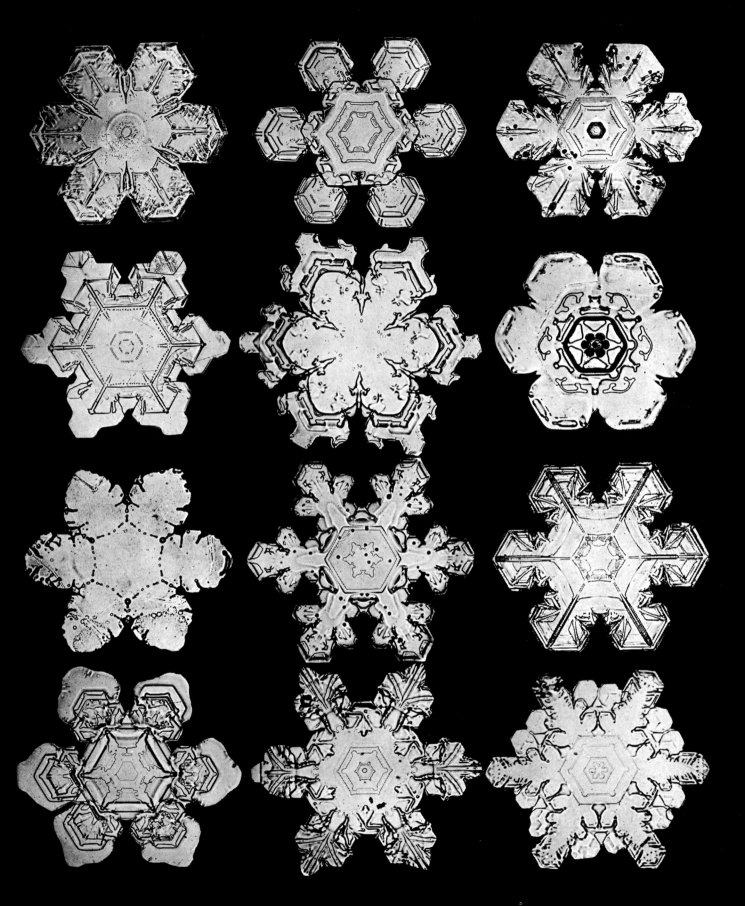

133

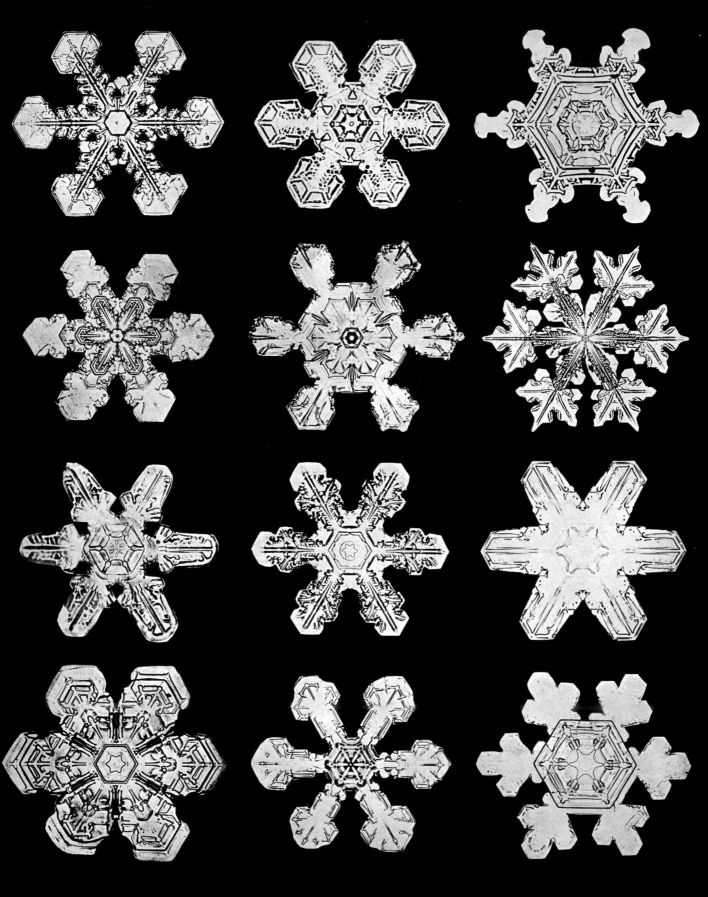

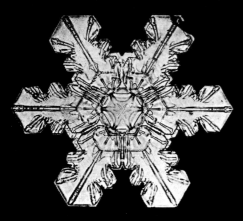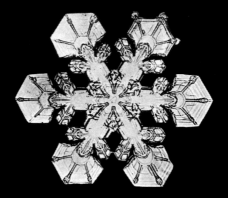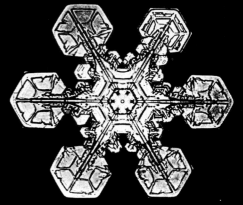

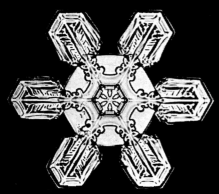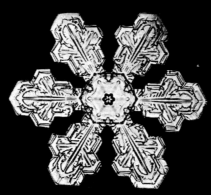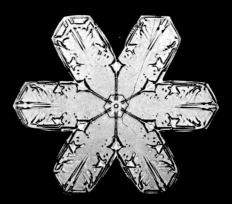

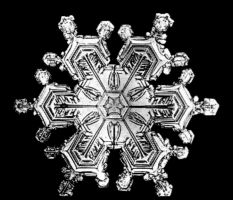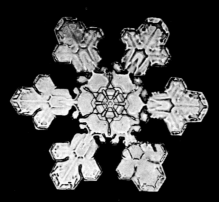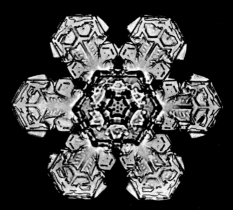

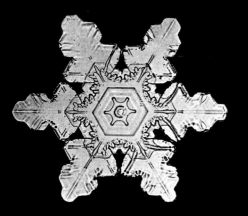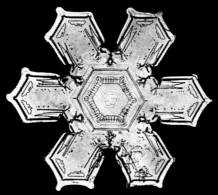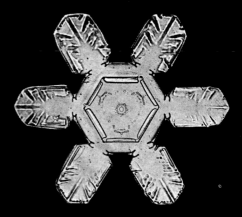

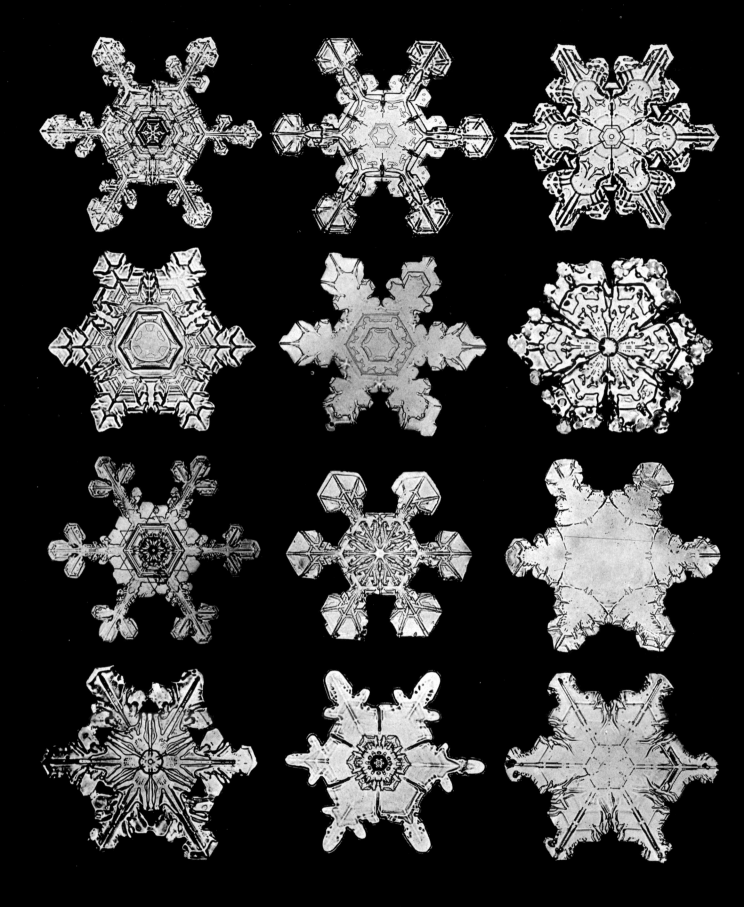

136

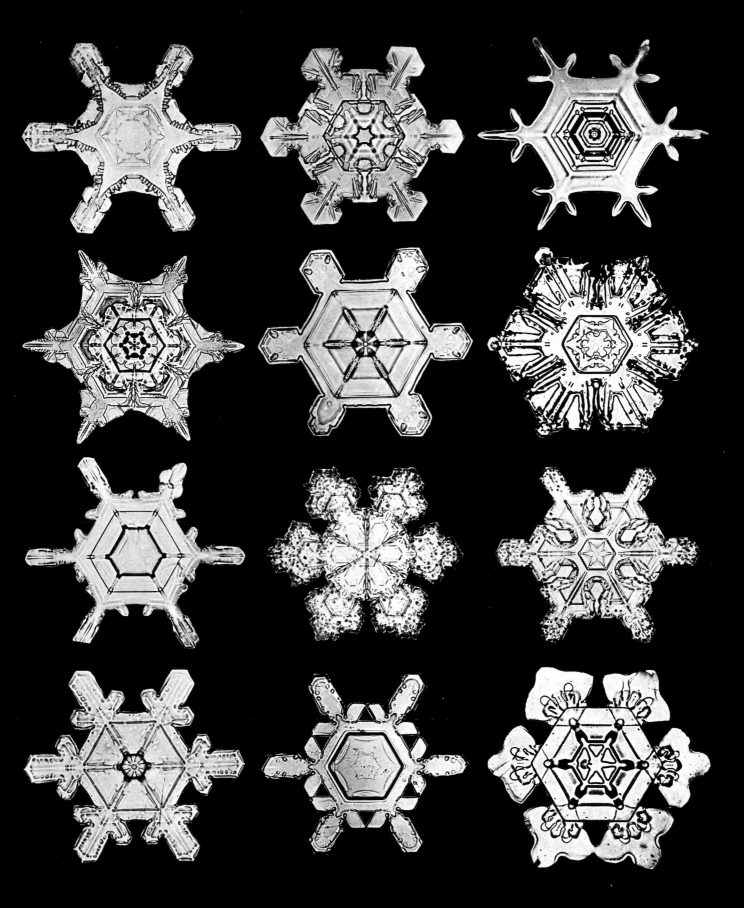

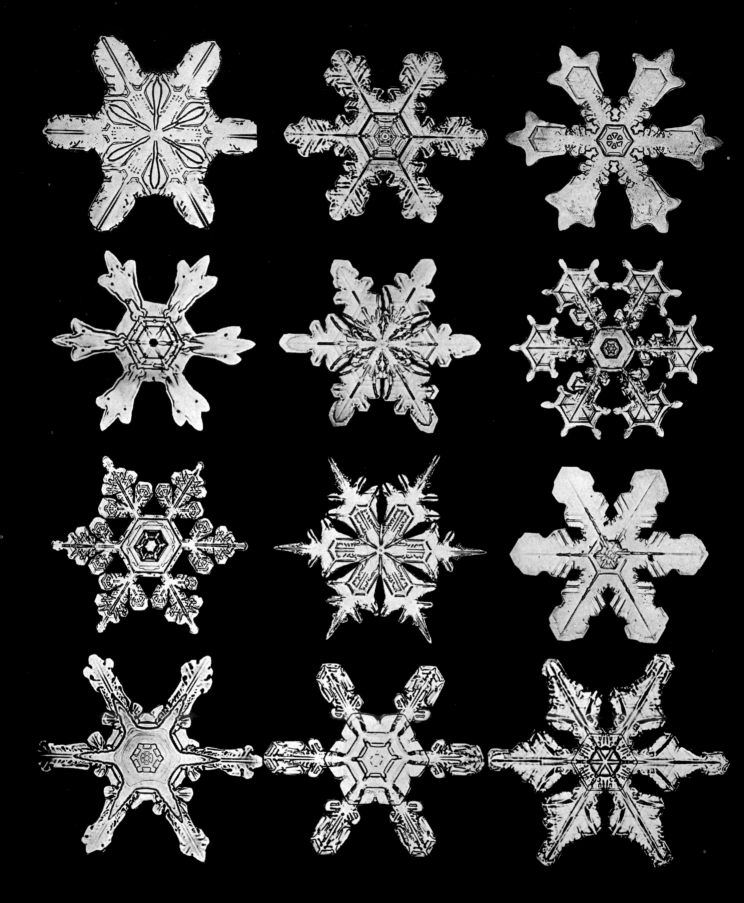

138

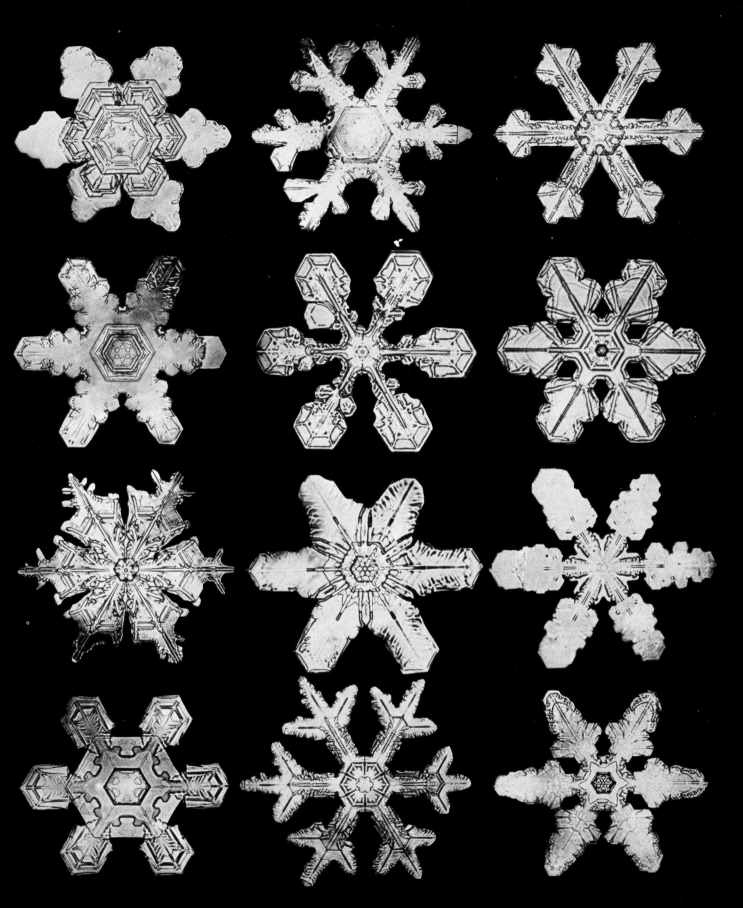

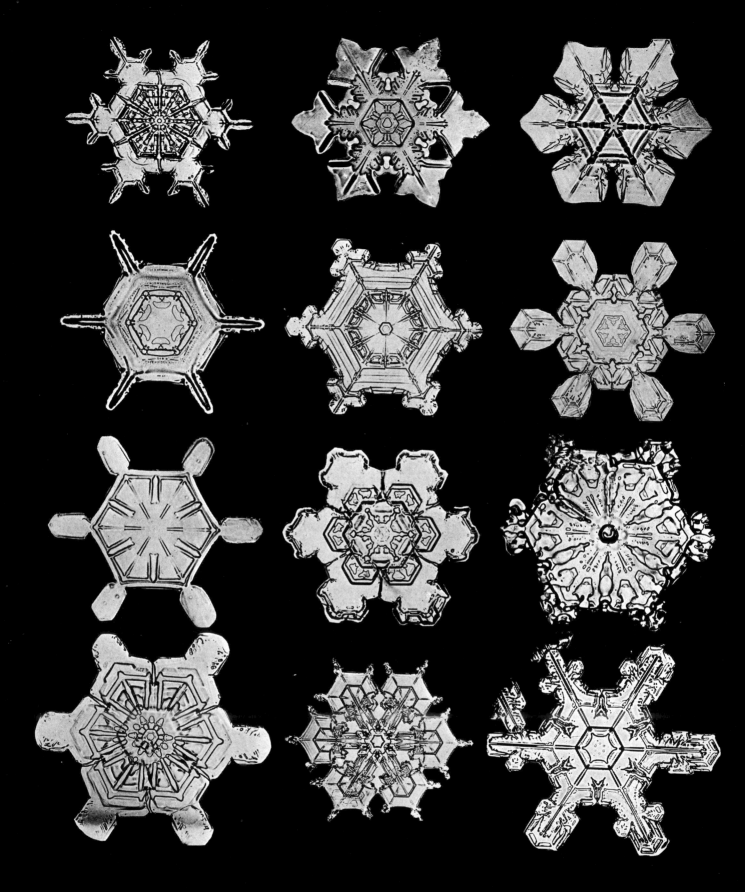

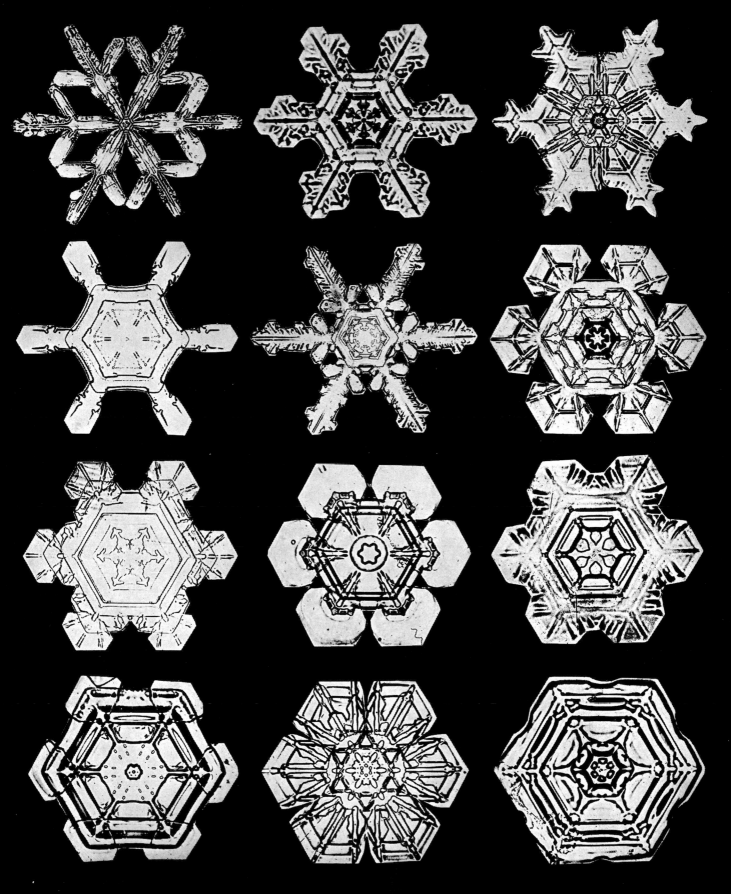

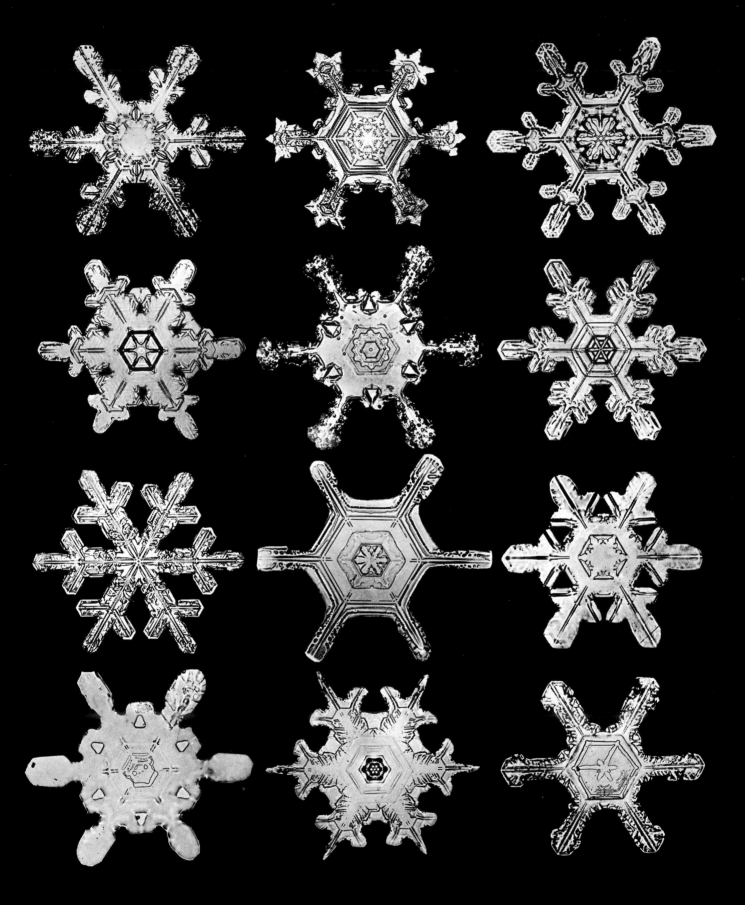

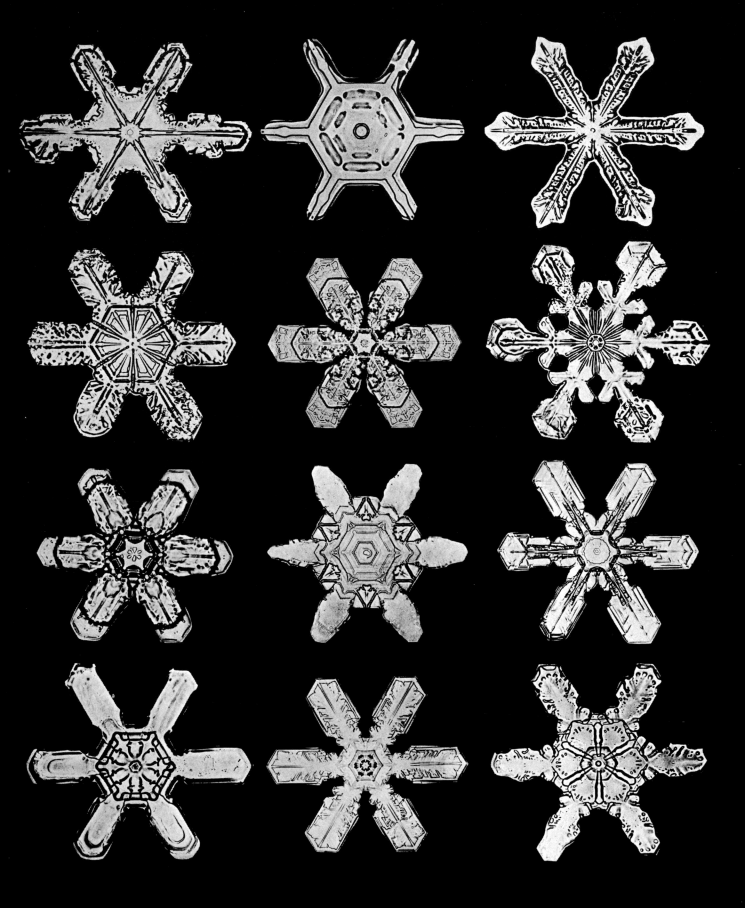

143

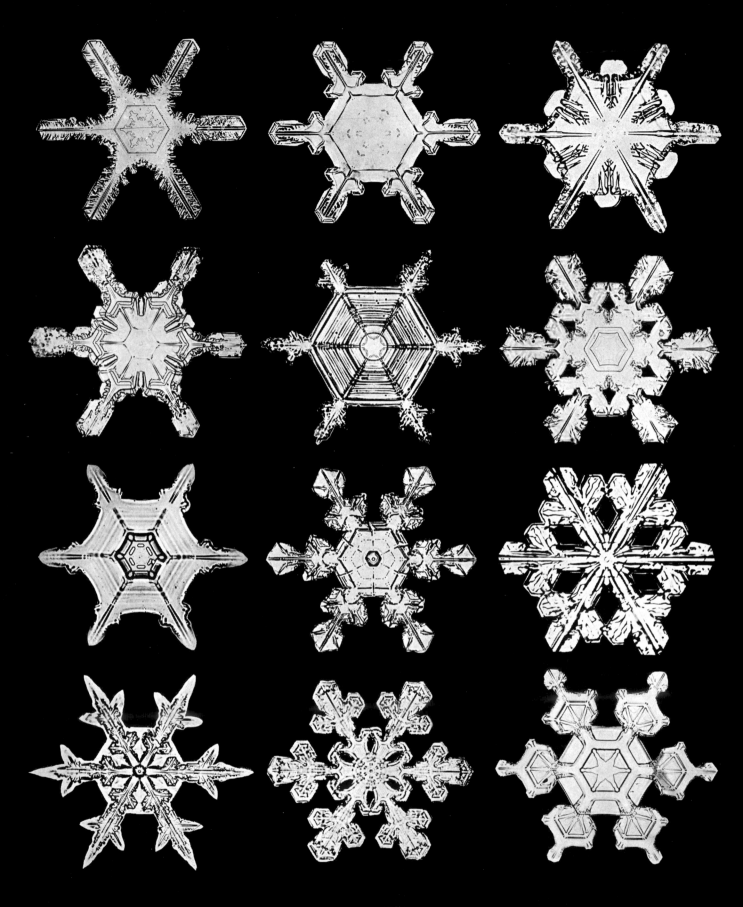

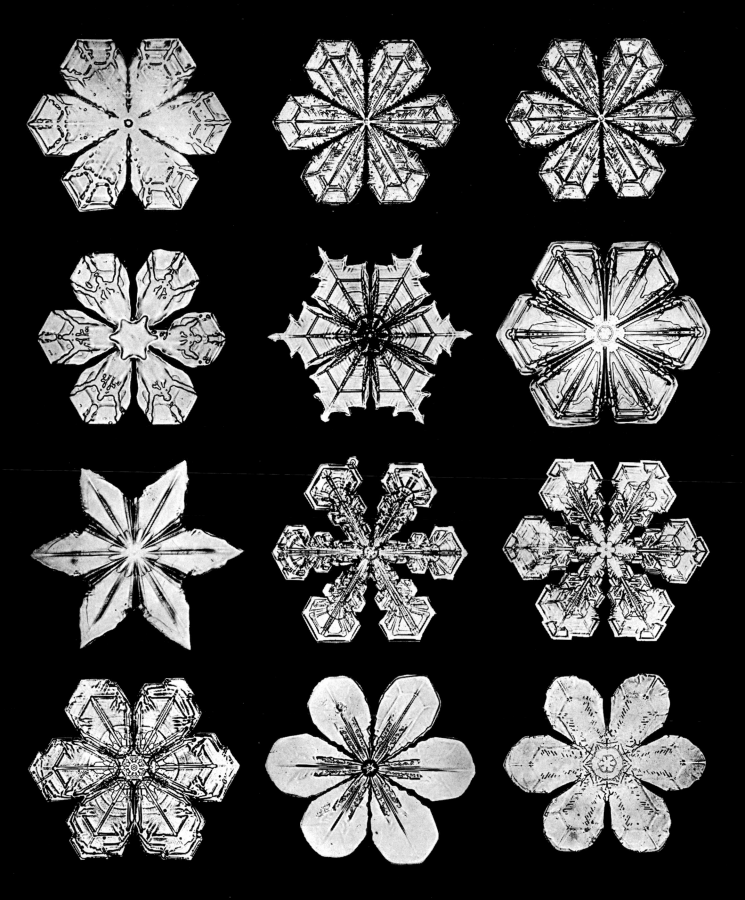

145

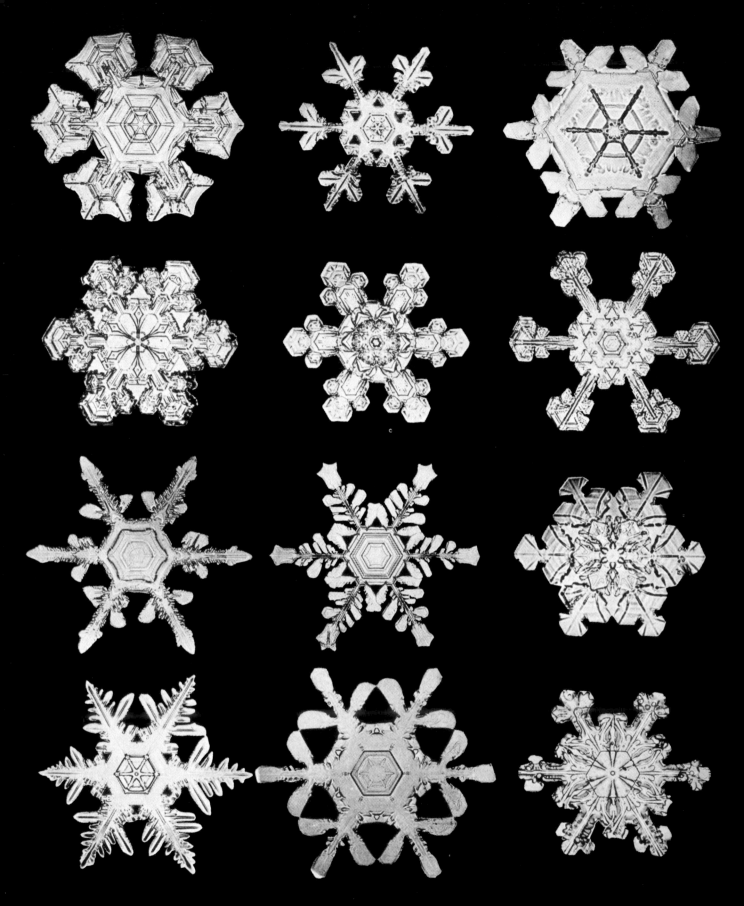

146

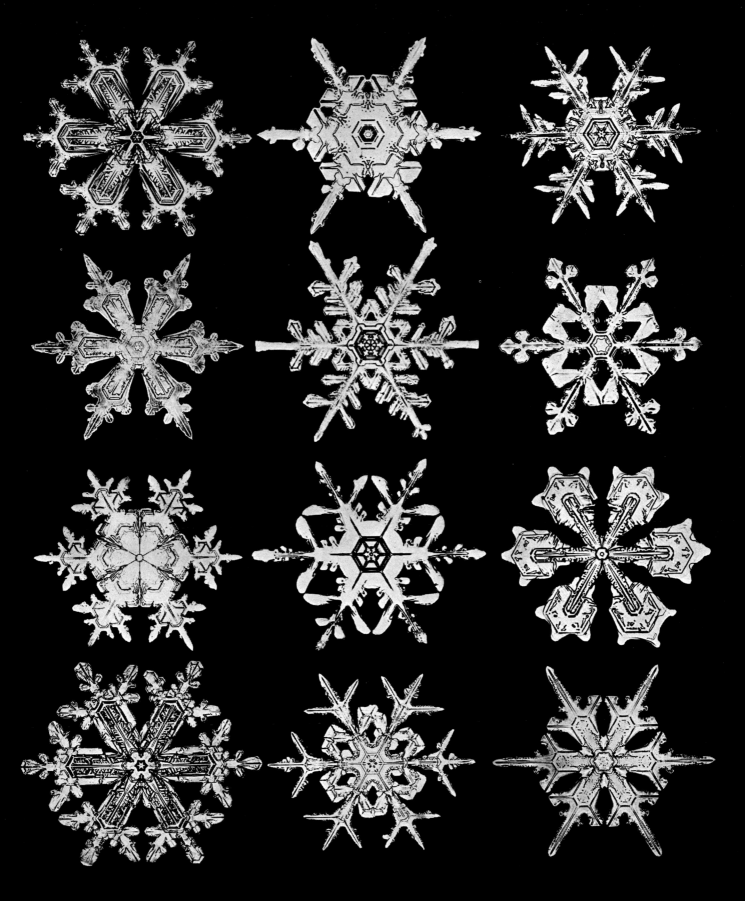

147

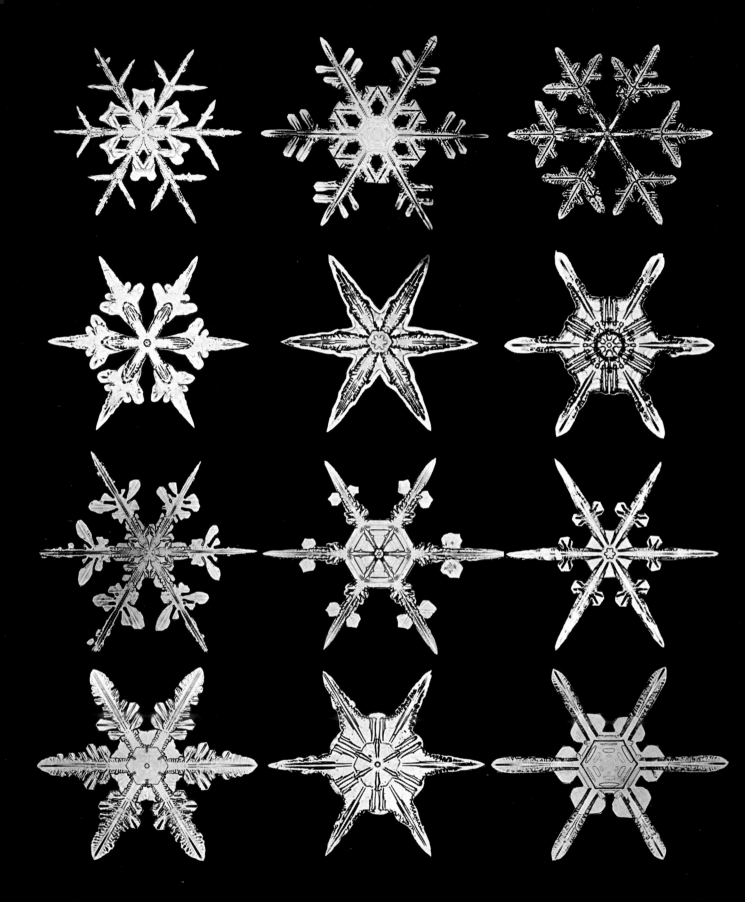

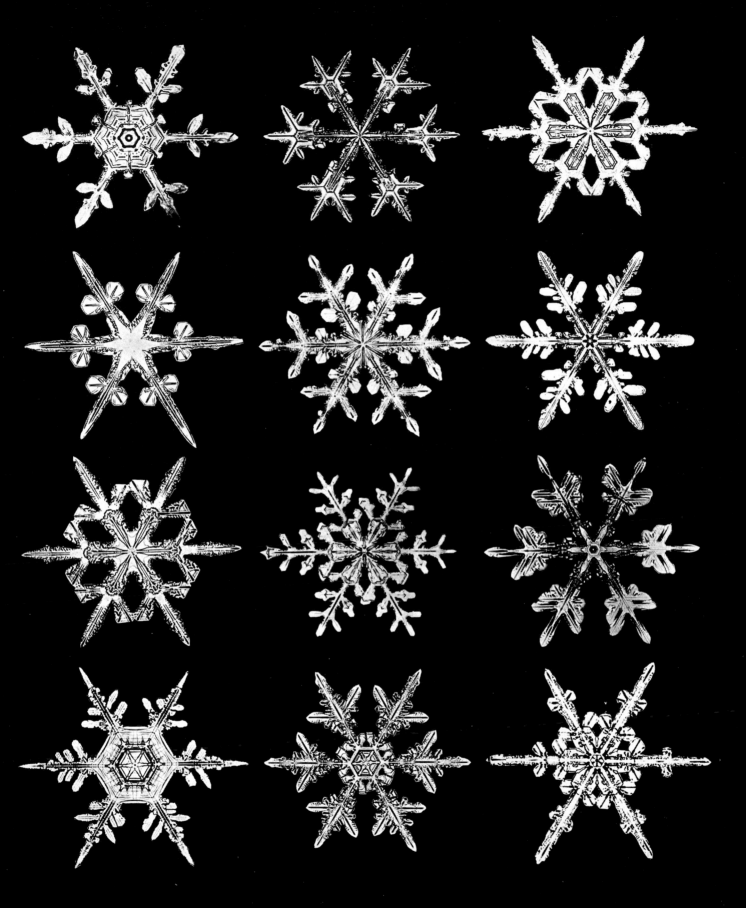

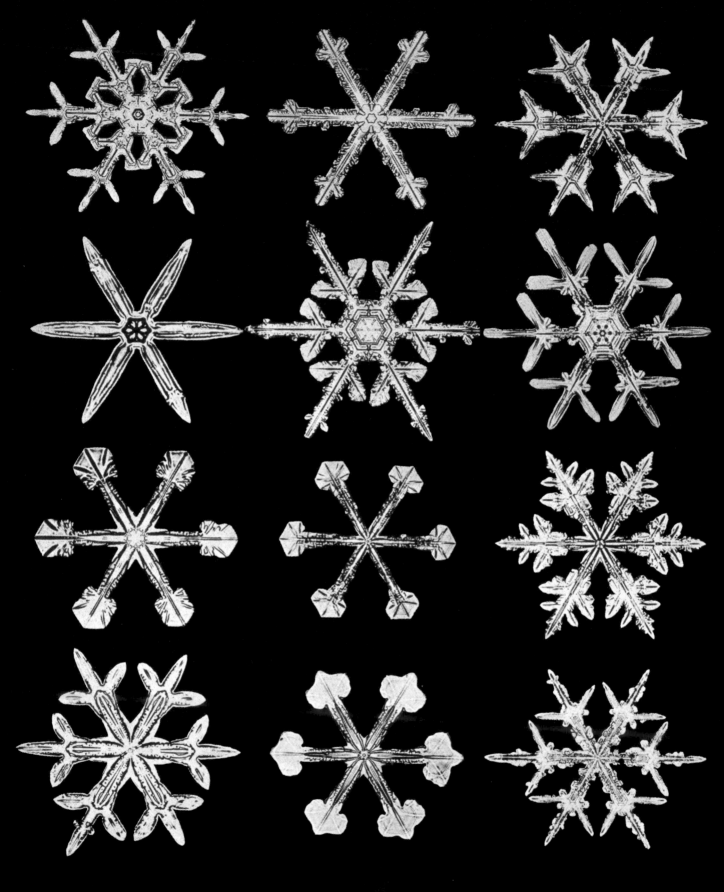

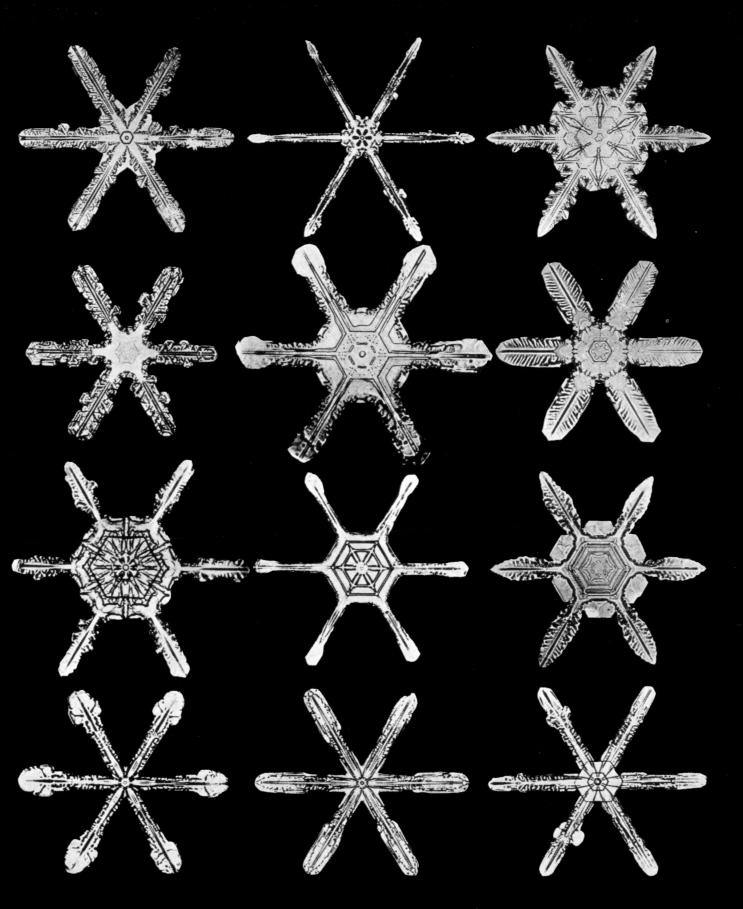

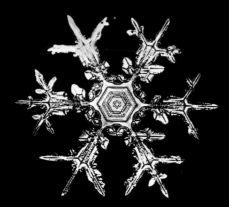
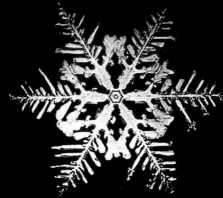
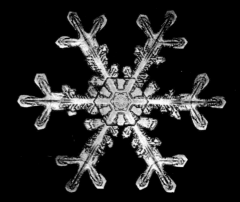
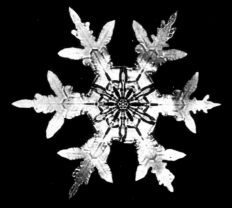
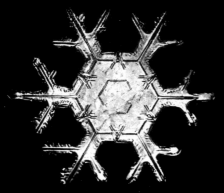
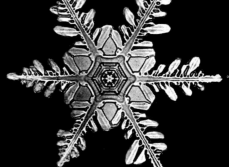
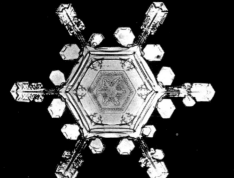
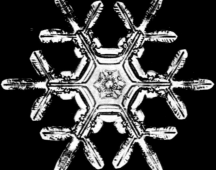
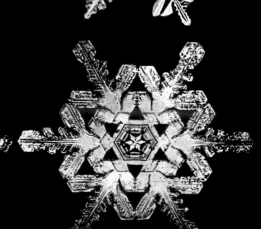
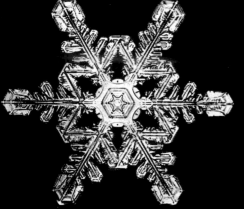
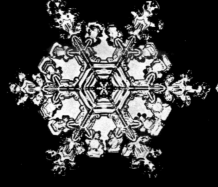

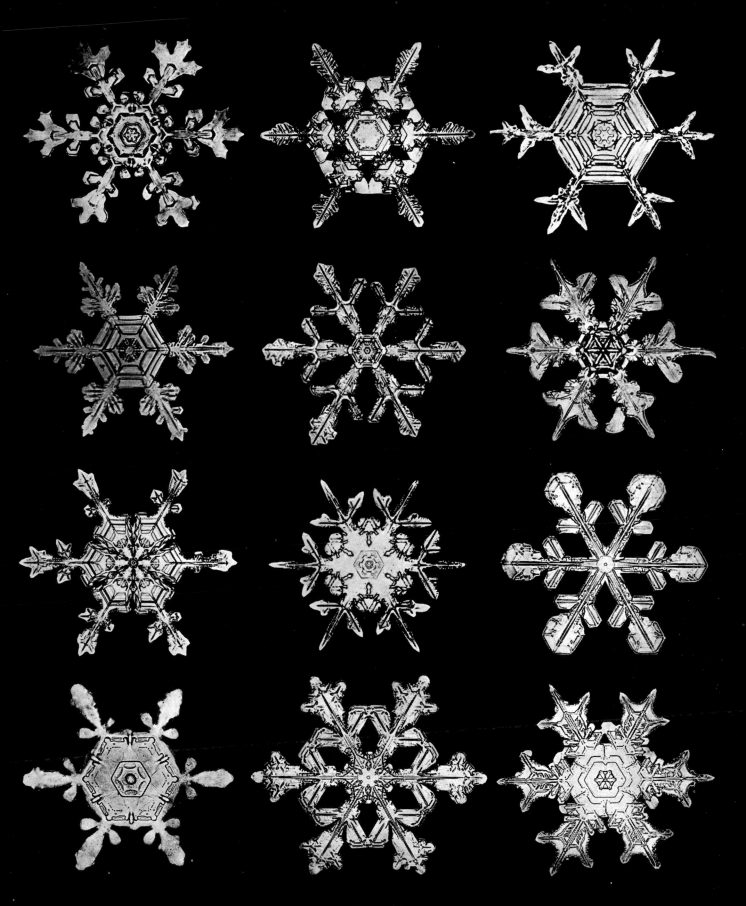

153

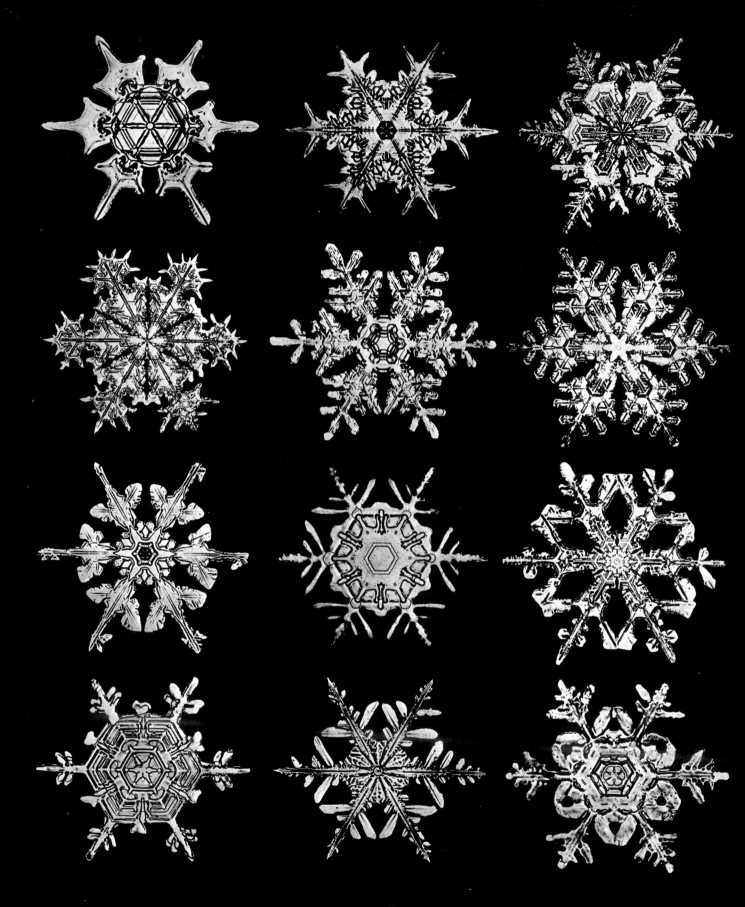

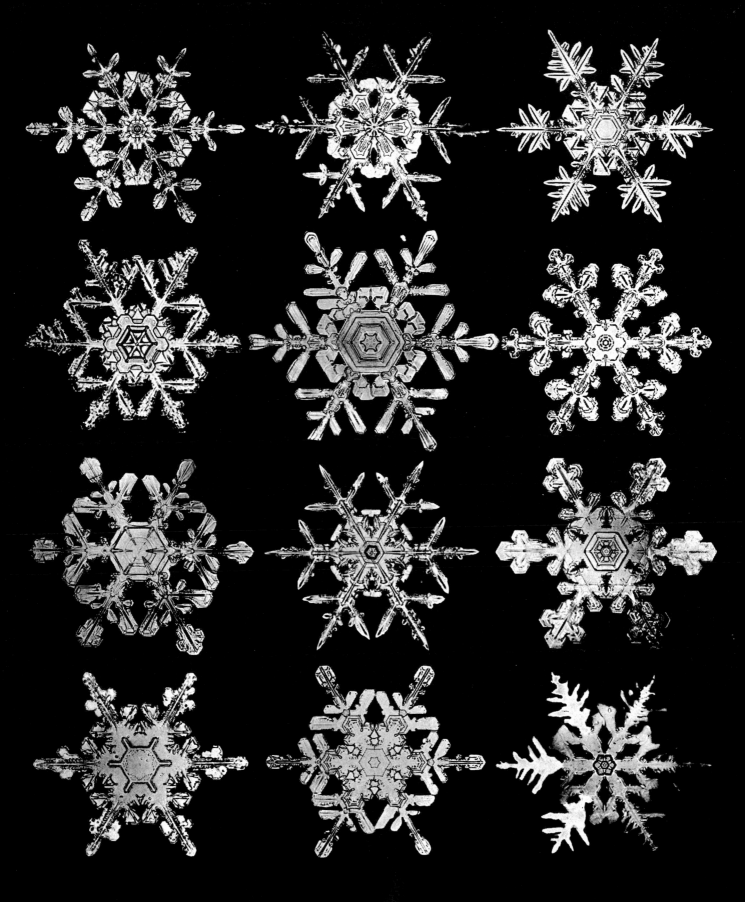

155

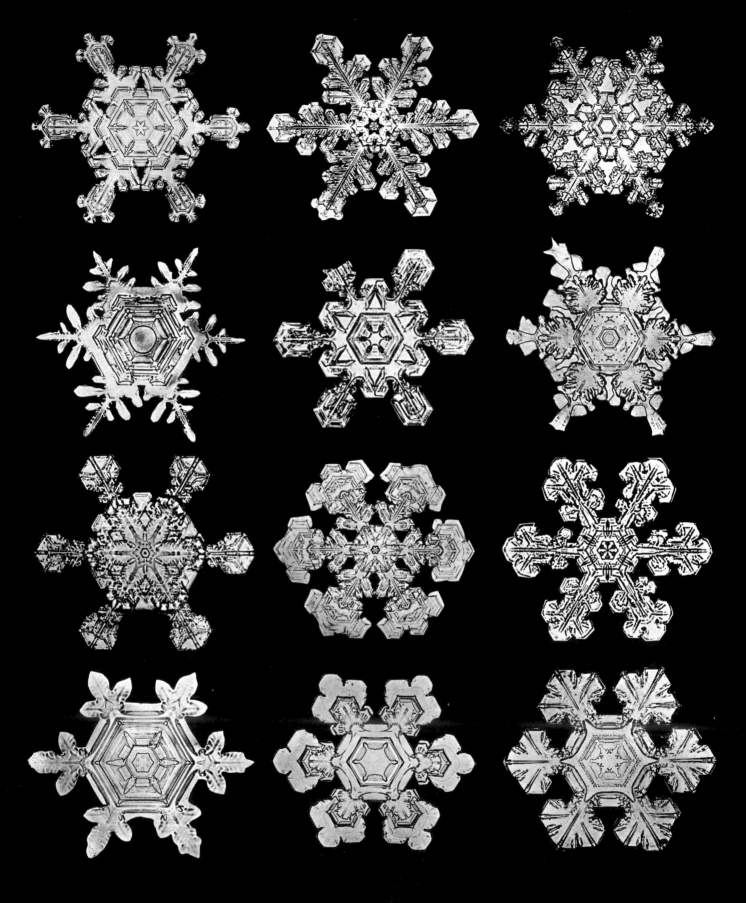

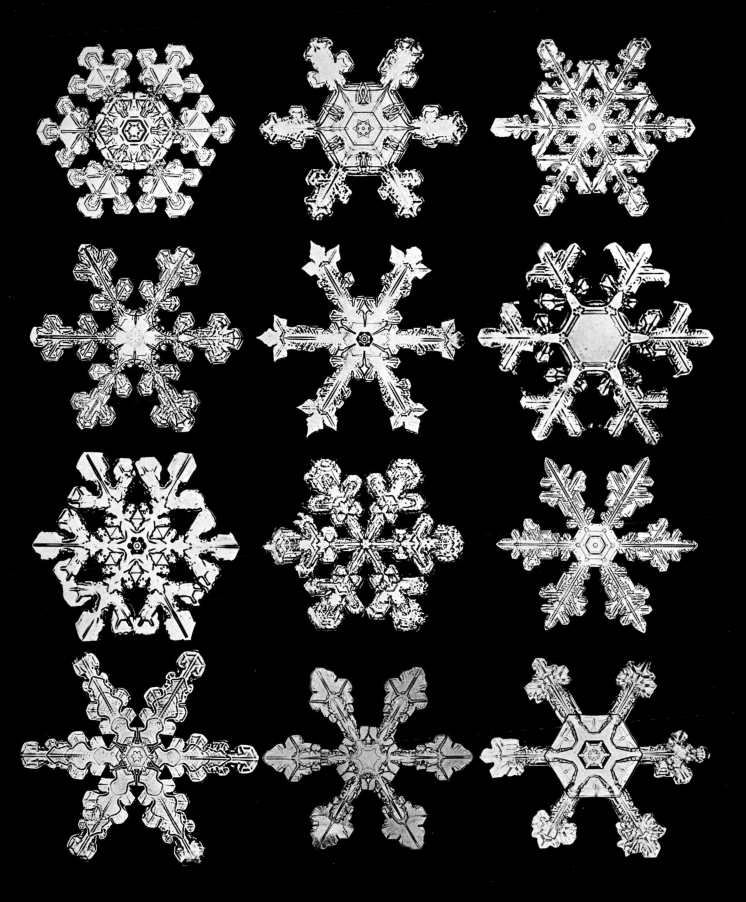

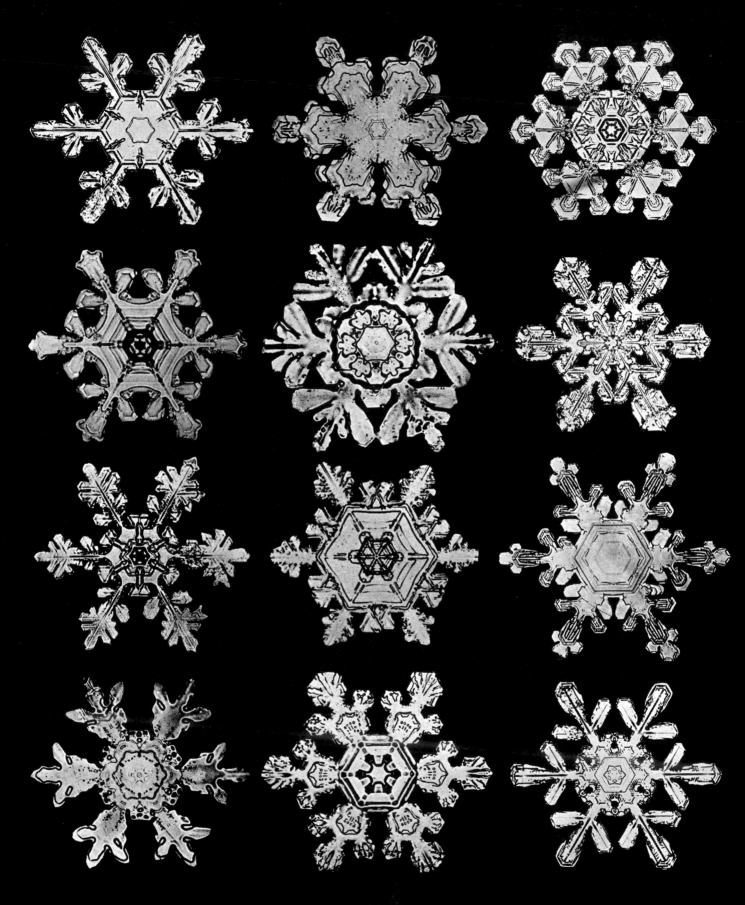

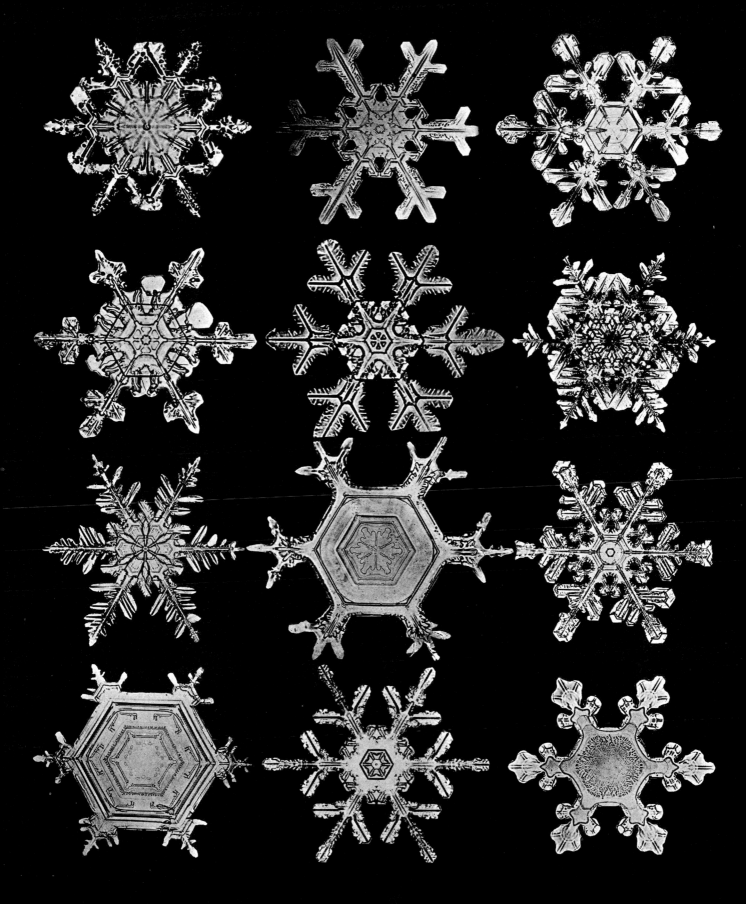

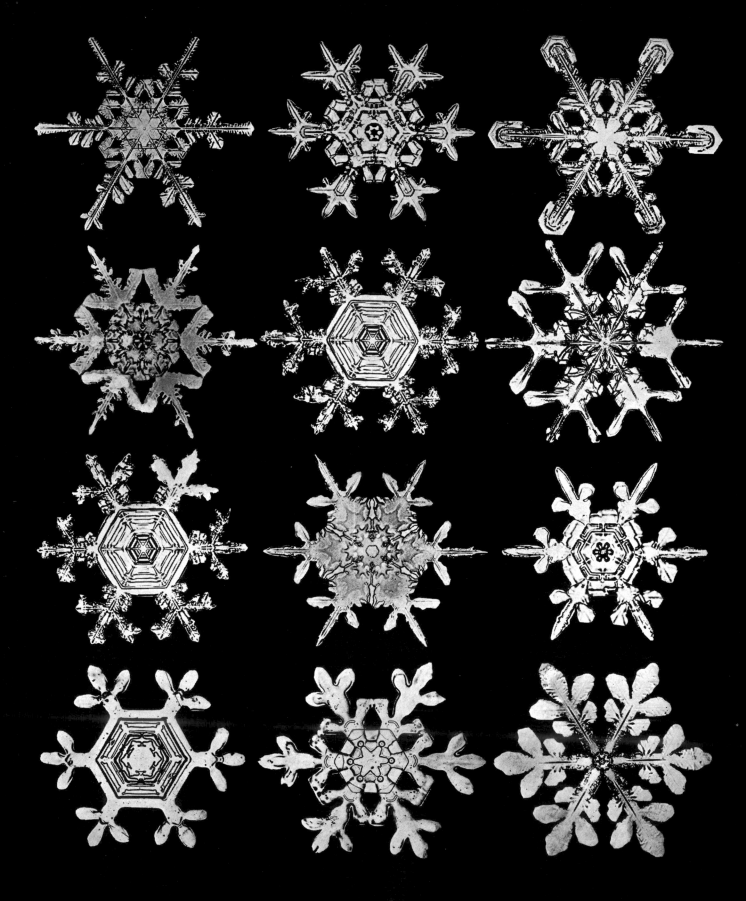

160

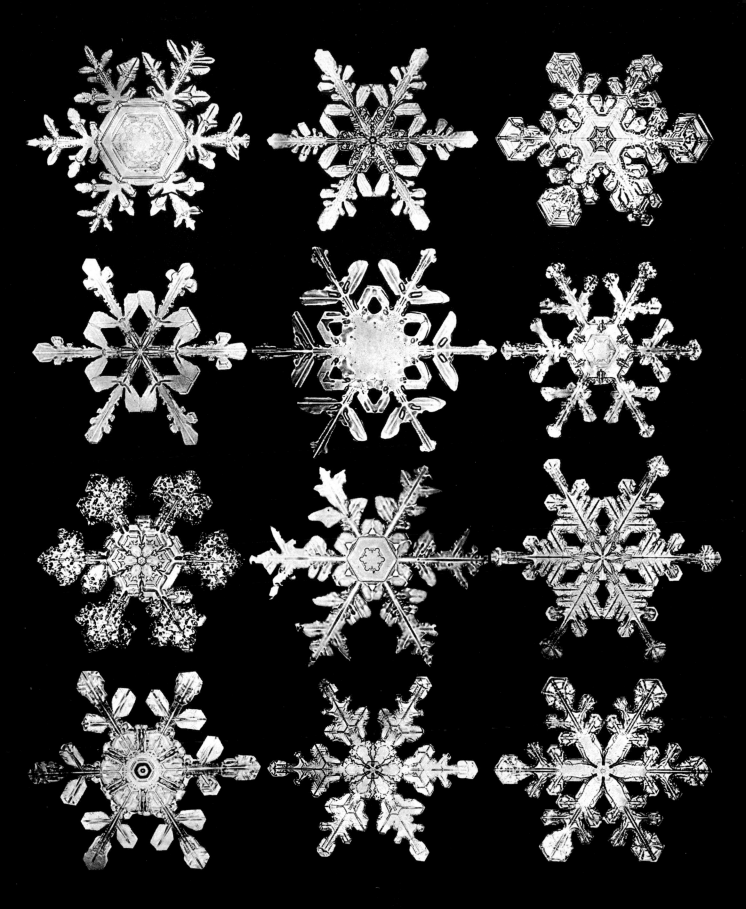

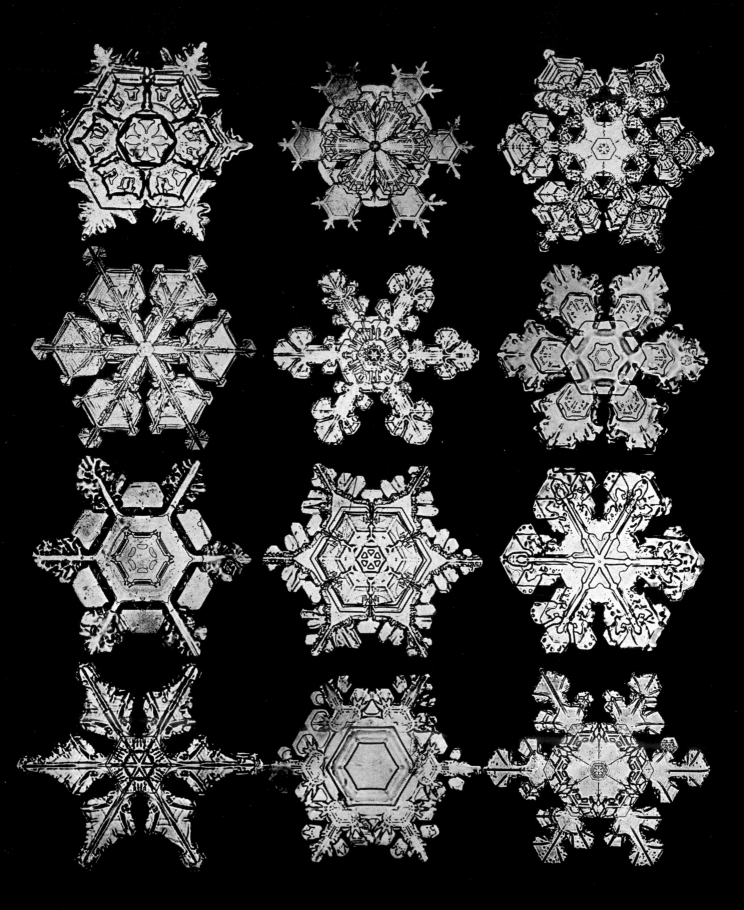

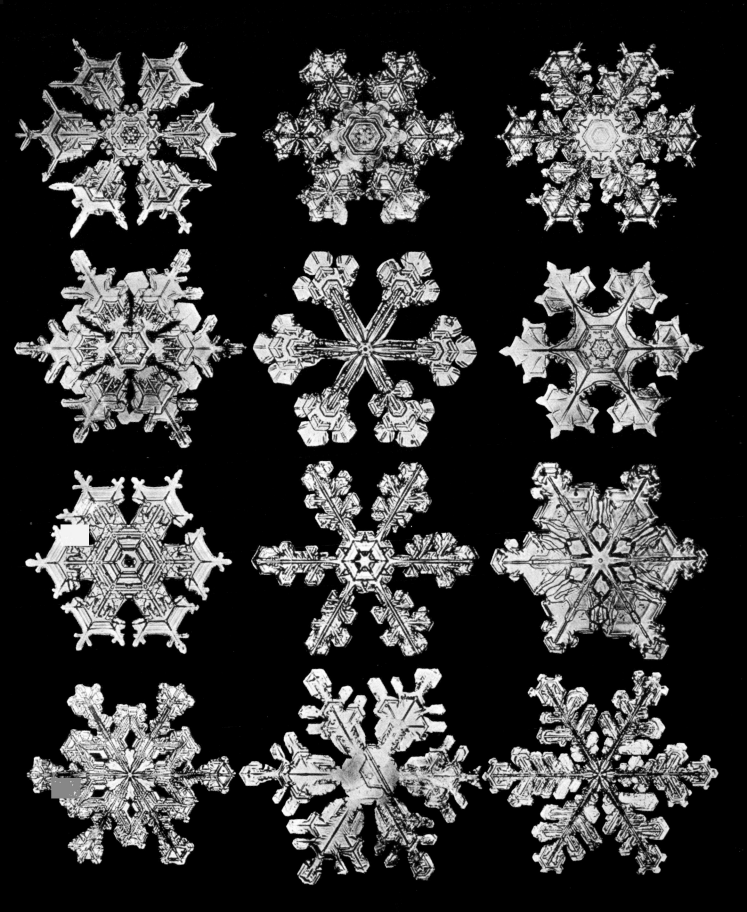

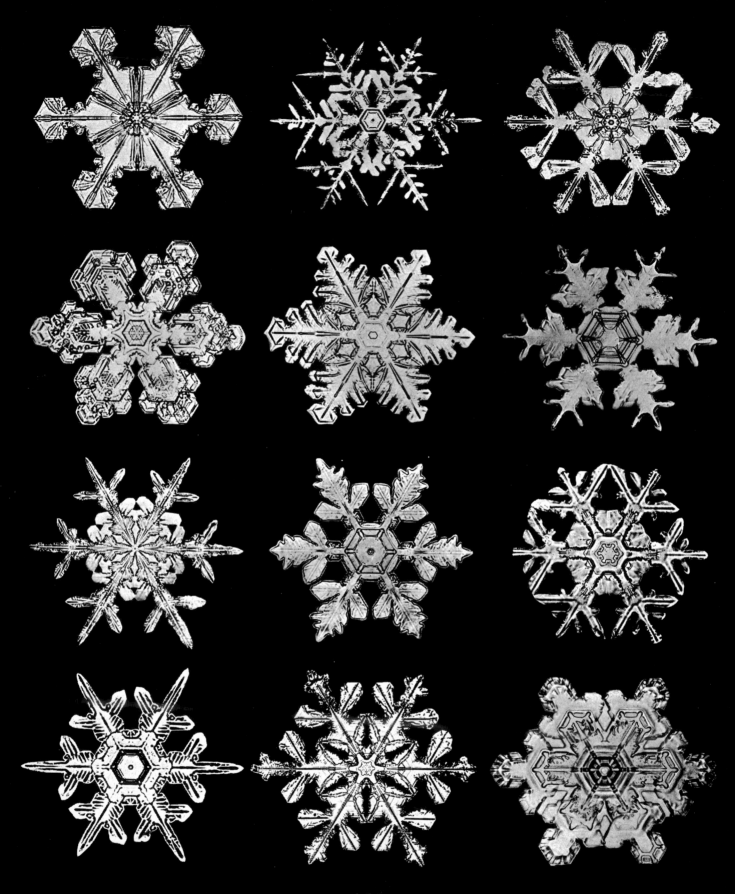

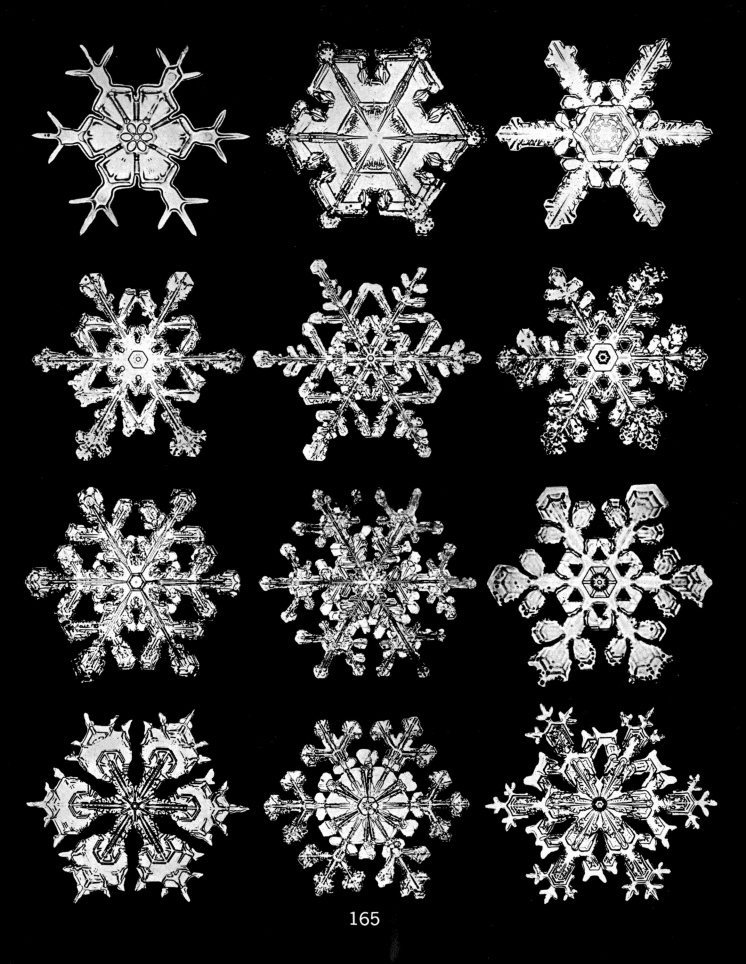

165

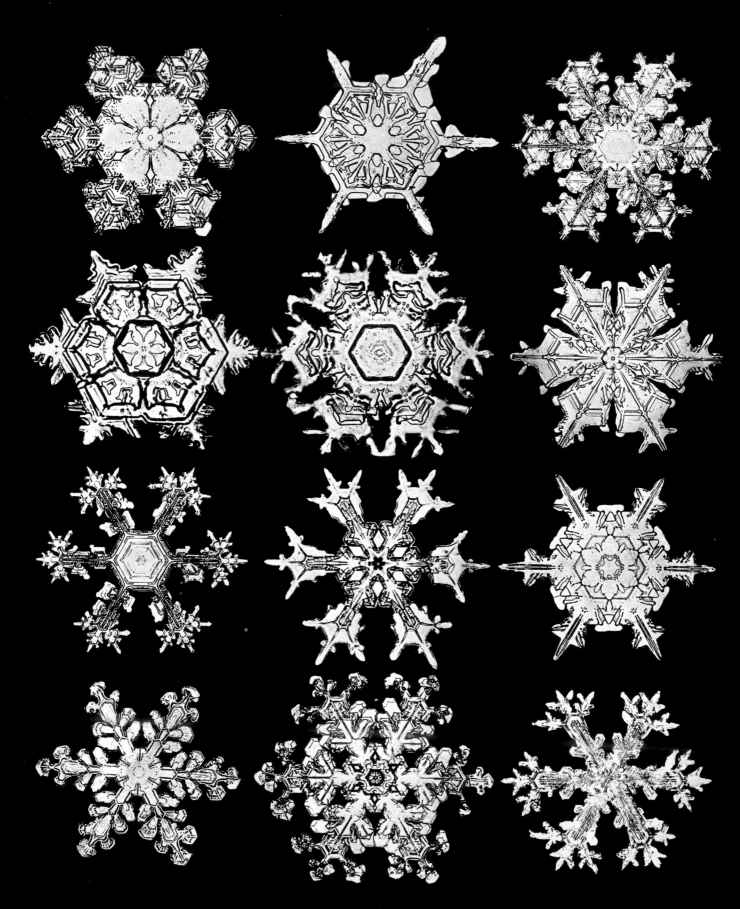

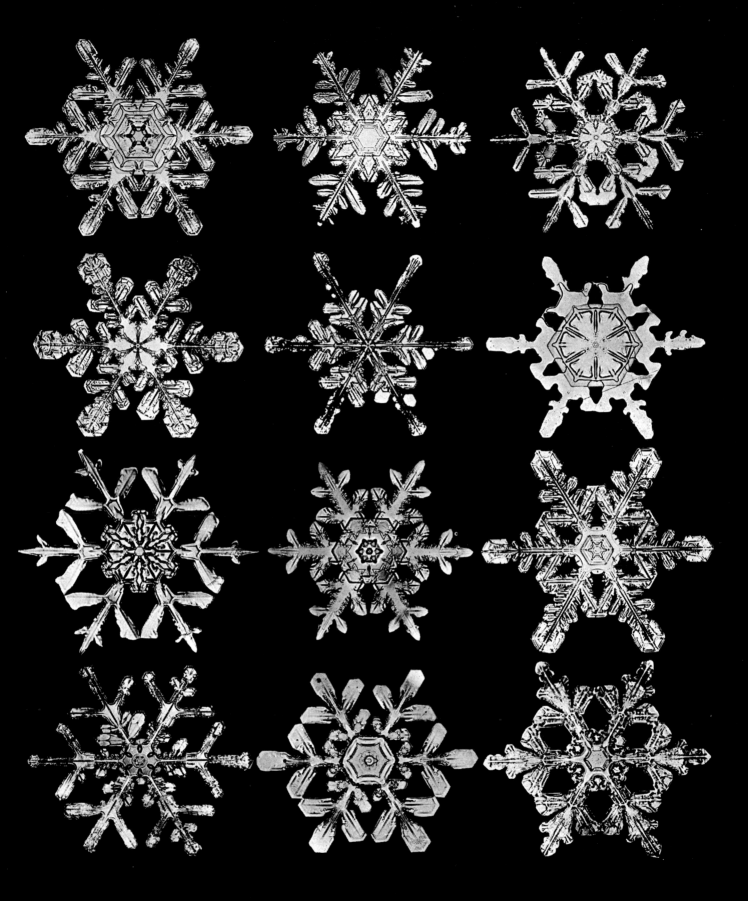

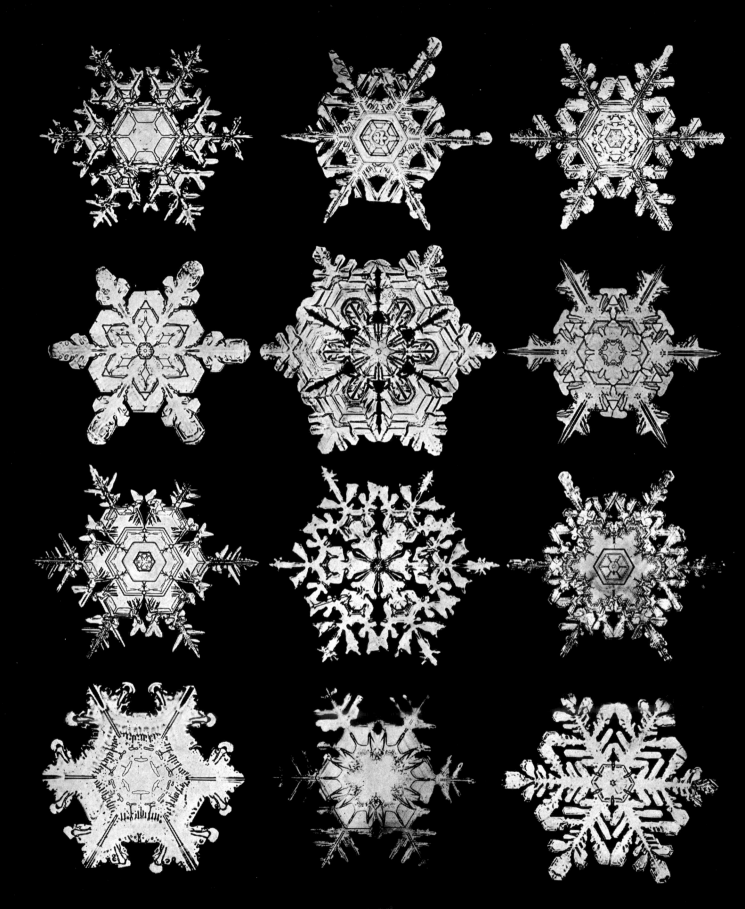

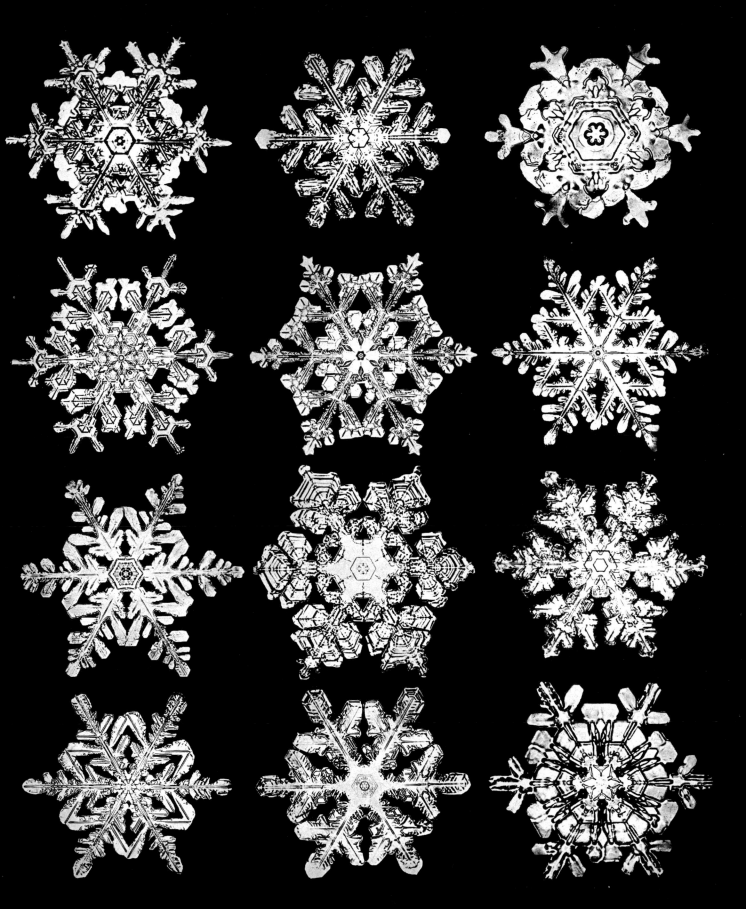

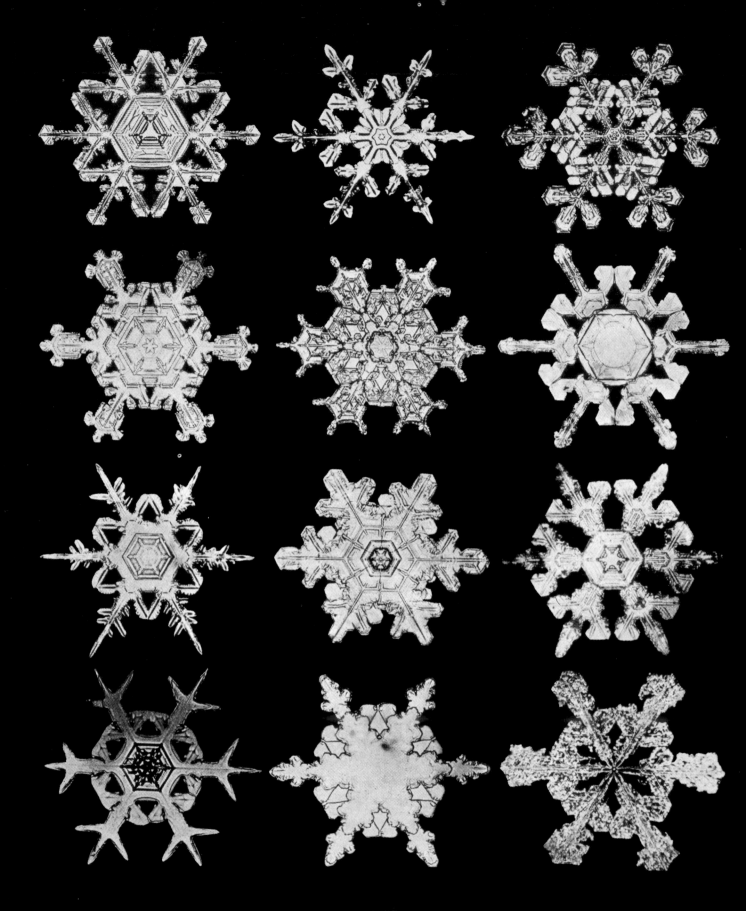

170

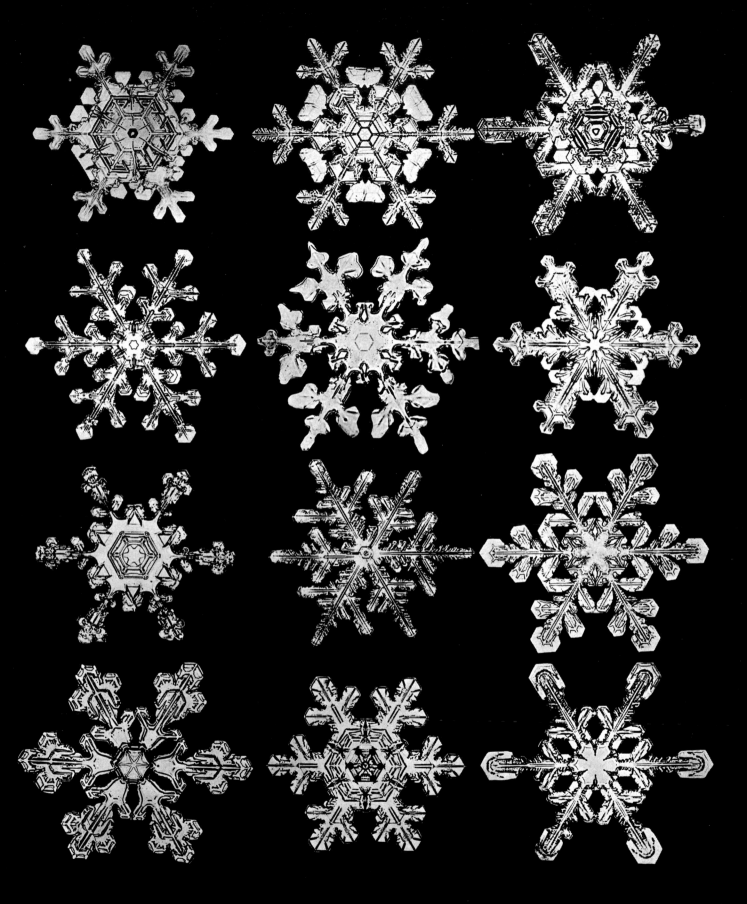

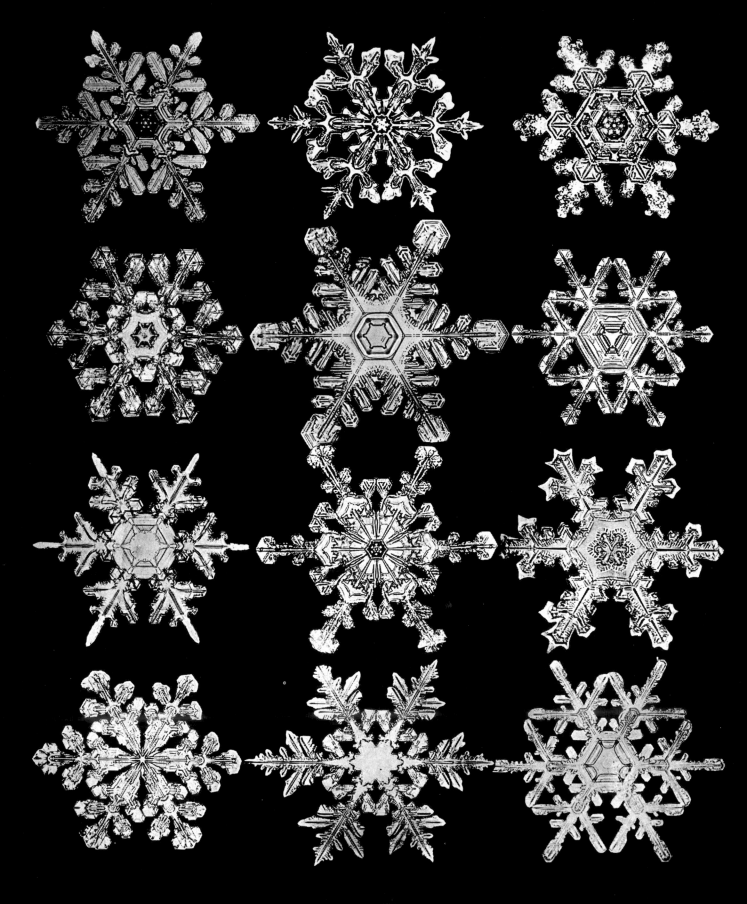

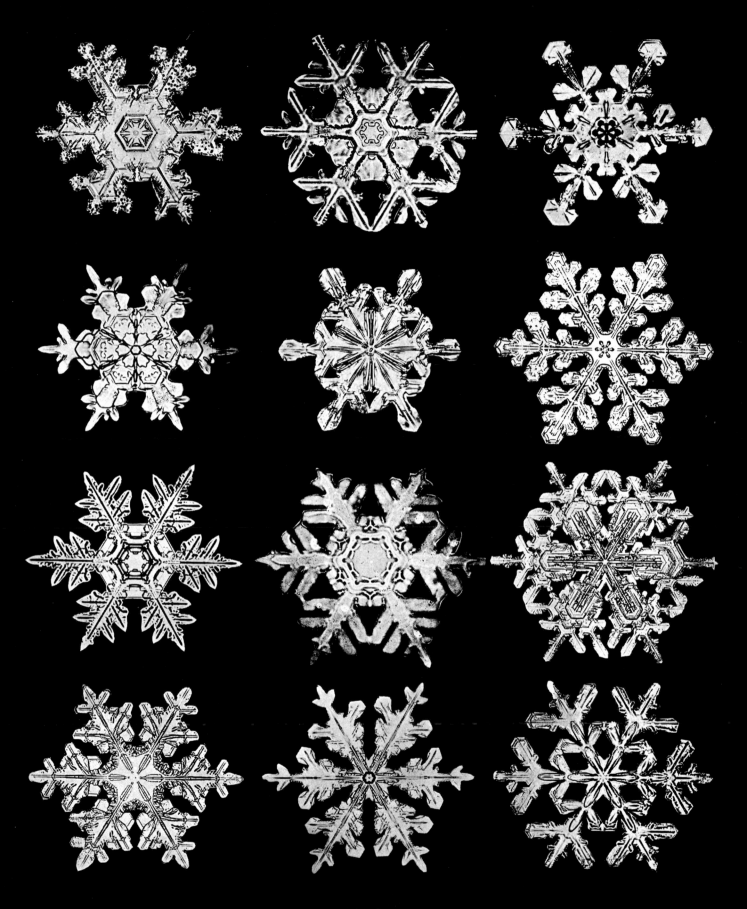

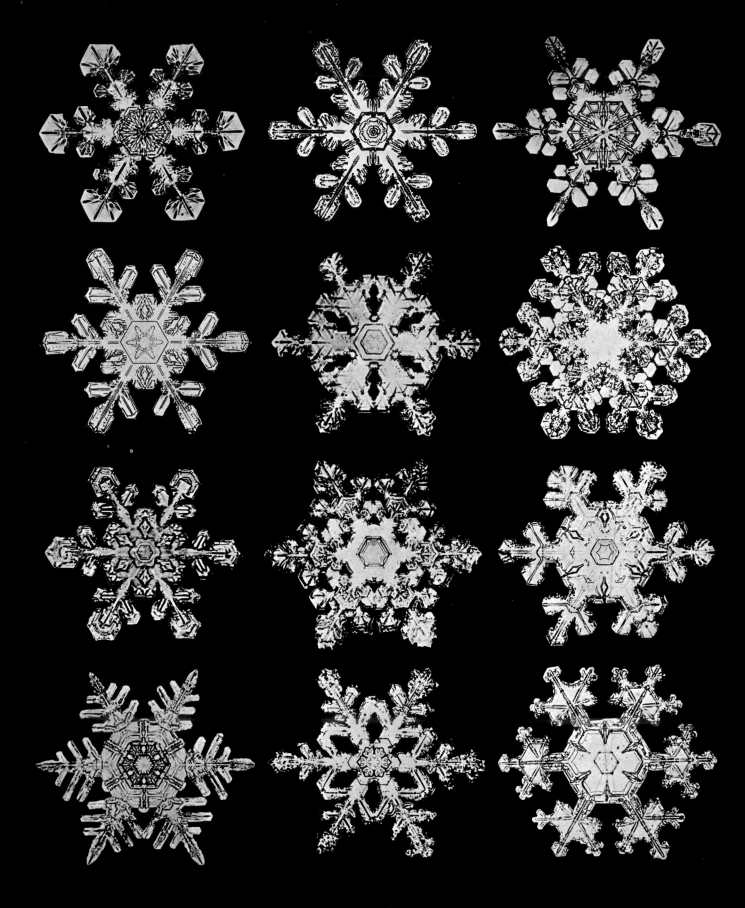

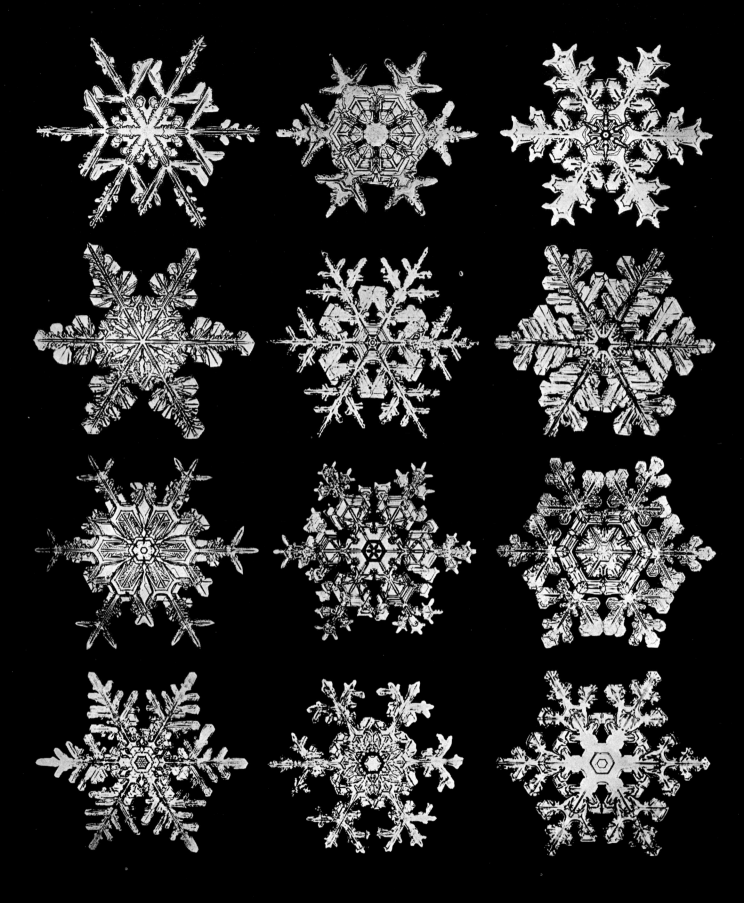

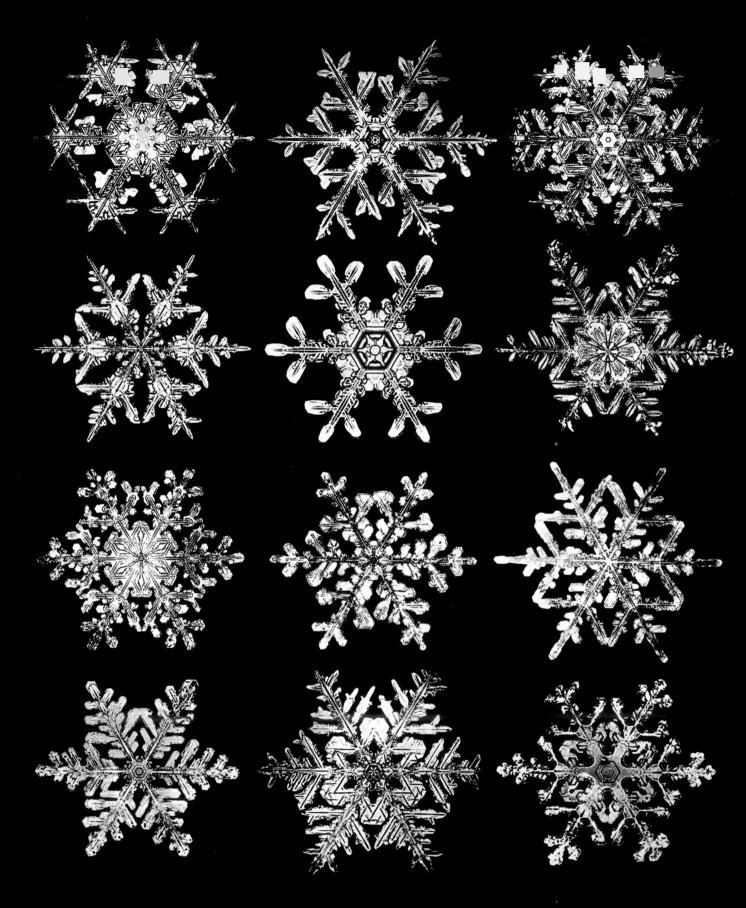

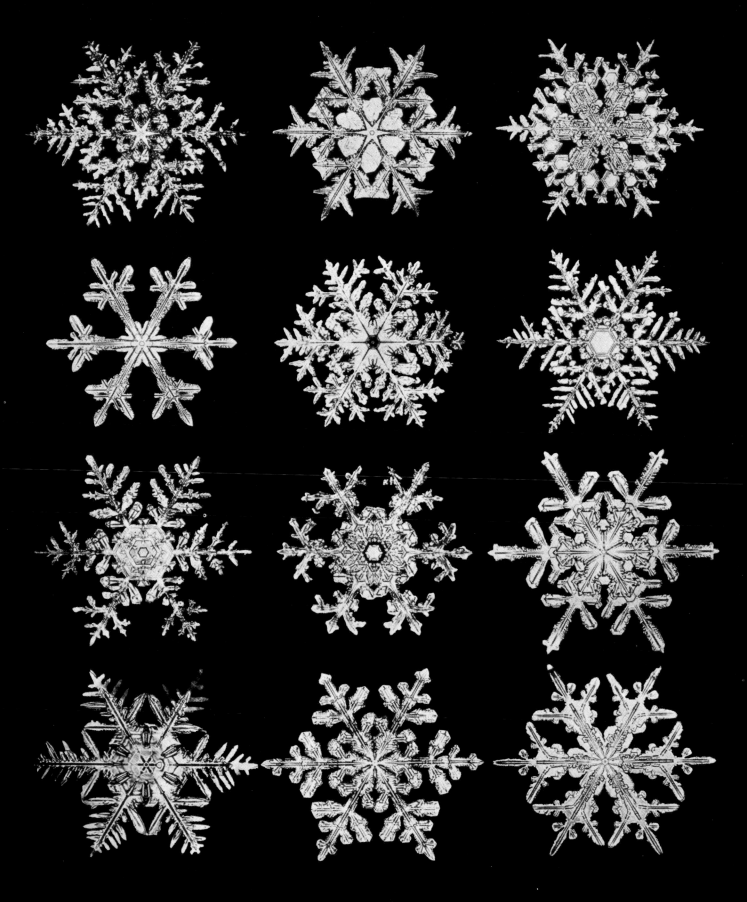

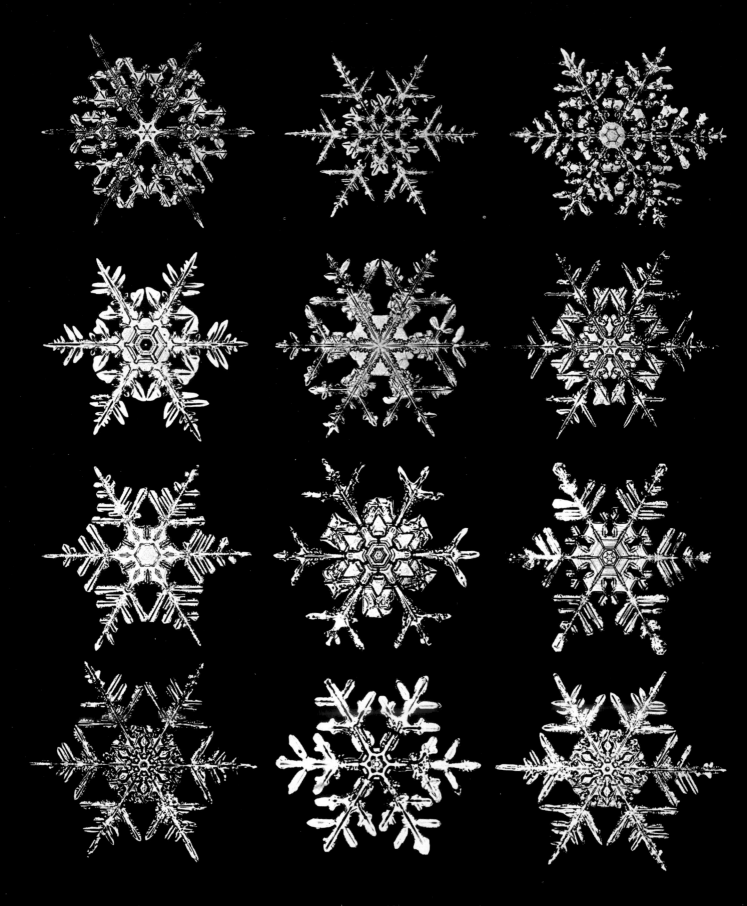

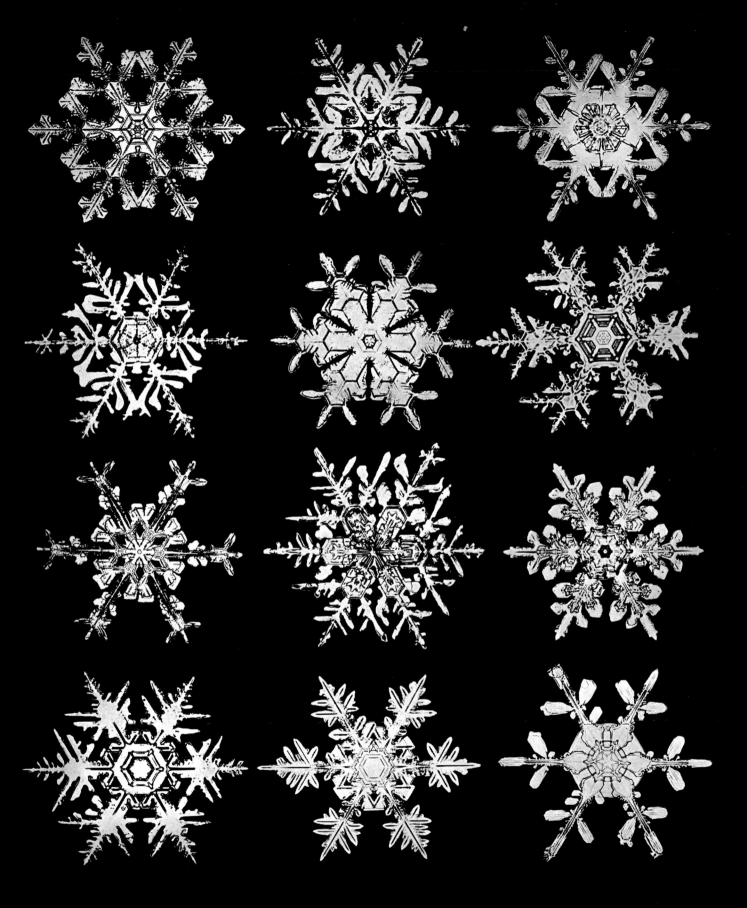

179

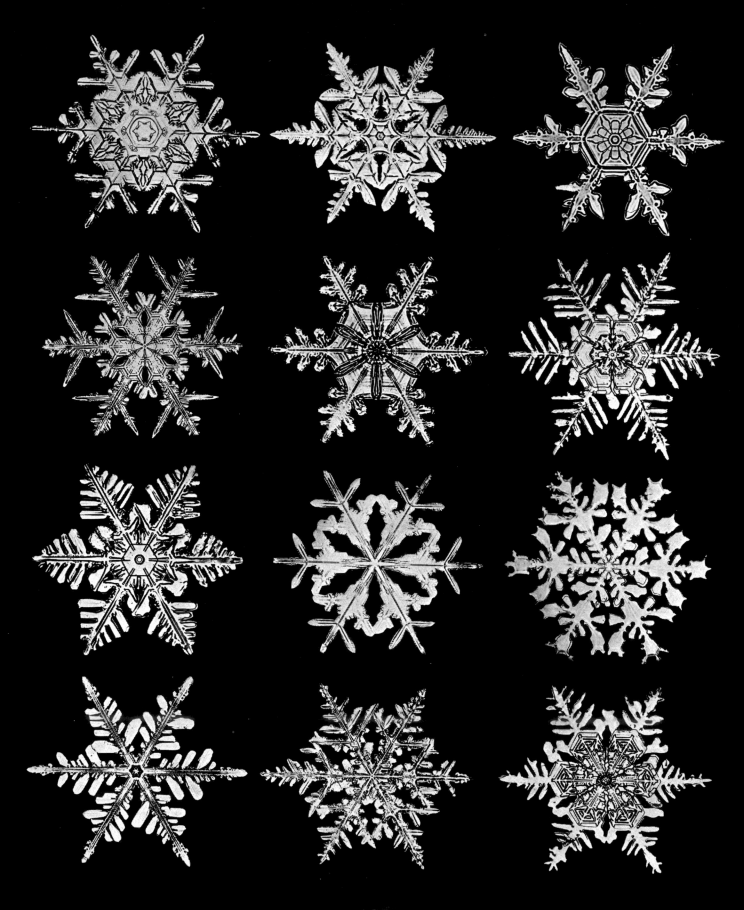

180

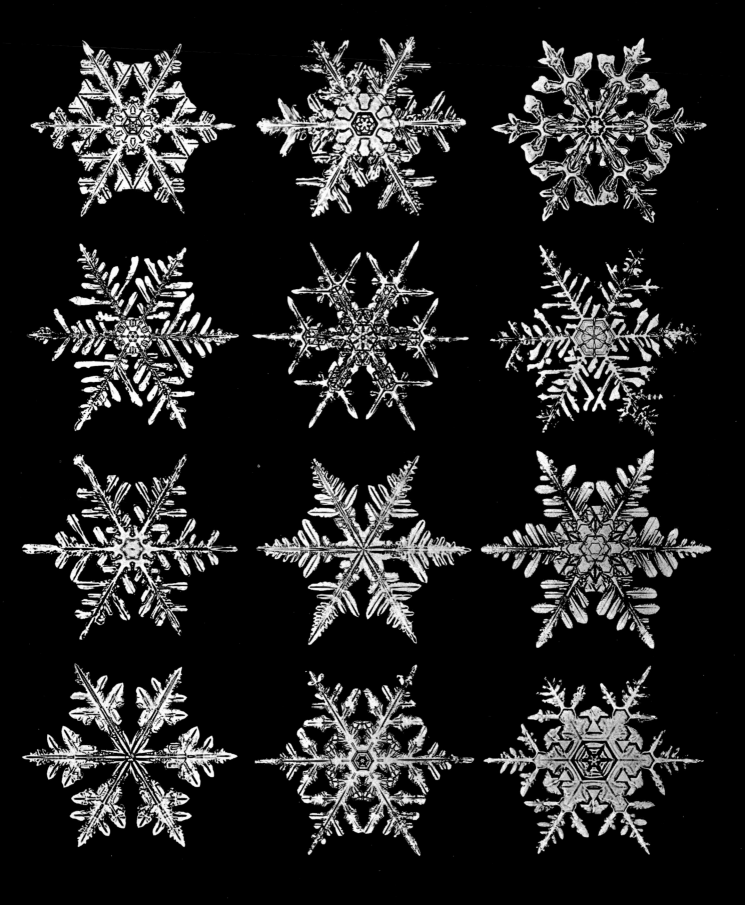

181

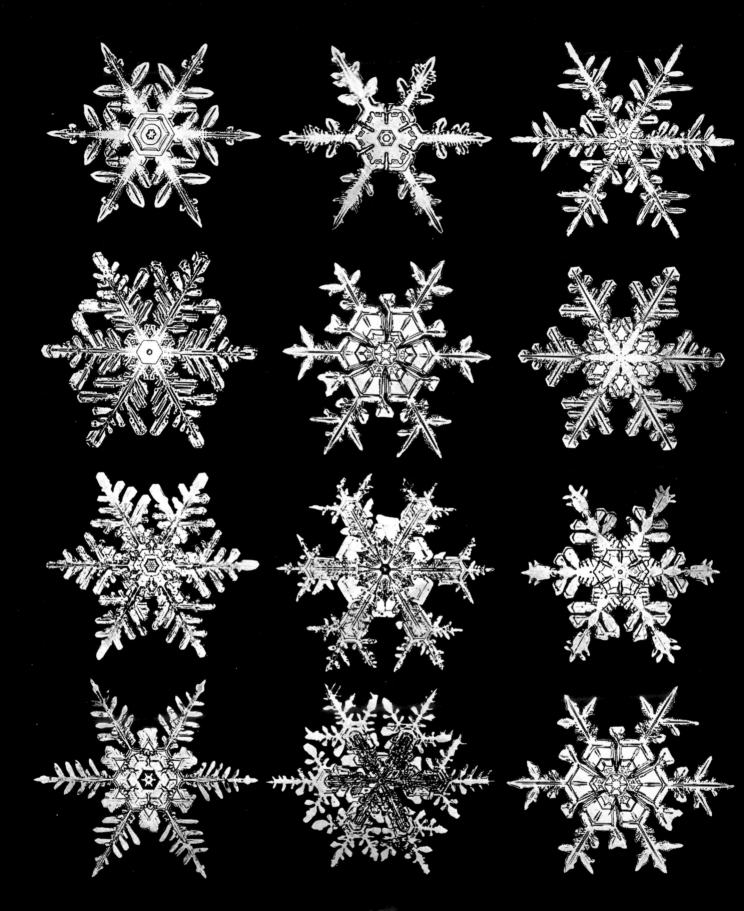

182

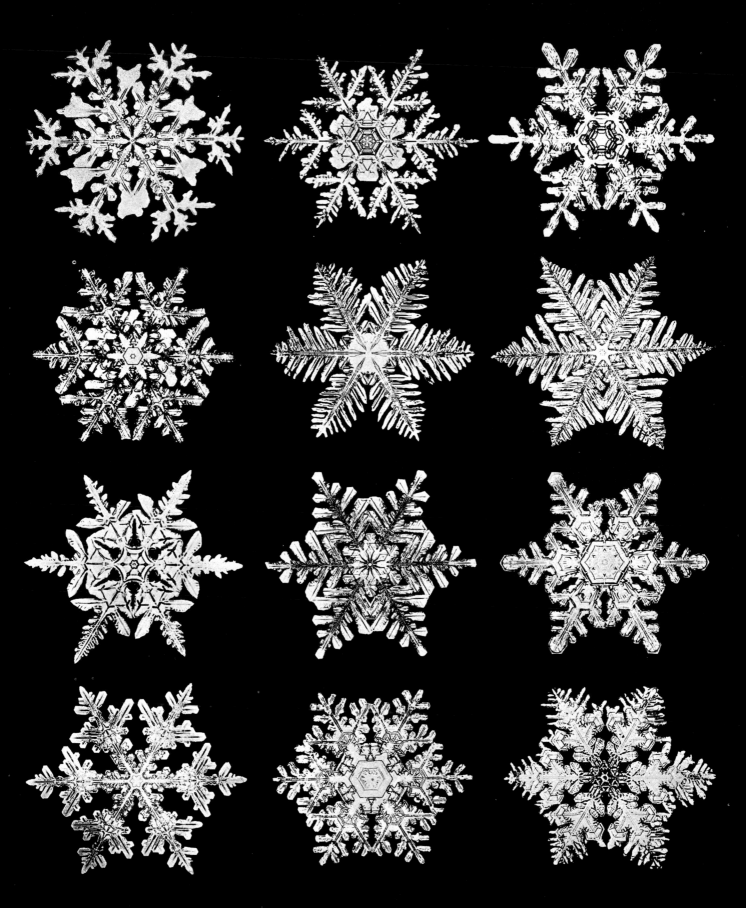

183

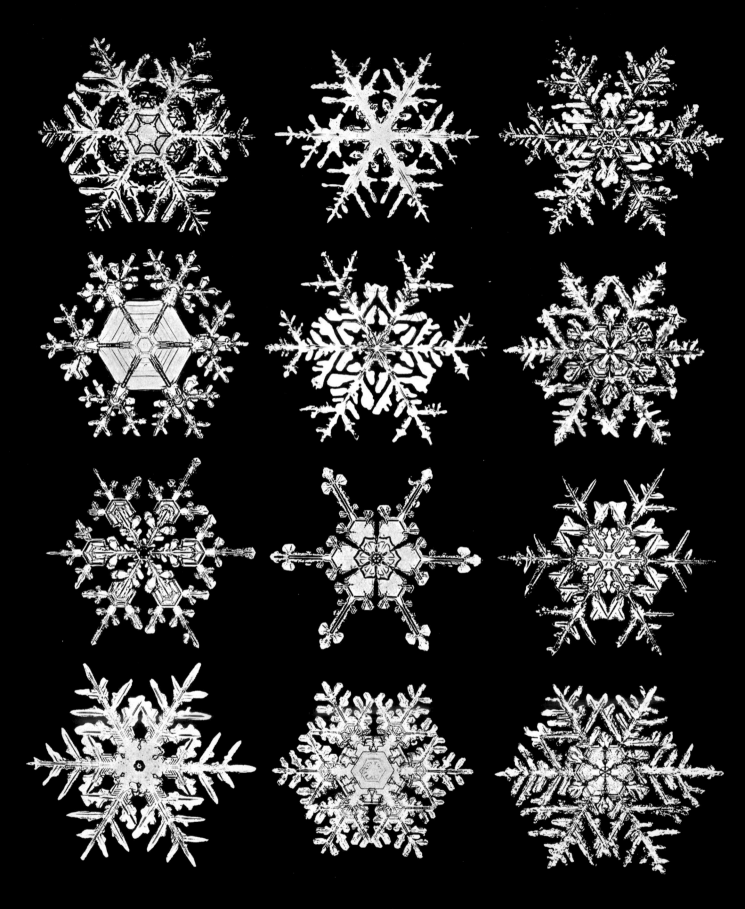

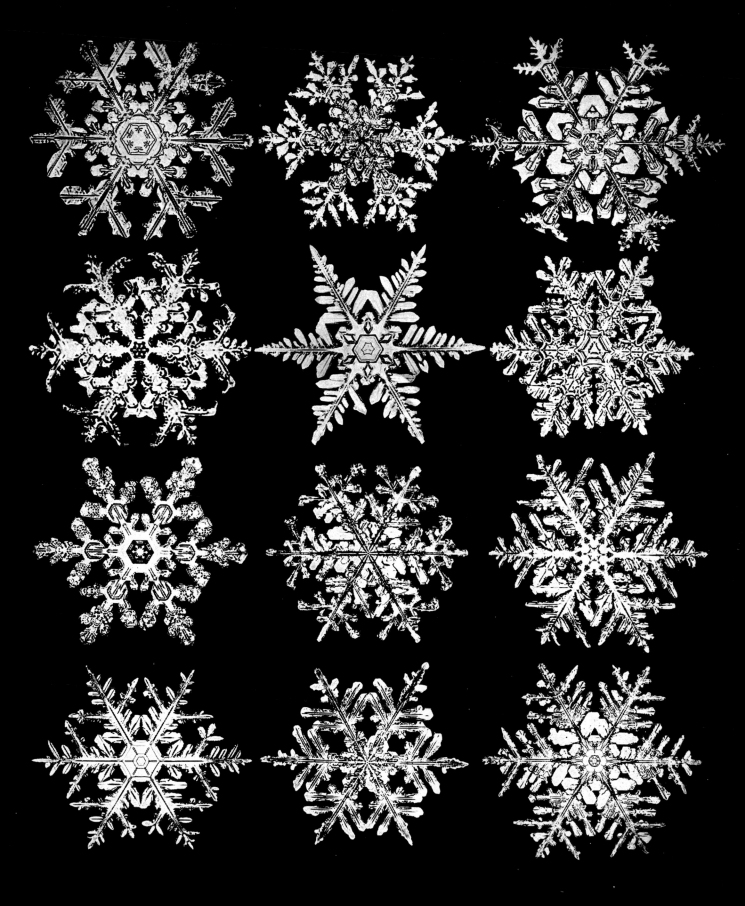

185

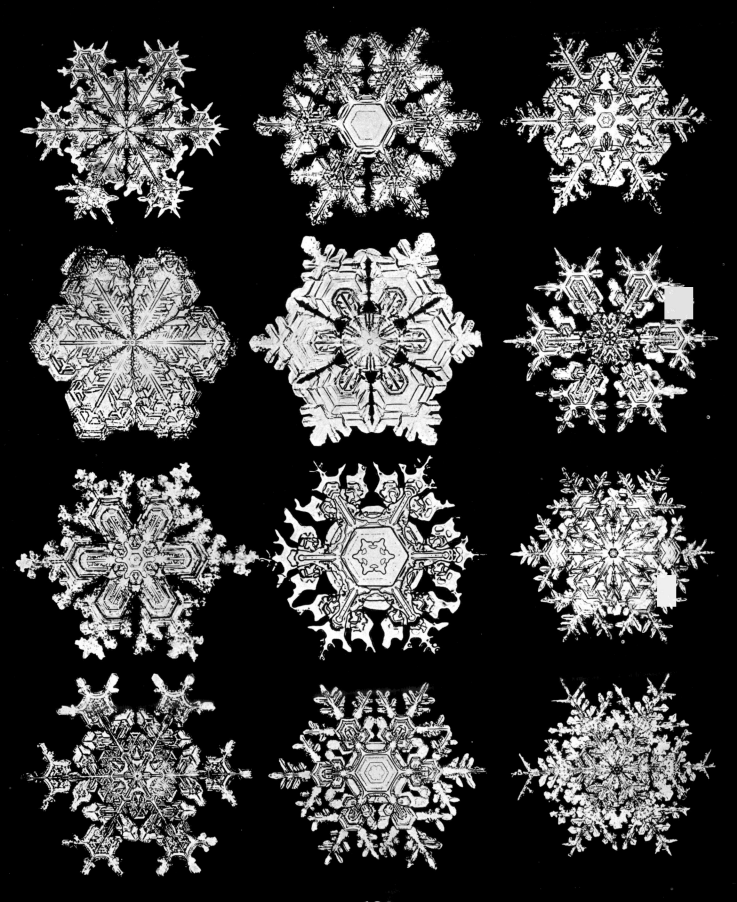

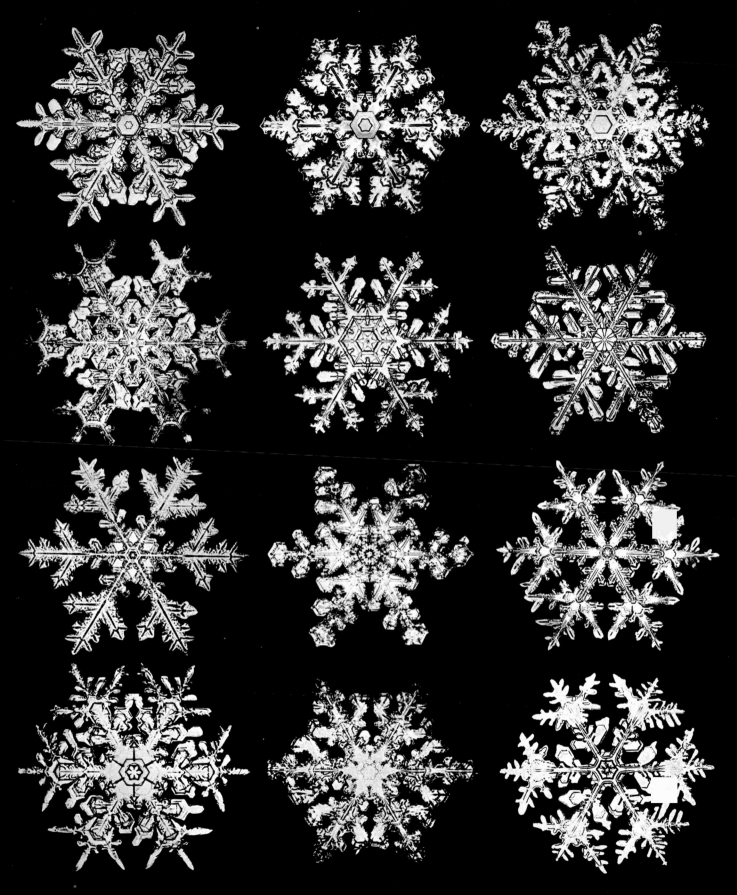

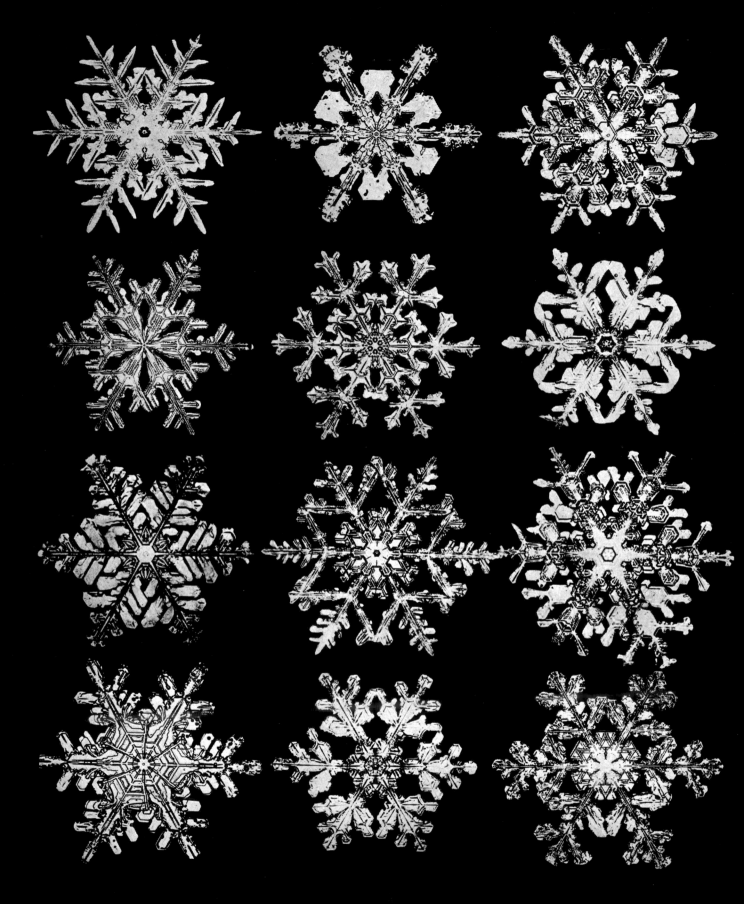

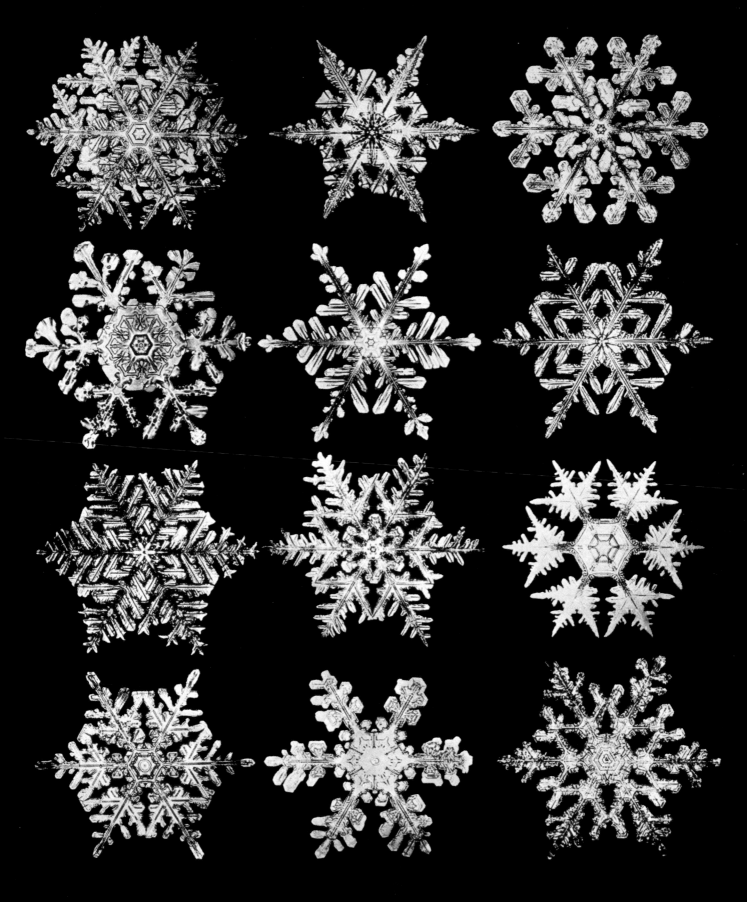

189

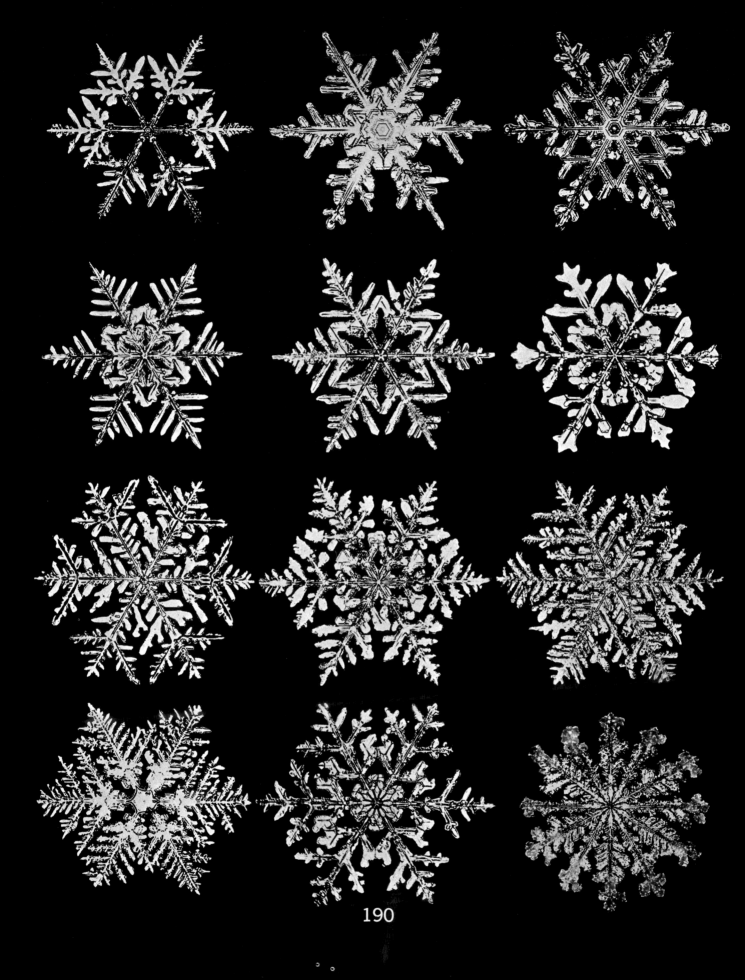

190

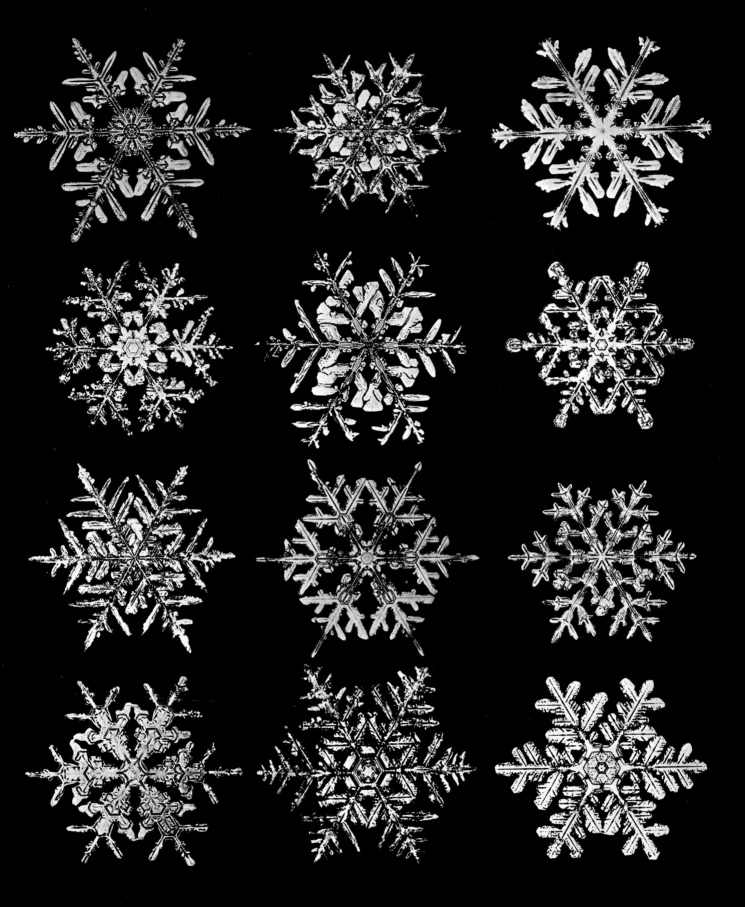

191

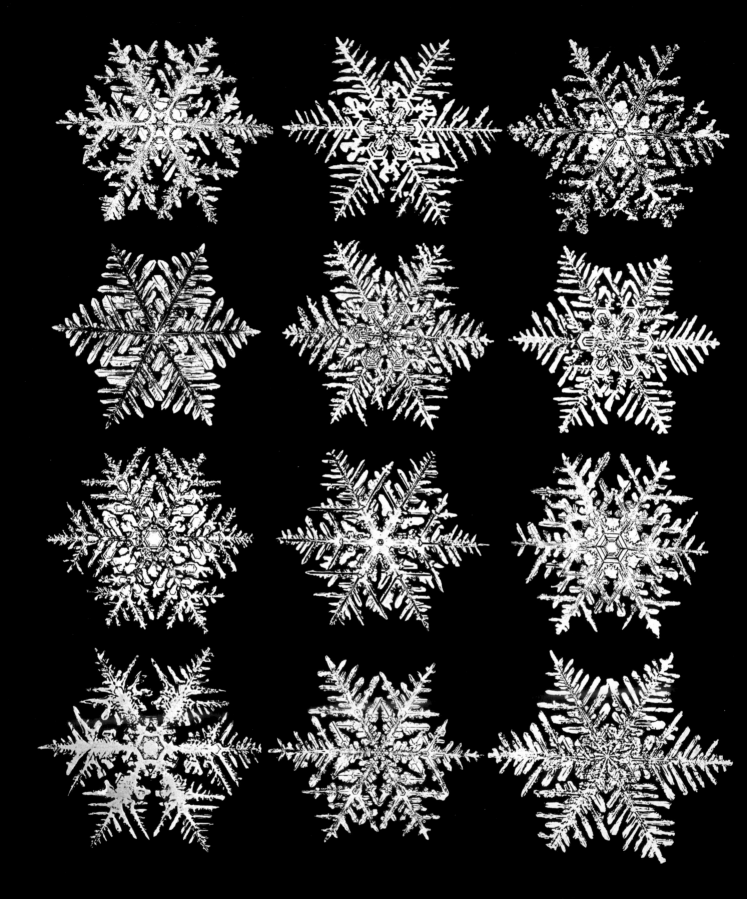

192

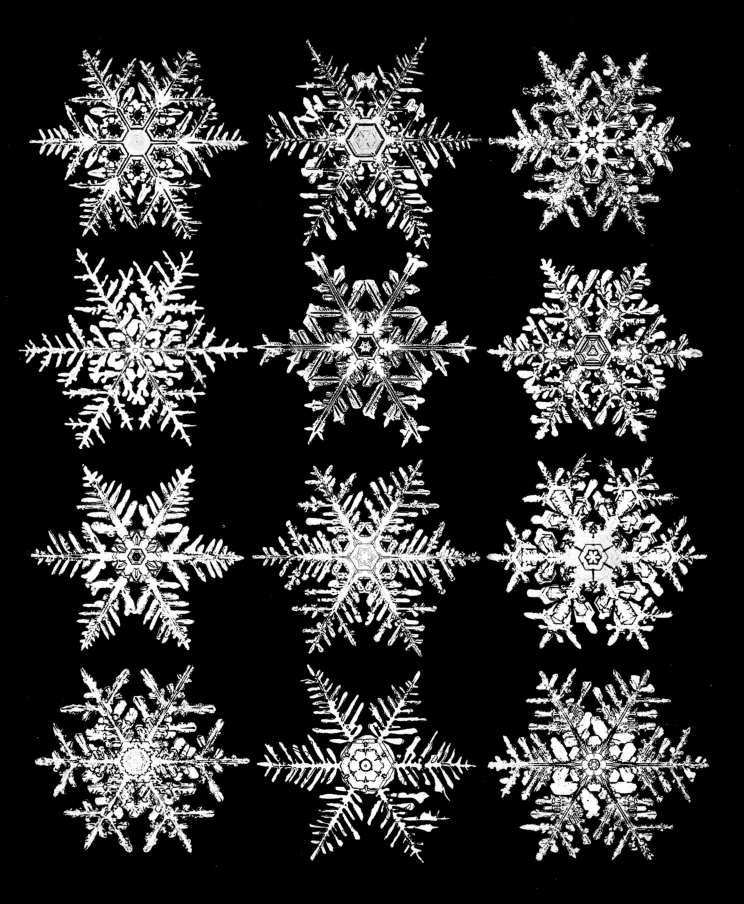

193

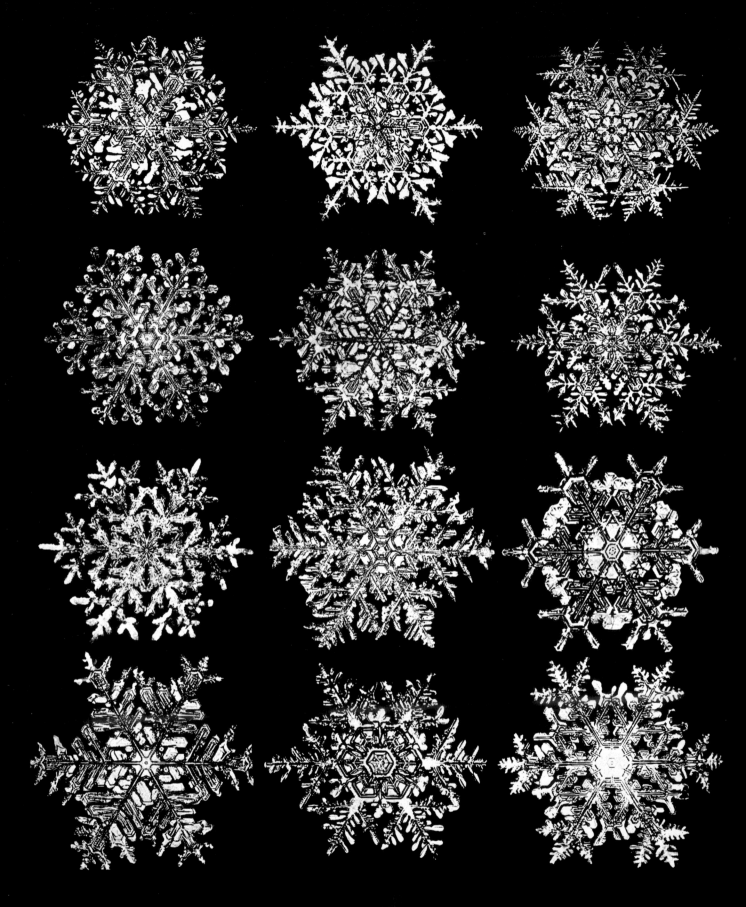

194

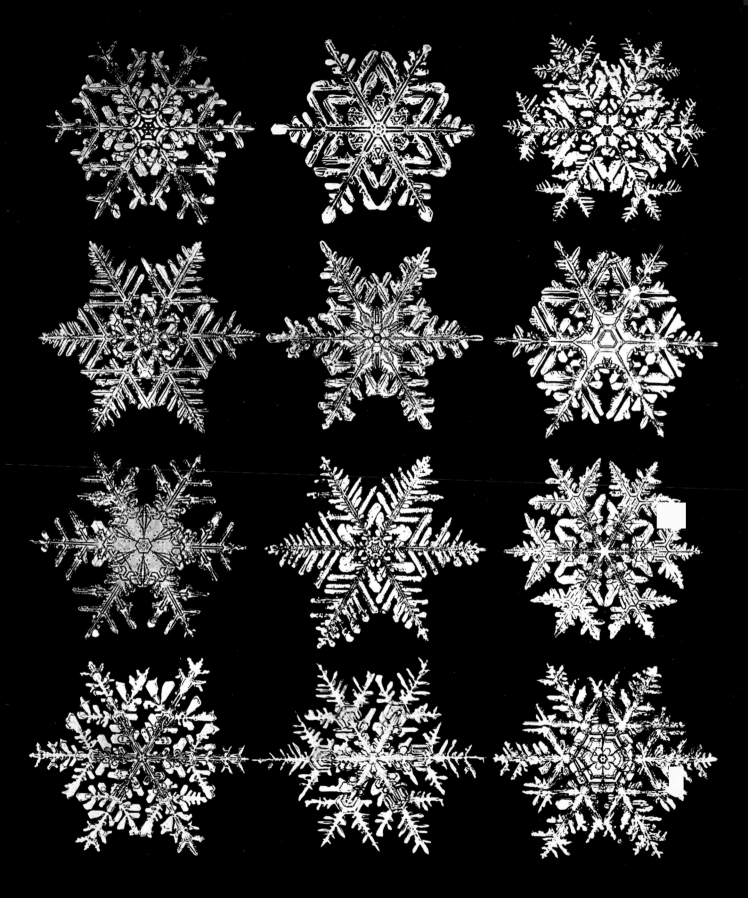

195

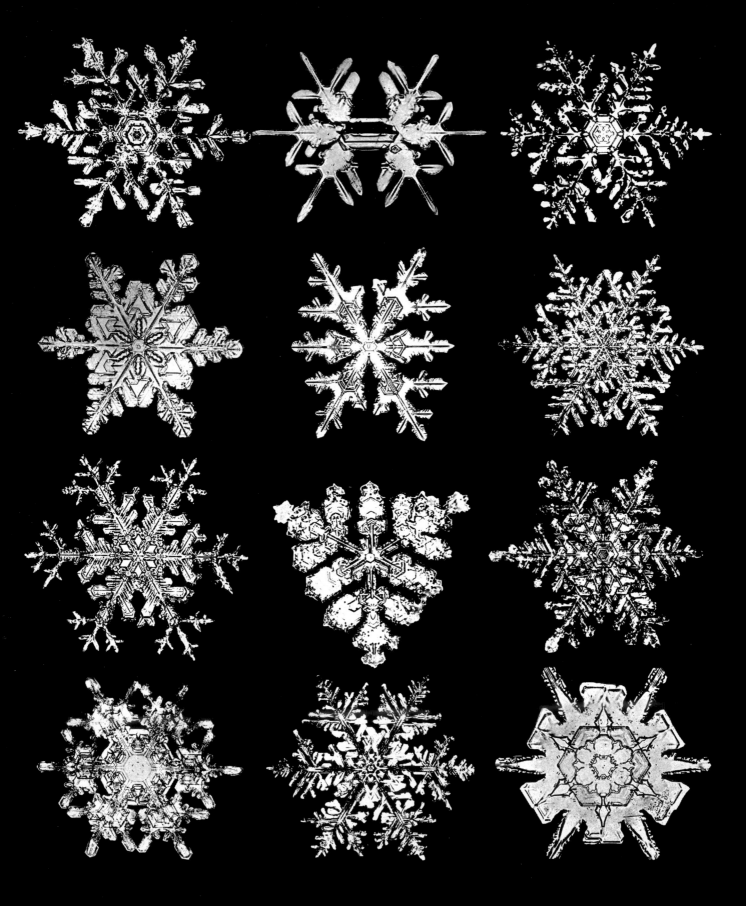

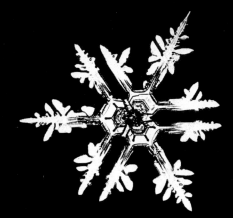 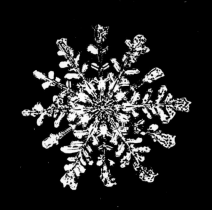 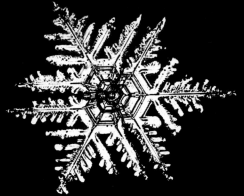

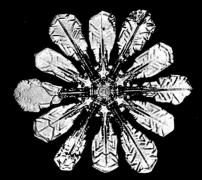 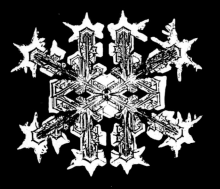 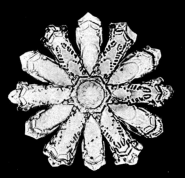

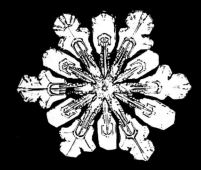 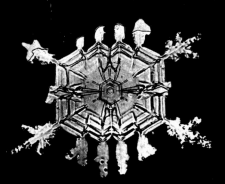 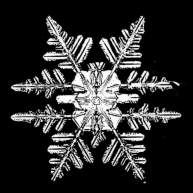

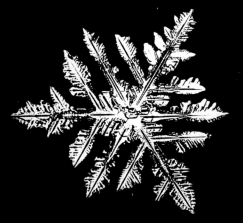 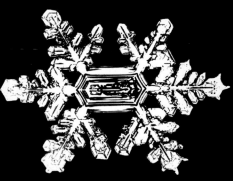 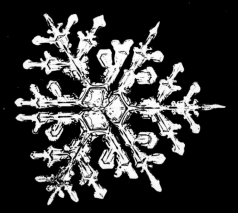

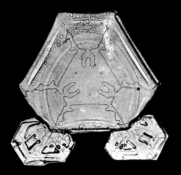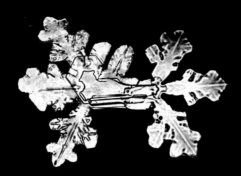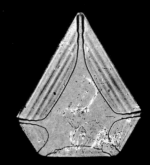

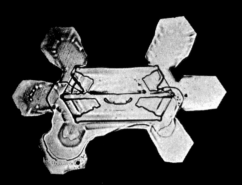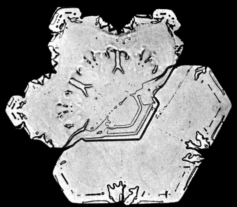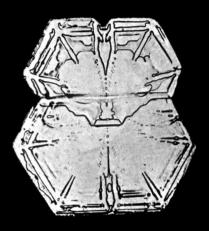

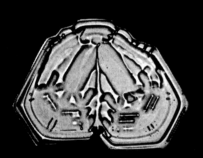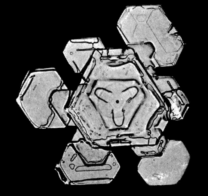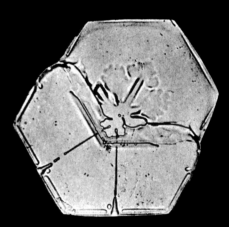

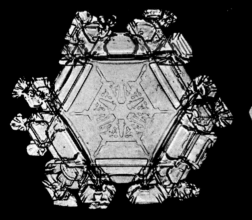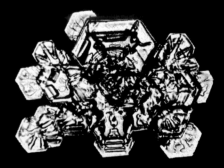

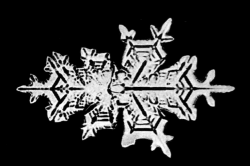
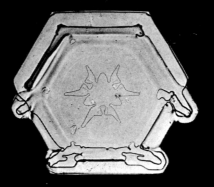
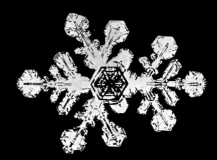

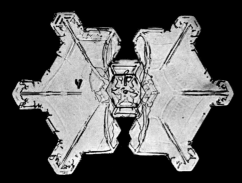
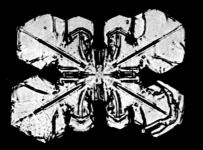
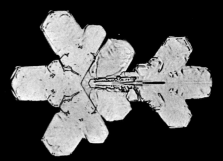

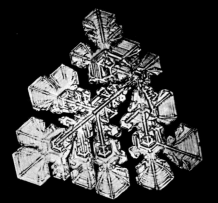
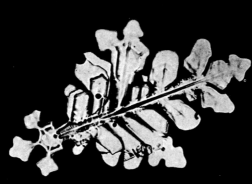
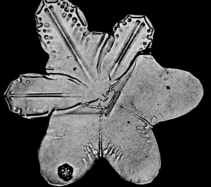

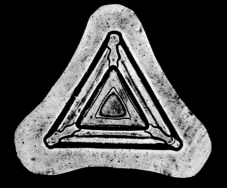
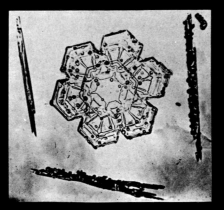
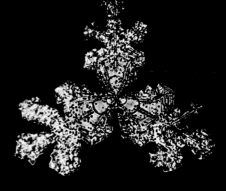

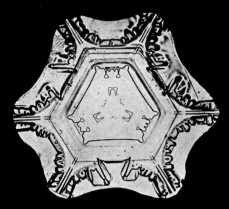
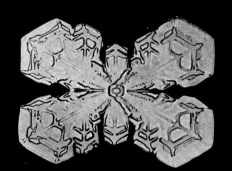
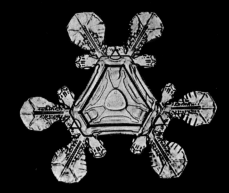
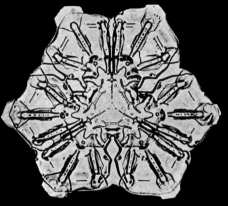
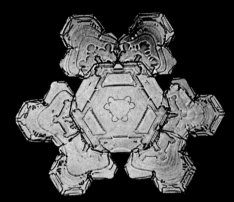
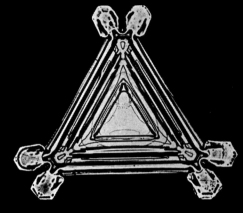
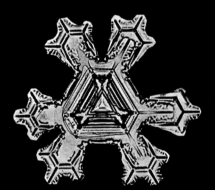
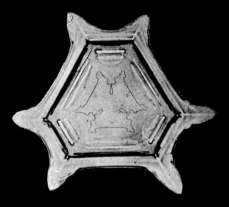
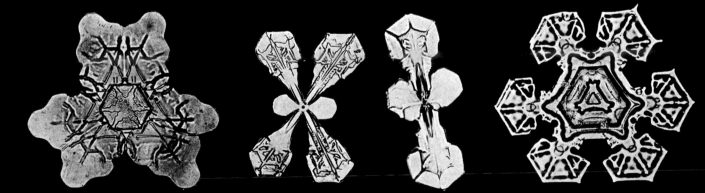

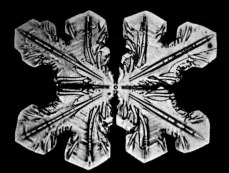
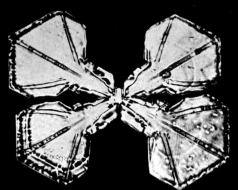
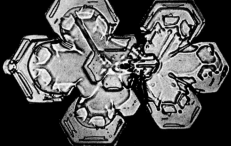
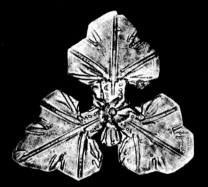
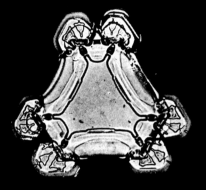
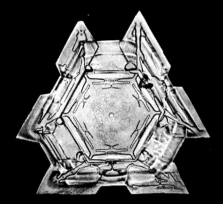
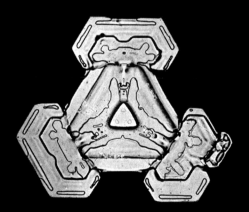
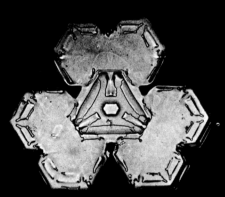
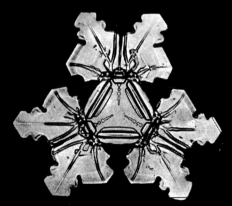
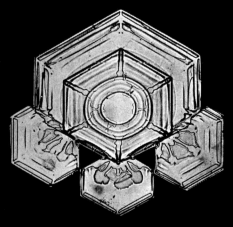
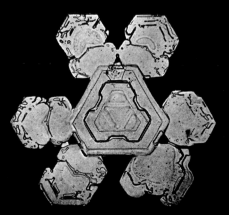
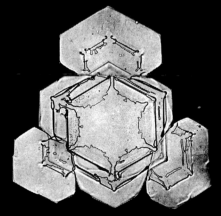

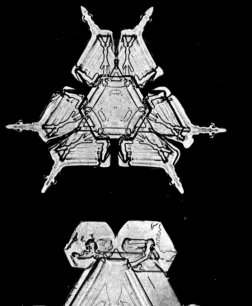
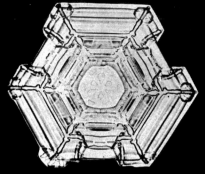
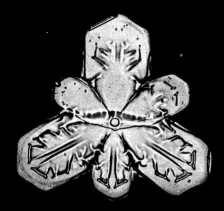
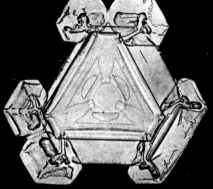
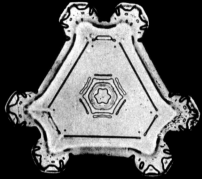
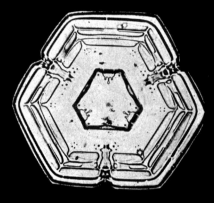
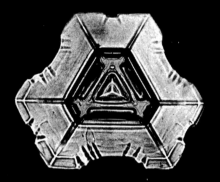
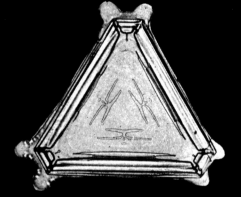
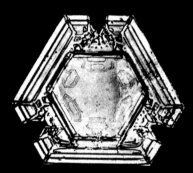
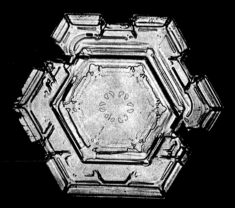
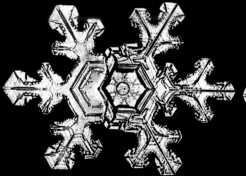
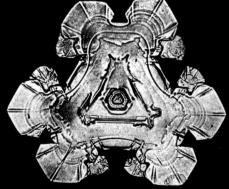

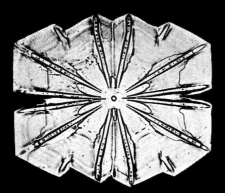
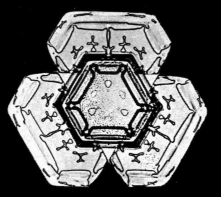
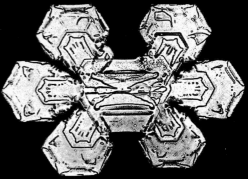

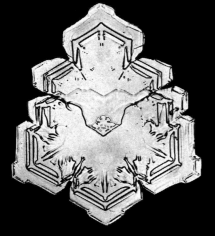
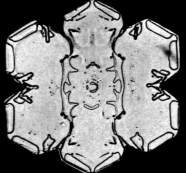
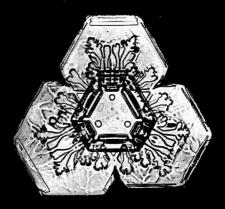

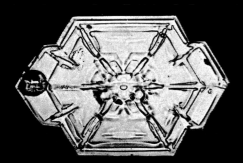
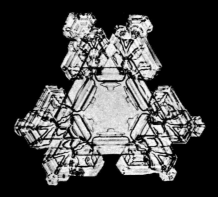
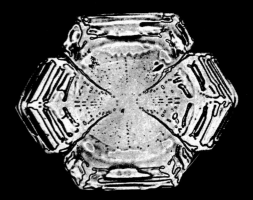

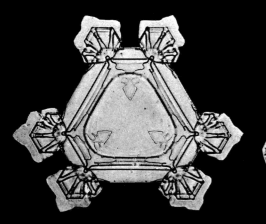
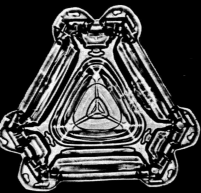
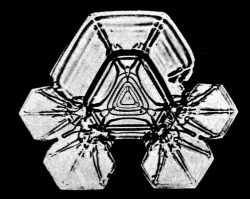

203

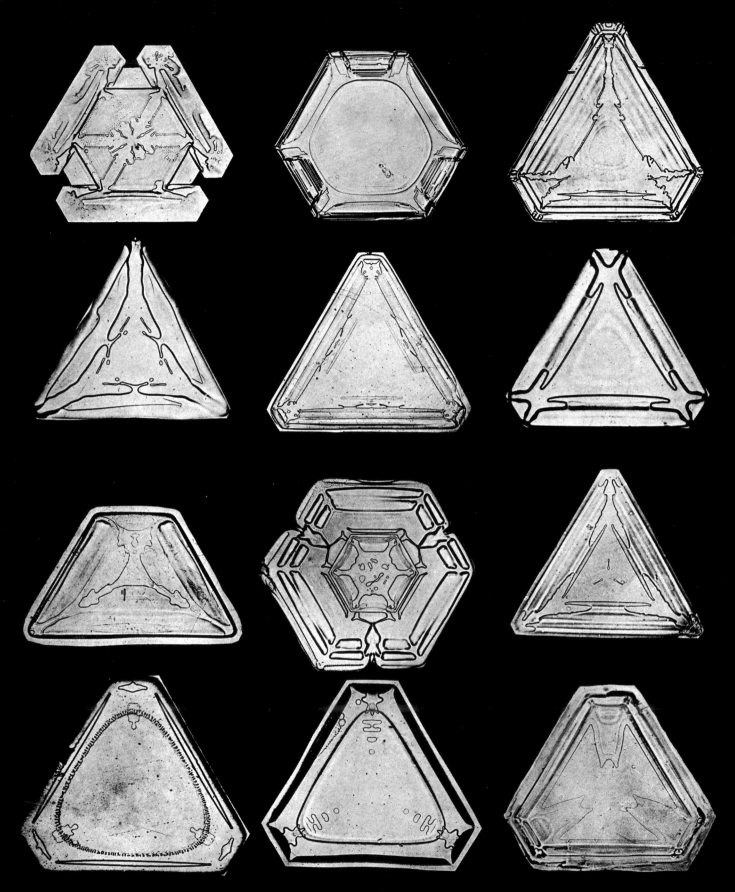

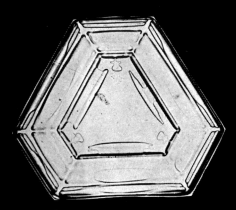
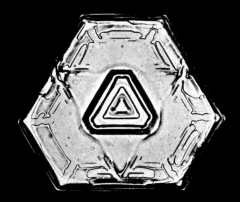
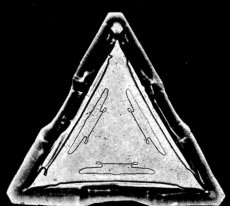
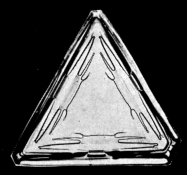
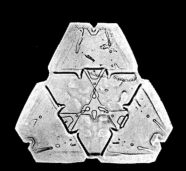
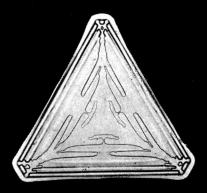
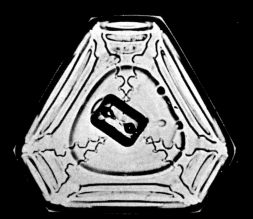
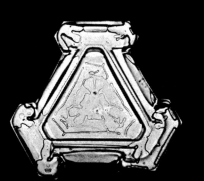
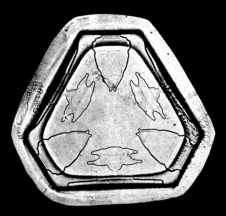
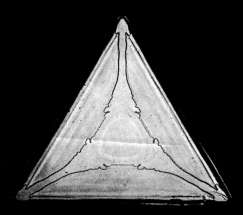
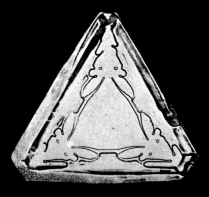
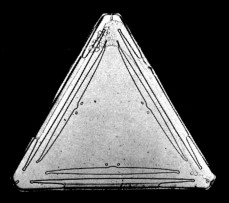

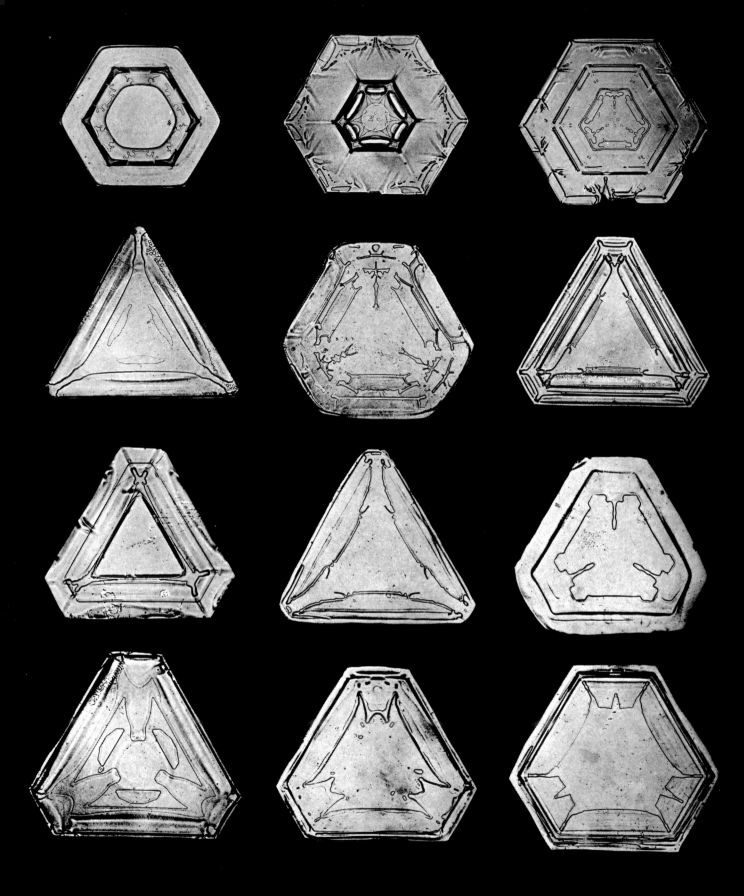

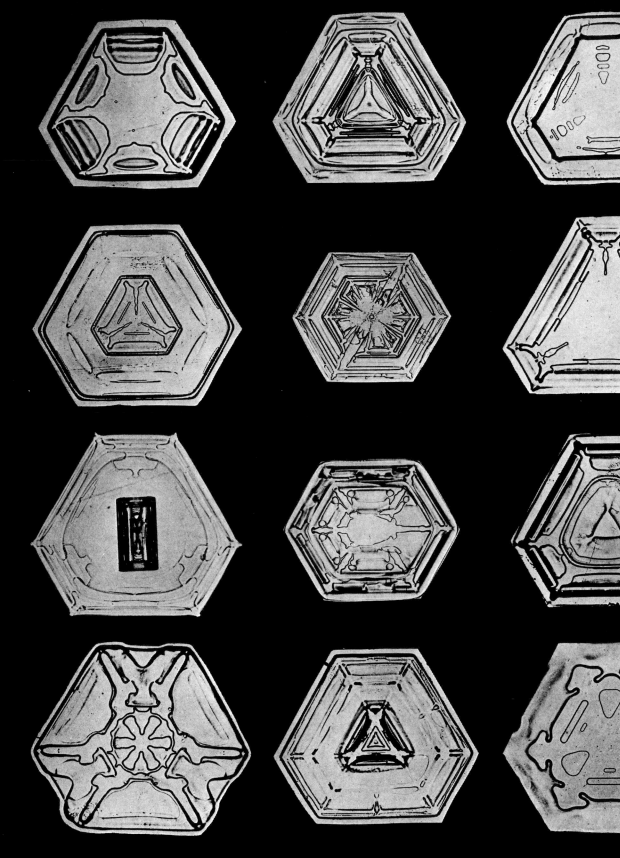

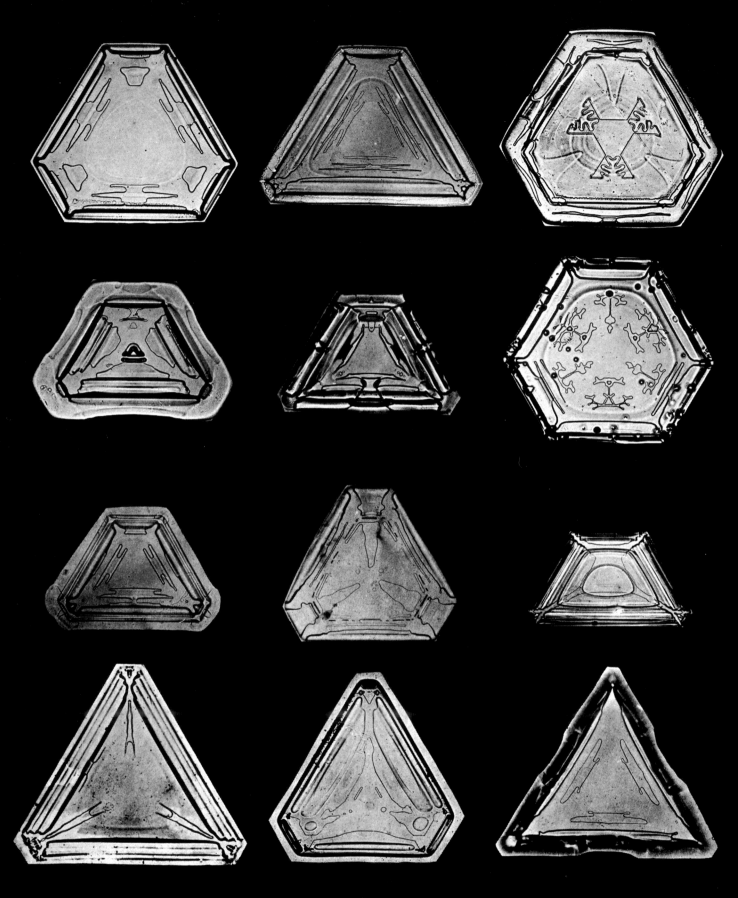

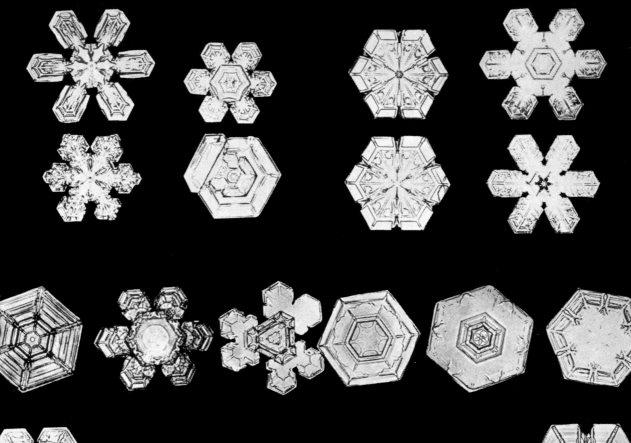

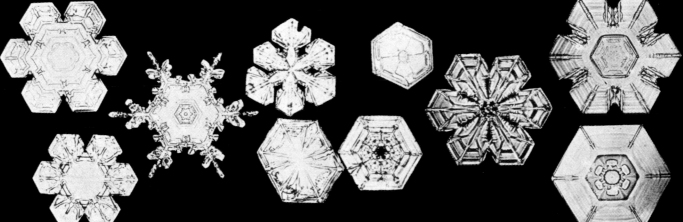

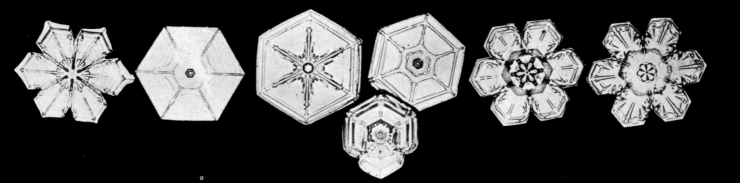

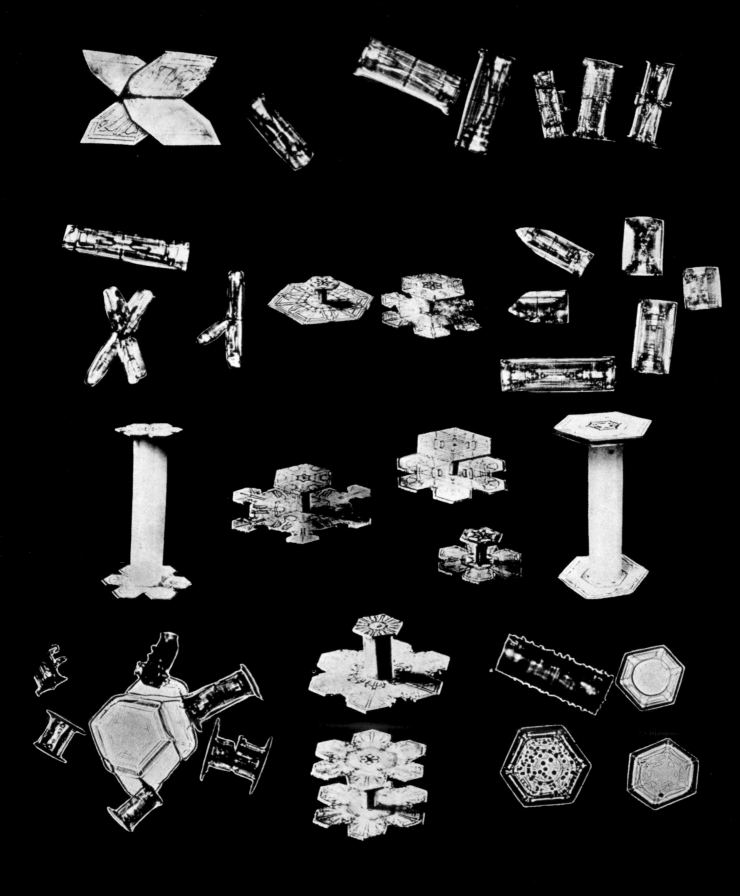

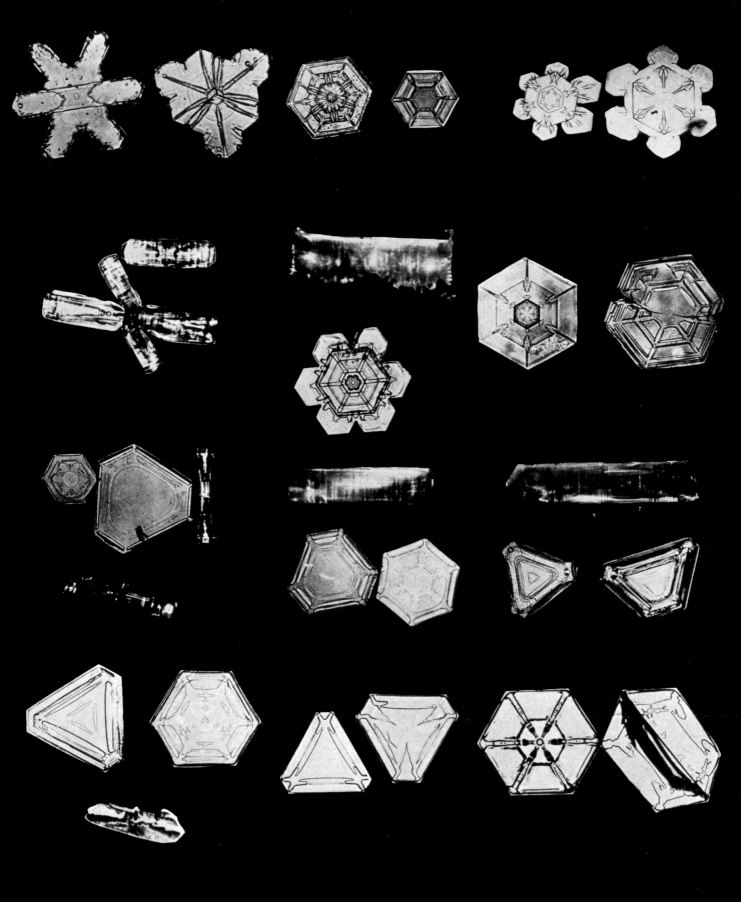

211

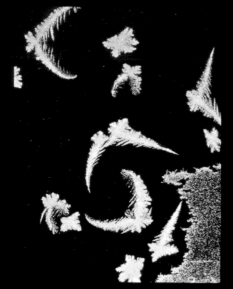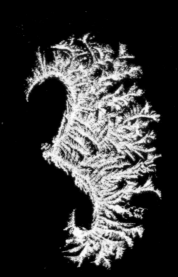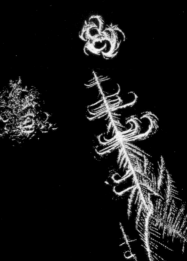
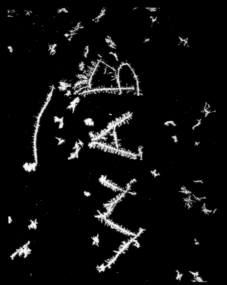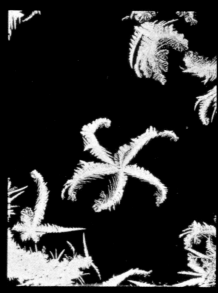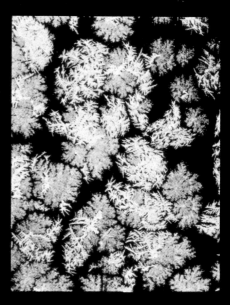
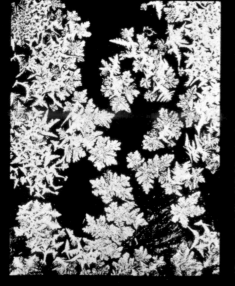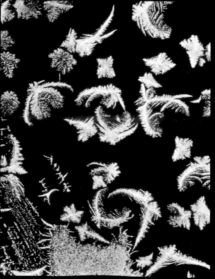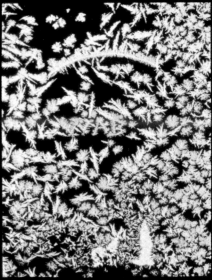

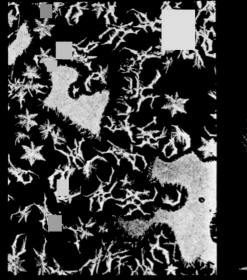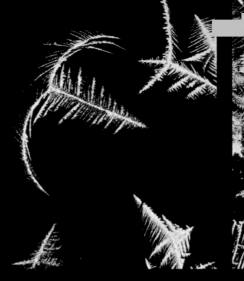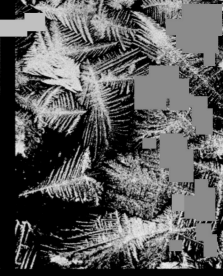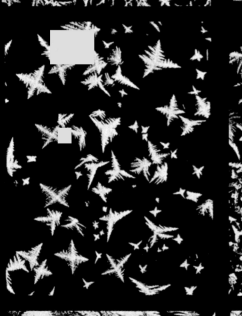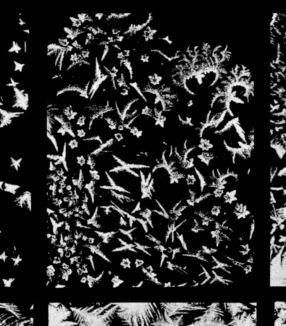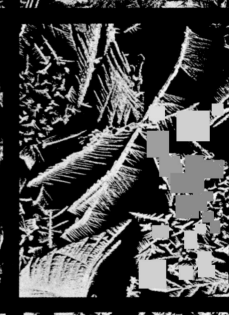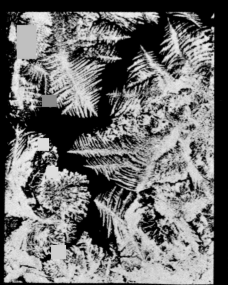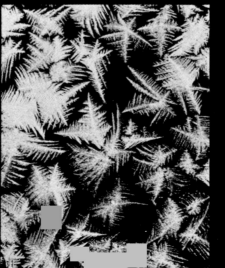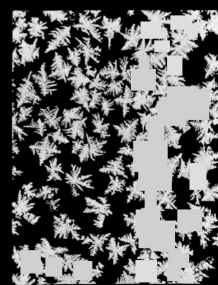

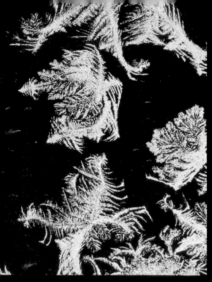 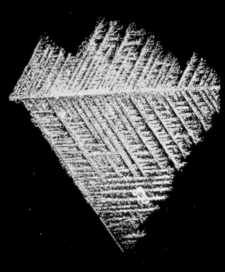 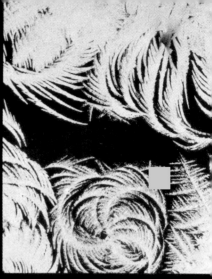
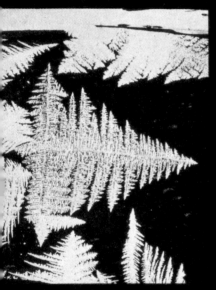 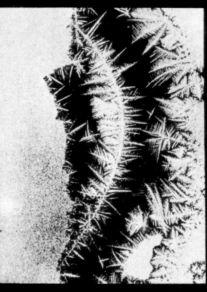 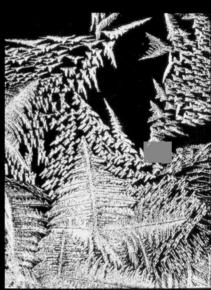
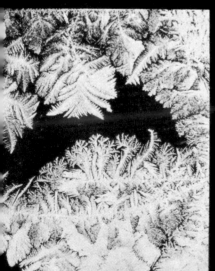 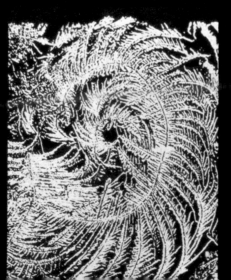 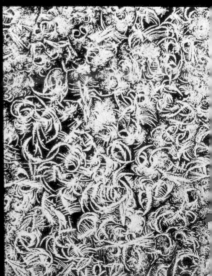

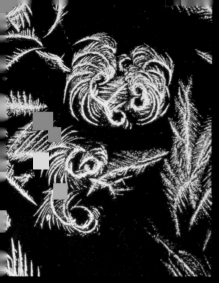
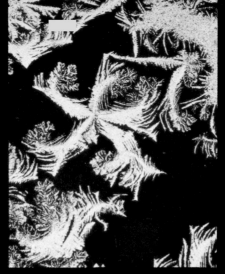

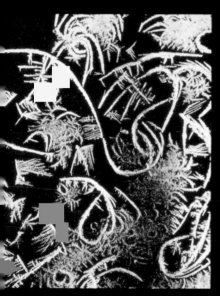
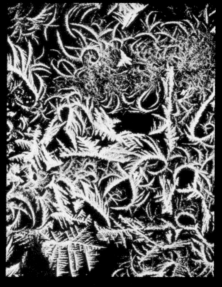
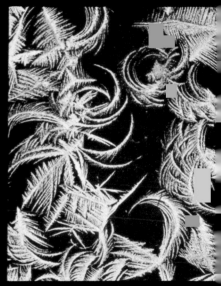
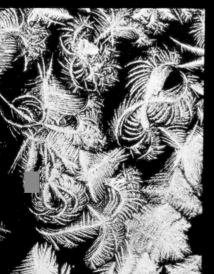
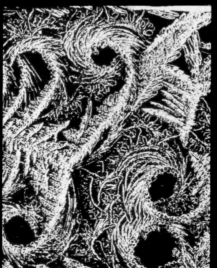

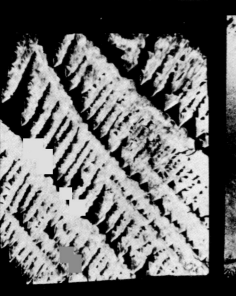 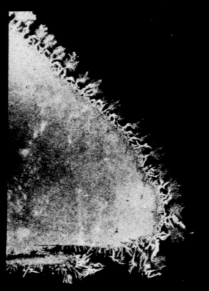 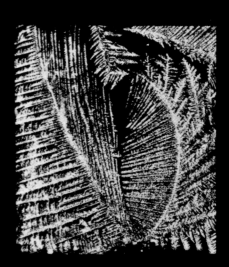

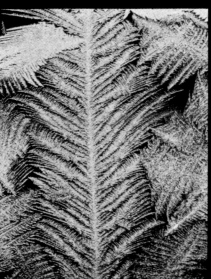 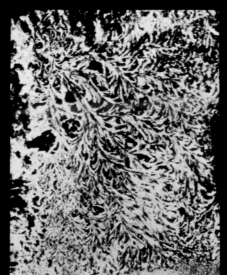 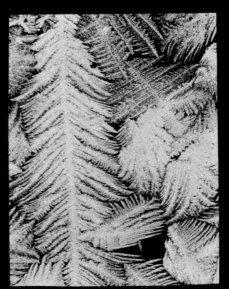

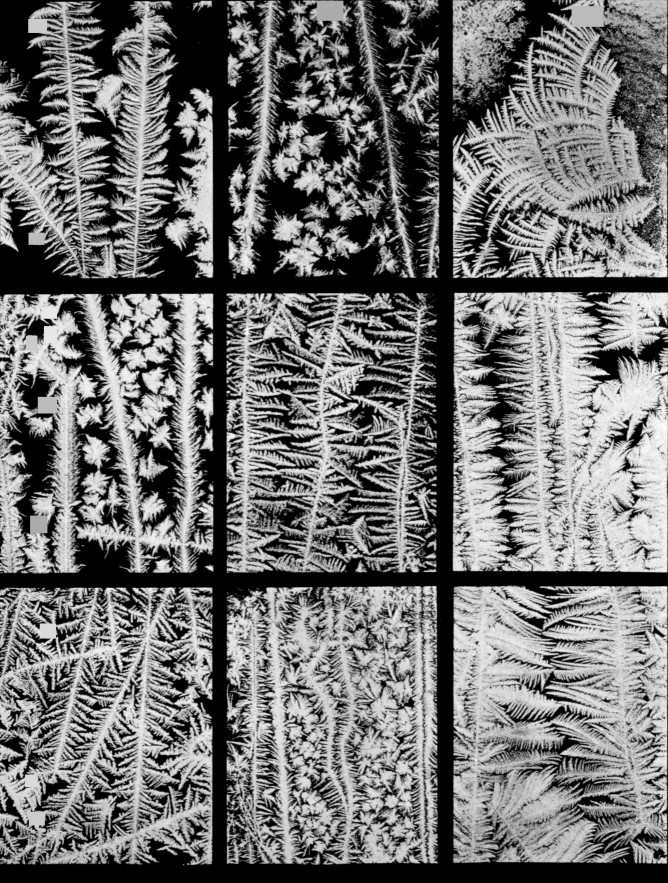

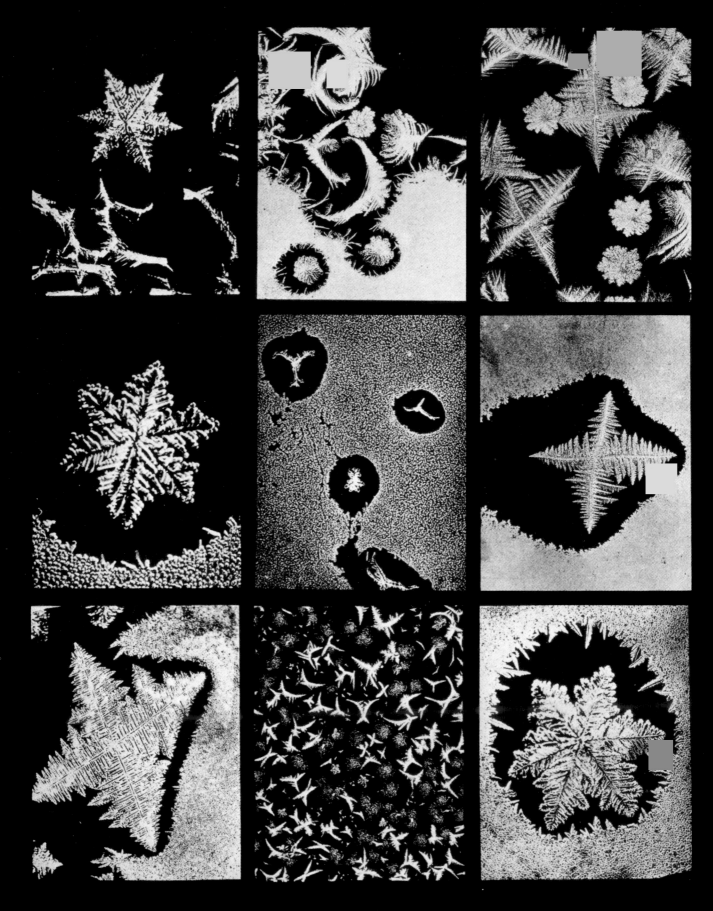

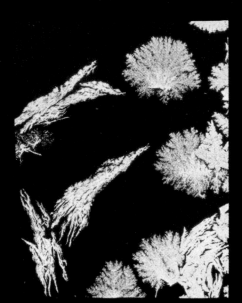
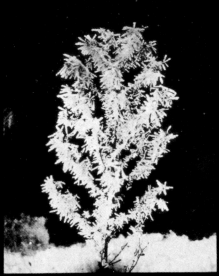
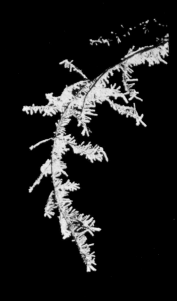
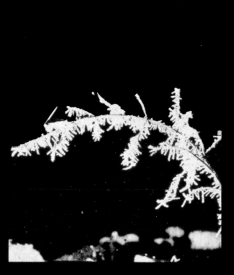
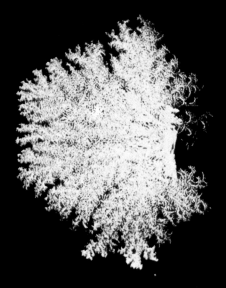
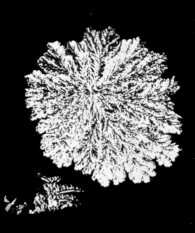
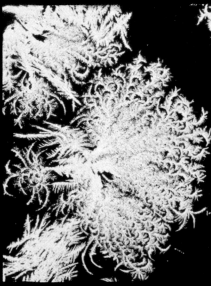
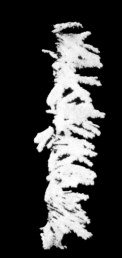
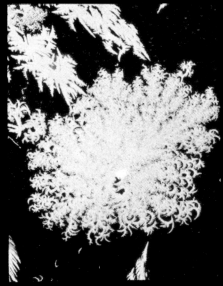

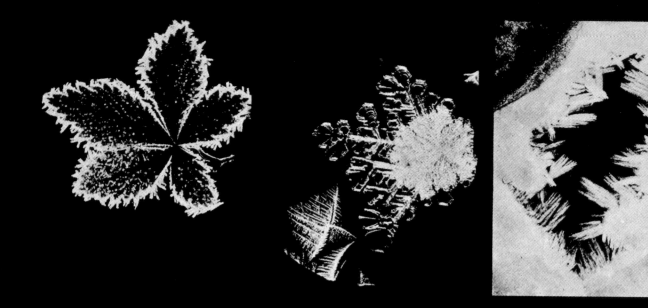

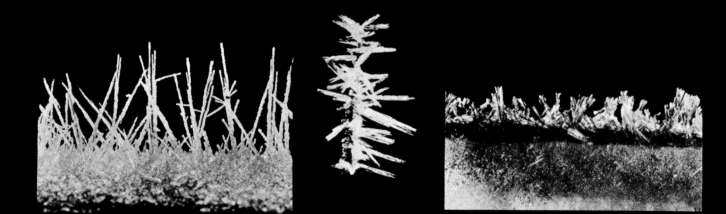

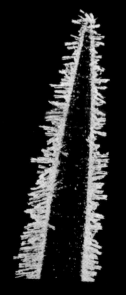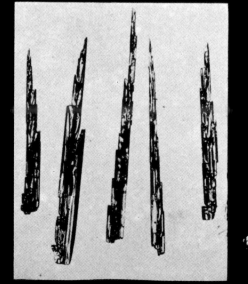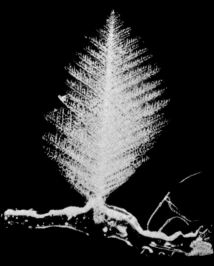

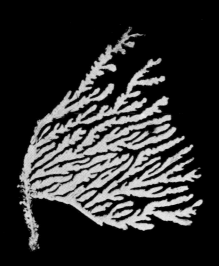
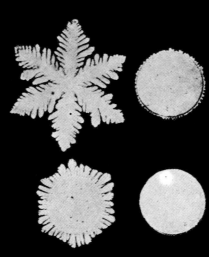
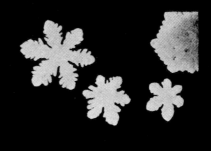
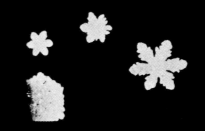
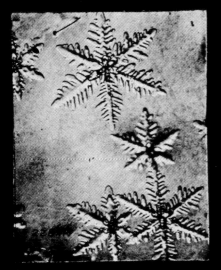
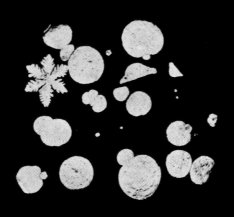

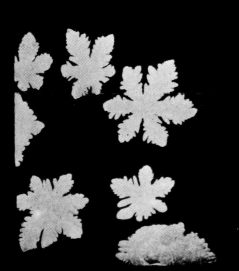
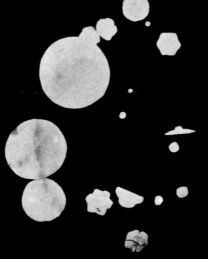
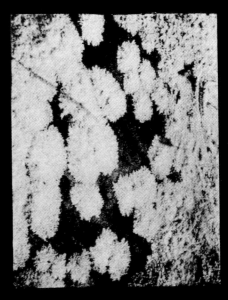

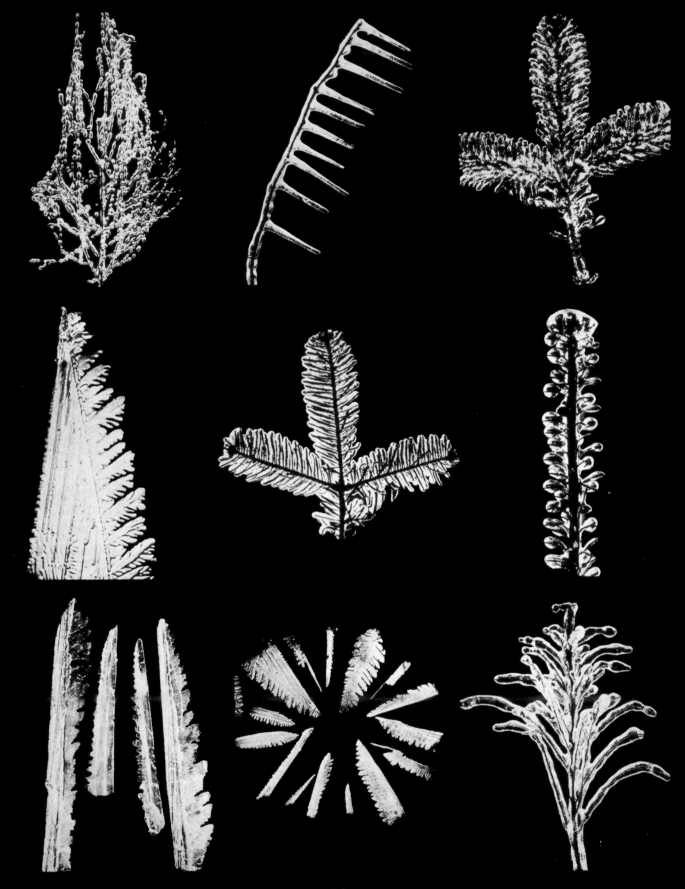

 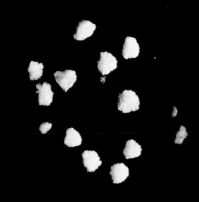 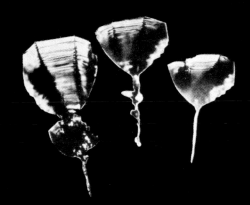

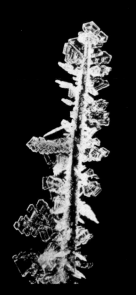 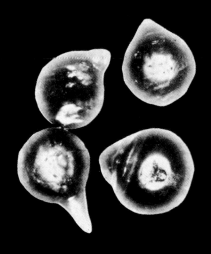 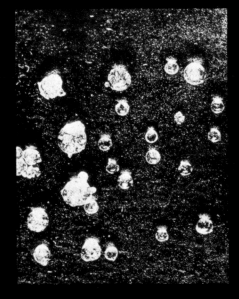

223

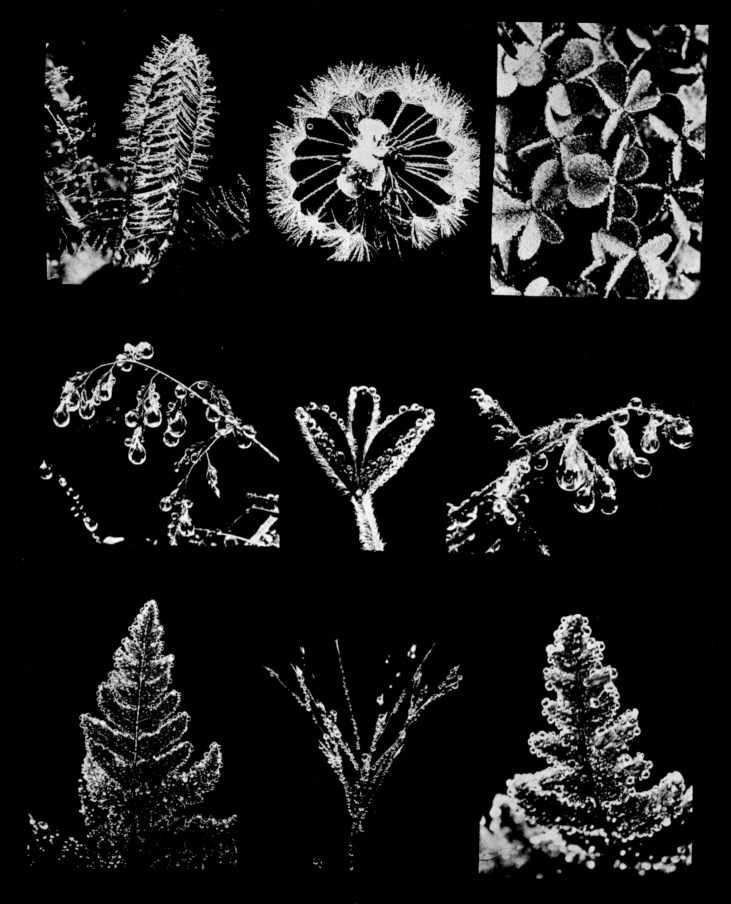

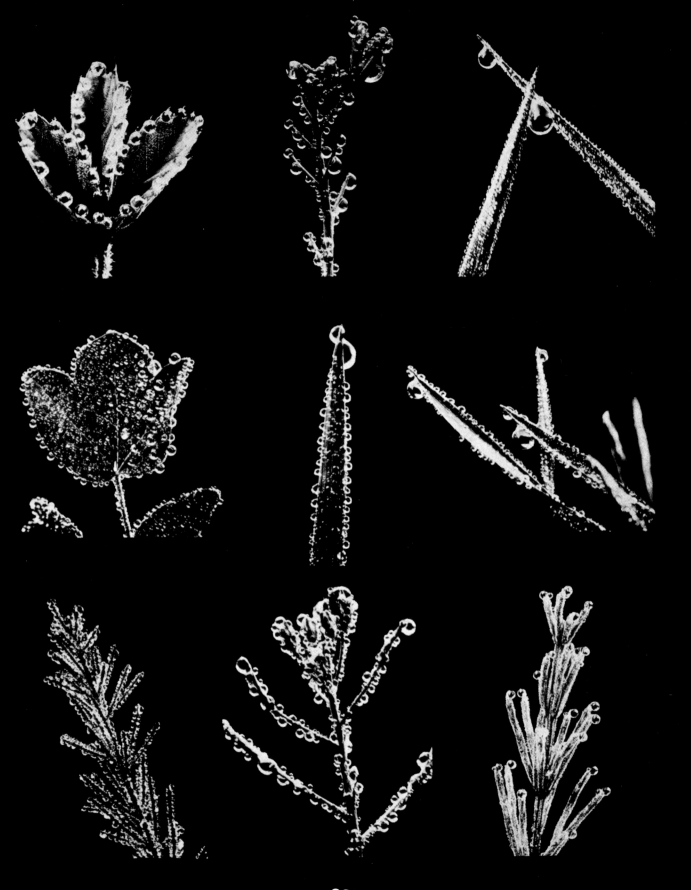

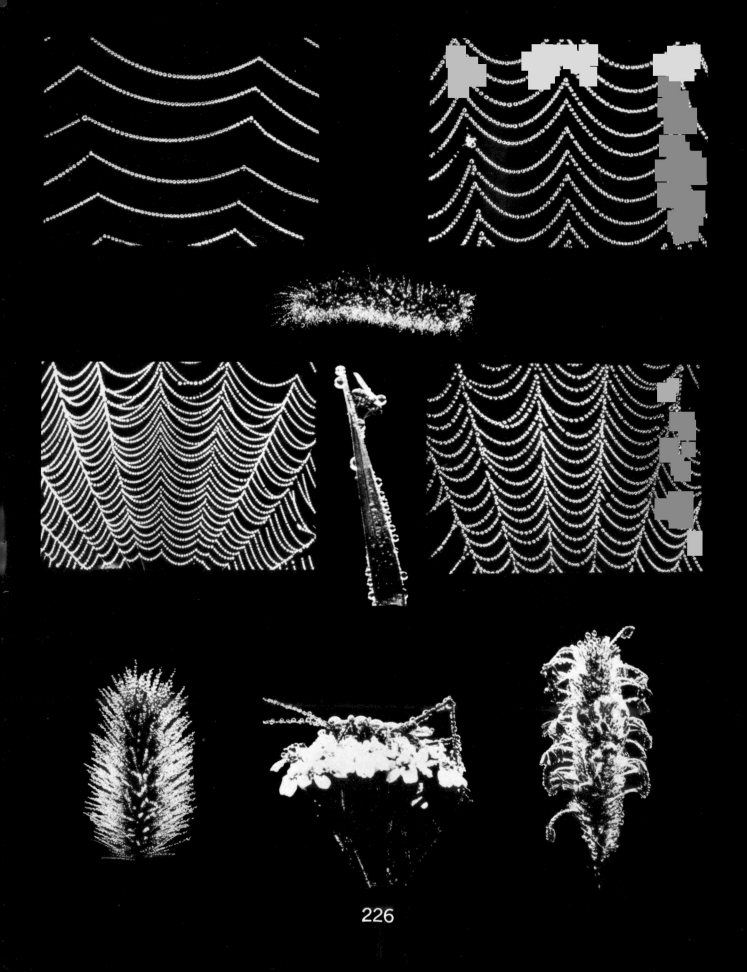

SNOW

Here delicate snow-stars, out of the cloud,
* Come floating down in airy play,*
Like spangles dropped from the glistening crowd
* That whiten by night the Milky Way.*

WILLIAM CULLEN BRYANT

FROST

He went to the windows of those who slept,
And over each pane like a fairy crept:
Wherever he breathed, wherever he stept,
* By the light of the moon was seen*
Most beautiful things. There were flowers and trees,
There were bevies of birds and swarms of bees,
There were cities, thrones, temples, and towers, and these
* All pictured in silver sheen.*

HANNAH FLAGG GOULD

DEW

The winds were still and the stars were bright,
And the fairies danced all night, all night,
Then scattered in glee from their infinite store
The sparkling jewels and gems they wore—
Sapphires and rubies that gleam in the sun,
Opals and pearls where their dancing was done.

W. J. H.